iN YOUR FACE TOO!

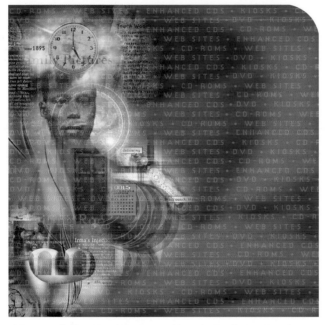

More of the Best Interactive Interface Designs

BOOK
 Author/Designer: Daniel Donnelly
 Cover Design: Daniel Donnelly
 Strategic Consultant: David J. Link
 IYF Design Copyeditor: Jeannie Trizzino
 Project Manager: Don Fluckinger
 Design Associate: Christian Memmott
 Editorial Assistants: Patrick Lang, Christian Memmott
 Production Assistant: Carolyn Short

CD-ROM
 Design: In Your Face Design
 Production: Patrick Lang, Carolyn Short

WEBSITE
 http://www.inyourface.com

Author and designer Daniel Donnelly is the owner and
creative director of Interactivist Design, a multimedia
design studio located in Northern California. Creating
interactive multimedia for consumer and corporate
clients, he specializes in World Wide Web and
CD-ROM design.

Donnelly is also the publisher of *IYF magazine*, a
Web-based magazine focusing on interface design for
multimedia professionals, and *IYF Express*, a monthly
newsletter for interactive designers.

First published in the United States of America by:
Rockport Publishers Inc.
33 Commercial Street
Gloucester, Massachusetts 01930-5089
Telephone: (978) 282-9590
Facsimile: (978) 283-2742

ISBN 156496-891-X

www.rockpub.com

10 9 8 7 6 5 4 3 2 1

Printed in Hong Kong

¡N YOUR FACE TOO!

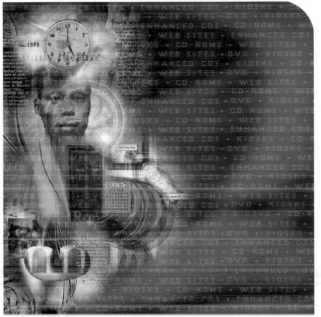

More of the Best Interactive Interface Designs

ROCKPORT

CONTEN

Introduction:
In Your Face Again!

The first *In Your Face* was first published in 1996, ancient history in terms of new media timelines. From then till now there have been a lot of changes in the new media industry—some media have come and gone, such as floppy disks; some software has shone briefly and faded away, such as SuperCard and mTropolis; and the cast of designers has grown considerably as more colleges and universities develop new media degree and certificate programs, churning out fresh-faced students bursting with creativity. In this rapidly changing industry one thing is certain, the Web is here to stay—it's a medium that encompasses functionality and beauty and much of the public in North America and Europe has found it to be useful. The Web and email have vastly improved communication on an international scale—the ease with which I was able to contact design firms via email in Europe, Asia, and South America was a far cry from the "fax and hope process" of the first edition of *In Your Face.*

CD-ROMs and Hybrid CDs

Along with the floppy disk, the new media industry has seen a major drop in the production of non-game and interactive CD-ROMs. Large companies are still producing games by the dozens, but design portfolios, interactive training, and marketing and promotional CD-ROMs are being supplanted by the Web. Enhanced CDs seemed much more promising in 1996 than they do in 2000. Quite a few have been produced over the years, but this medium seems to be falling into the same hole as the CD-ROM, again supplanted by the Web. Websites like the Mary J. Blige Website (p. 109) or the Dreamworks Records Website (p. 95) are good examples of how content that once might have been restricted to a CD-ROM medium is now manageable on a Website.

Websites

The buzzwords among Web designers now are "streaming media." The development of stable, interactive mini-applications for Websites is contributing to the demise of the non-game CD-ROM. Streaming media allow audio, video, and interactivity to fill the Web with sound, action, and responsiveness in a reasonable package (i.e., one not requiring a T1 line). The most popular software used to deliver streaming interactivity is Macromedia's Flash; nearly every Website selected for this edition features some form of Flash (see dFilm.com, p. 86, and Discovertoys, p. 112). Other streaming media software to watch for includes RealPlayer, Apple QuickTime, and Windows Media Player. Streaming media is crucial in releasing Web browsing from HTML's typographic and design constraints. Flash allows talented multimedia designers to create what are essentially interactive Web applications that play within browsers and are cued by HTML coding.

Flash can be used in place of HTML, or as a complement to basic HTML Web design. Bandwidth is becoming of less concern, especially as faster connections are developed (cable modems and DSL) and compression technologies are improved.

Kiosks

Kiosks still hold their own in the multimedia industry—they are a niche market, and as such probably will not experience the same kind of growth as the Web. For the experienced professional they offer the chance to design beautiful and functional interfaces without the current bandwidth problems of the Web, and new software for designing Internet kiosks allows companies to produce them without the need for expensive programming (see Royal Caribbean Cruise Lines p. 152). Kiosks remain an elusive form of media to capture and display in book form because of their large-scale and limited distribution.

DVDs

If any form of interface design has a chance of giving the Web a run for its money, it is the DVD (Digital Video Disc). A medium in its infancy, these discs can hold up to six gigabytes of information and are poised to replace videocassettes, delivering movies to personal computers or to televisions via DVD-ROM players. Interfaces are required to allow viewers access to additional material supplied on the DVD, such as accessory voiceover tracks, alternate language soundtracks, or movie trivia. In many cases two interfaces are required—a simple one to accommodate the limited movement options of television remote controls for set-top DVD players, and a second one to take advantage of the unlimited movement range of a computer mouse for computers with DVD-ROM players. DVDs are bringing the world of interface design to homes that do not have computers. Designers are still finding their way around this medium, but a look at the James Bond Collection interfaces (pp. 124–127) shows that the future for DVD interface designers is rich.

In Your Face Too! follows in the footsteps of the first *In Your Face* by offering readers a selection of interface designs that are beautiful as well as functional. No matter what the medium, the qualities that make these examples of fine interfaces are that they are visually pleasing, balanced, and appropriate for the content they represent. It is also very important that the organization of the interface adequately represent the content, making it easier for users to find what they're looking for. Essentially, these interfaces make complexity manageable while remaining pleasing to the eye. The times have changed, but design essentials remain the same.

Daniel Donnelly
In Your Face Design

OMS and ENHANCED CDS

2

cd-roms and
enhanced cds

EDUCATIONAL

Sigmund Freud: Archaeology of the Unconscious is an award-winning CD-ROM created by Nofrontiere Design, located in Vienna, Austria. The CD-ROM, developed in conjunction with the Sigmund Freud Society in Vienna, is an engaging multimedia narrative about the life and work of Sigmund Freud, as well as an interactive exploration of the history of psychoanalysis and the influence it has had on the world of literature, visual arts, and other forms of expression.

A dream-like sequence of scrolling imagery composed of metaphorical Freudian objects defines the navigational structure of the CD-ROM. Wispy animated linework, moving backgrounds, and various photographic montage sequences combine with concrete visual elements, such as couches, money, and other sexually suggestive items to represent eleven different narratives.

Dynamic elements such as the interactive contents screen (below)—where the user must move the cursor around the screen to reveal the main navigational links—animated transitions between narratives, and artfully designed video segments are just a few of the dynamic techniques used to interpret Freud's theories.

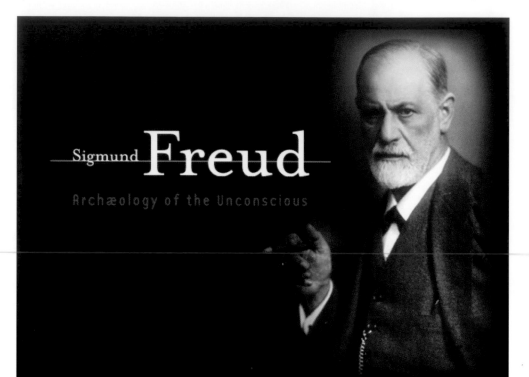

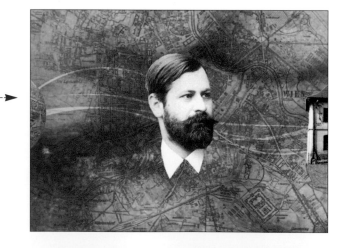

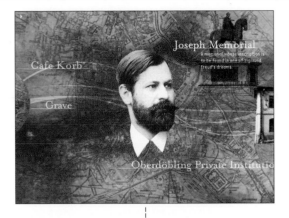

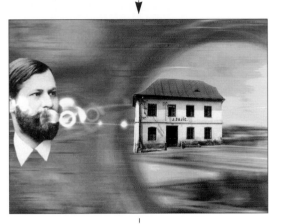

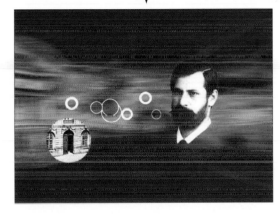

Project:	*Sigmund Freud: Archaeology of the Unconscious*
Client:	Sponsored by the City of Vienna
Design Firm:	Nofrontiere
Art Direction:	Etienne Mineur, Peter Turtschi, Ulf Harr
Programming:	Ulla Gusenbauer, Ulf Harr
Executive Producer:	Alexander Szadeczky
Project Manager/Production:	Lisa Löschner
Sound:	Rupert Huber
Design:	Sabine Kleedorfer, Flo Koch
Copywriting:	Oscar Habermaier, Kathie Tietz
Technical Consulting:	Hans Peter Heinzl, Marcus Dohnal
3D Design:	Marcus Salzmann
Scientific Authors	Michael Wiesmüller, August Ruhs, Wilhelm Burian
Authoring Program:	Macromedia Director
Platform Specs:	Macintosh, Windows PC

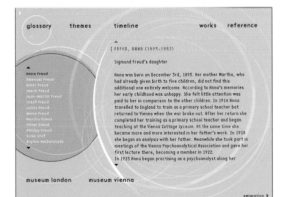

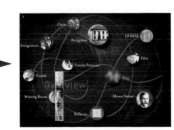

EDUCATIONAL

CO2 Media creates promotional materials for the Maryland Institute College of Art; projects range from print materials and catalogs to the design of the school's Website, and most recently the CD-ROM featured here. Since all of the materials CO2 creates for MICA focus on capturing the attention of artists and designers interested in attending the school, the design firm enjoys much artistic freedom in designing projects.

Most media projects cater to an inherently conservative audience, so the CO2 designers enjoyed creating an interctive piece that catered to a more refined and more playful user.

The CD-ROM opens with an animated introduction that combines multi-layered typographic elements with bright, colorful images that convey the sense of a motion picture title sequence, while expressing the possibilities available when merging art and technology.

The main navigation screen follows this same design, with layered and textured imagery pulled from various student projects, overlaid with the titles of each student project featured on the CD-ROM.

Project:	*MICA Techtile Stimuli*
Client:	Maryland Institute College of Art
Design Firm:	CO2 Media
Design:	Max McNeil, Jeff Wilt
Authoring Program:	Macromedia Director
Platform Specs:	Macintosh, Windows PC

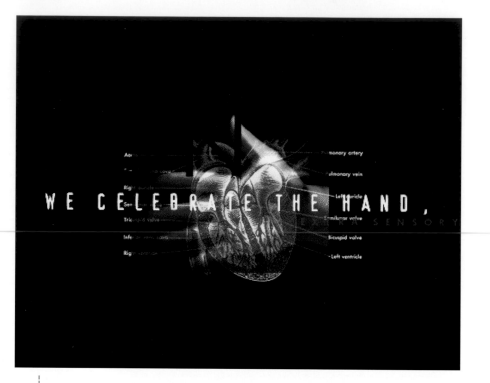

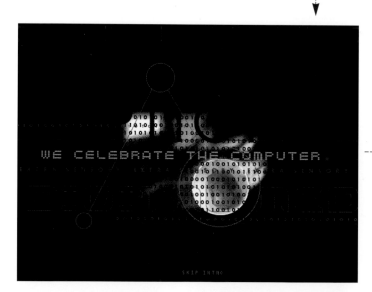

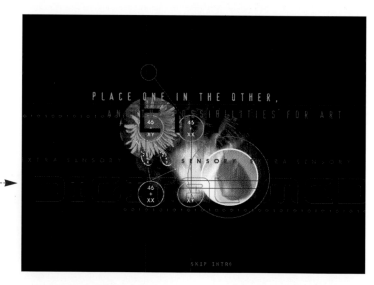

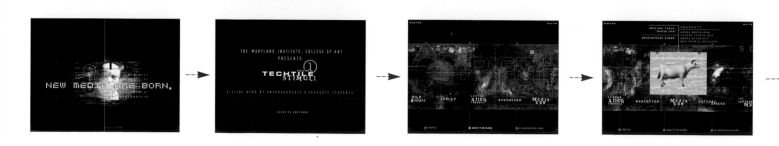

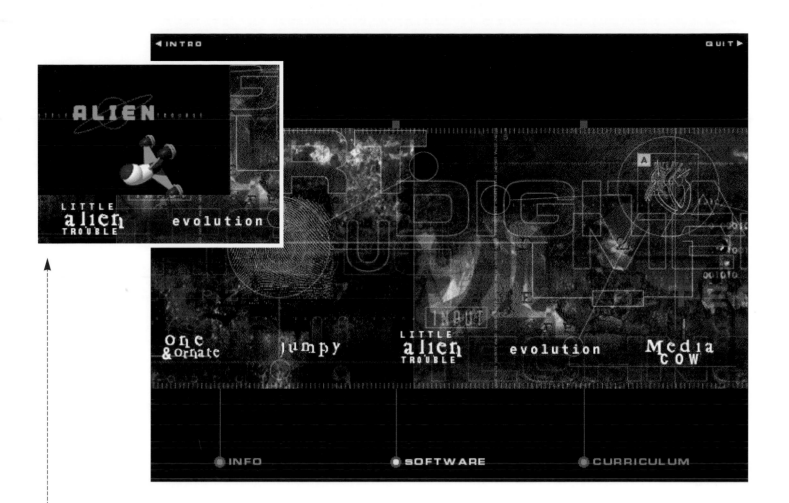

Rather than design a set of static buttons, CO2 designers created an exciting and functional navigation screen to view the main contents of the CD. When viewers move an arrow-cursor from left to right on the screen, the large background image moves along horizontally at one speed, while the titles move at a slower speed. This element evokes depth in otherwise flat art. As the cursor approaches the left or right edge of the screen the interface reverses its horizontal movement, and increases or decreases the scrolling speed. Clicking on a title pops up a smaller window (inset above) to show a specific student's project.

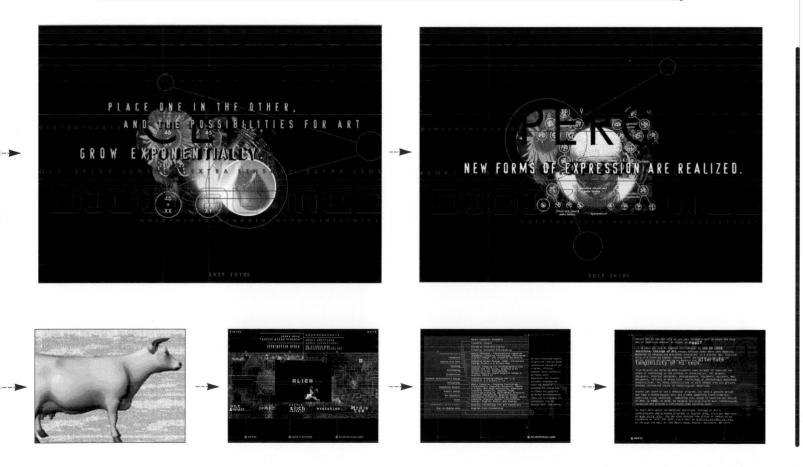

STUDENT WORK

Inside: The Secret Life of Trees is the first of three interactive projects featured on the *Inside* CD-ROM that was created by students at Wanganui Polytechnic in Wanganui, New Zealand. All three pieces are viewed by navigating from the main title screen (right). The piece shown here is the work of Ooi Yeong Hoang, a computer graphics major whose theme was to interpret the "importance of trees to humans."

The piece begins with a video of an animated 3-D insect traveling through a foreboding, darkly forested landscape, and the opening text sets the tone of the project by stating that "Humans are great inventors, but they are also great destroyers." The video ends with the insect—the main navigational icon used throughout—landing in a tree, which is used as the main interface for the project.

Ooi created three distinct sections for users to explore while discovering the history and importance of trees. Each section is richly illustrated and separately unique in its interaction. The controls for opening windows into the world of the tree are often hidden among leaves, draggable branches, or glowing petroglyph-like drawings carved into the bark.

Two of the most important design elements are the use of lighting within each section that gives the images a rich, otherworldly glow, and the use of highly textured backgrounds and organic imagery that give the viewer a sense of being deep within the trunk of an ancient tree.

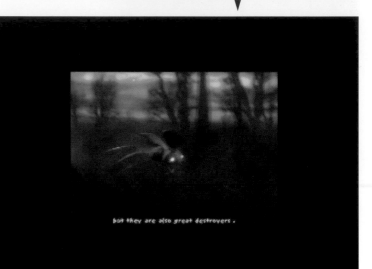

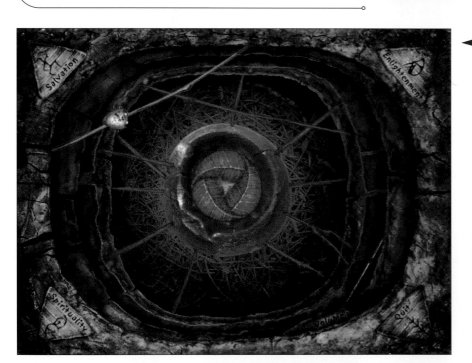

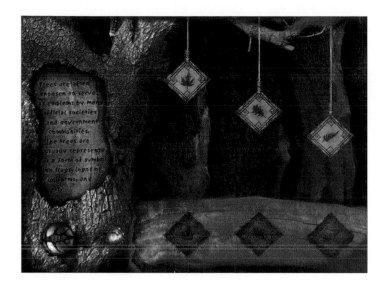

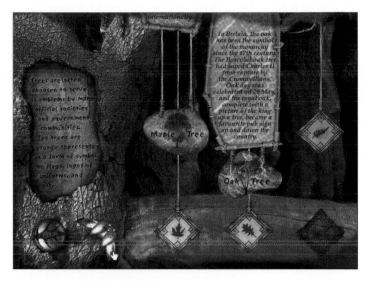

Project: | *Inside: The Secret Life of Trees*
Client: | Wanganui Polytechnic
Design Firm: | Dept. of Computer Graphic Design
Design: | Ooi Yeong Hoang
Programming: | Yulius
Production: | Yeoh Guan Hong, Yulius
Authoring Program: | Macromedia Director
Platform Specs: | Macintosh

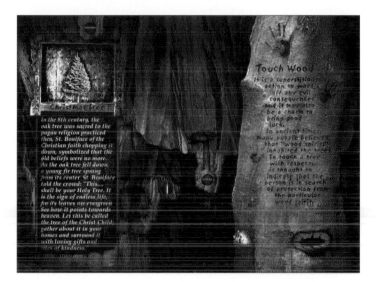

STUDENT WORK

N•E•W (*New Electronic World*) is the second student project featured on the *Inside* CD-ROM produced by designers at Wanganui Polytechnic in New Zealand. The designer, Chen Lin Yew, majors in design for interactive media.

The project opens with a flashy, fast video sequence of blurred monitors moving across the screen, which come together to form a series of adjectives drawn from a designer's vocabulary. The words then break apart as if being blown off the screen by a strong wind. This opening animation sets the theme for other interactive elements within the design, and establishes the overall look and feel of the project.

To navigate from the contents screen, users move a cursor over one of the small orange dots, which shoot out letters spelling each section title. Clicking on one of these section titles sends the user to one of four different areas that continue to use large typographic imagery, and the dynamic use of blurred moving images and type treatments.

Advanced programming in Macromedia Director afforded Yew the opportunity to create dynamic interactive navigation that allows the user to rotate images and text on an invisible three-dimensional axis.

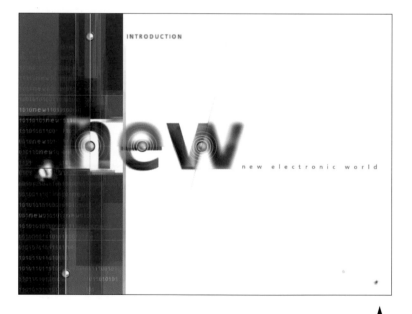

Project:	**N•E•W (New Electronic World)**
Client:	**Wanganui Polytechnic**
Design Firm:	**Dept. of Computer Graphic Design**
Design:	**Cheang Lin Yew**
Programming:	**Yulius**
Production:	**Yeoh Guan Hong, Yulius**
Authoring Program:	**Macromedia Director**
Platform Specs:	**Macintosh, Windows PC**

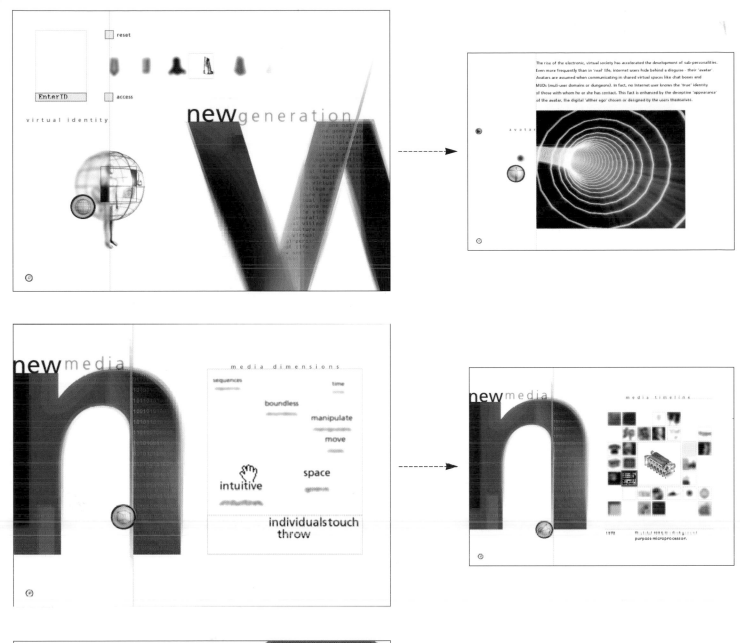

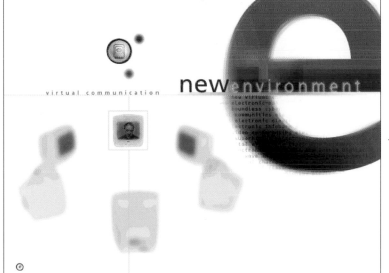

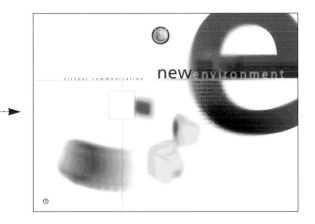

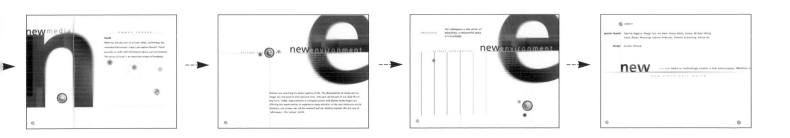

STUDENT WORK

The Mansion of Cheong Fatt Tze is the third interactive project to be featured on the *Inside* CD-ROM. This in-depth project was created by Anthony Chan, a computer graphic design student majoring in interactive media, 3-D modeling, and computer animation at Wanganui Polytechnic in New Zealand. The project centers around a Chinese mansion located in Malaysia, focusing on the history and art of the mansion, and gives a biography of the owner.

A black and white 3-D animation leads the viewer into the house by panning around the room, focusing on various objects, and foreshadowing the navigational interface. The video ends with the viewer looking into a photograph of the mansion's main room, which is also the main contents screen used for navigating the interface.

The 3-D navigation, beautifully rendered settings, and creative use of period icons —such as the abacus volume control—work together to create a convincing interactive experience. Each area of the interface commands the viewer's attention by offering either interesting information, or further exploration into the mansion and the elements that make it so intriguing.

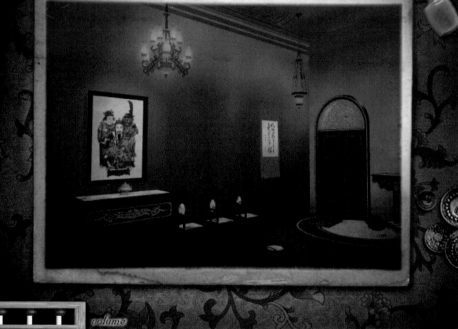

Project:	**The Mansion of Cheong Fatt Tze**
Client:	**Wanganui Polytechnic**
Design Firm:	**Dept. of Computer Graphic Design**
Design:	**Anthony Chan**
Copywriting:	**Carey Ong, Elain Ho**
Programming:	**Yulius**
Production:	**Yeoh Guan Hong, Yulius**
Authoring Program:	**Macromedia Director**
Platform Specs:	**Macintosh, Windows PC**

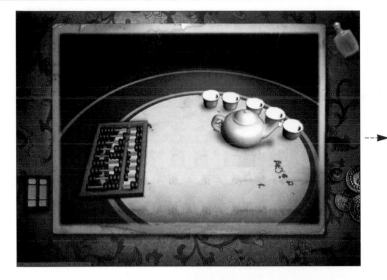

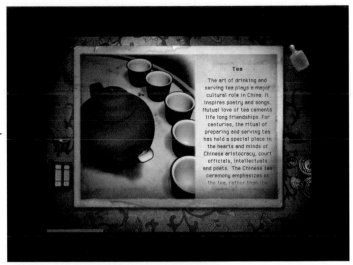

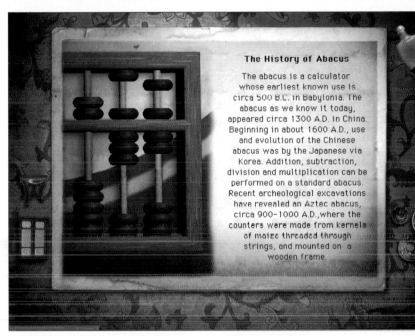

The History of Abacus

The abacus is a calculator whose earliest known use is circa 500 B.C. in Babylonia. The abacus as we know it today, appeared circa 1300 A.D. in China. Beginning in about 1600 A.D., use and evolution of the Chinese abacus was by the Japanese via Korea. Addition, subtraction, division and multiplication can be performed on a standard abacus. Recent archeological excavations have revealed an Aztec abacus, circa 900-1000 A.D., where the counters were made from kernels of maize threaded through strings, and mounted on a wooden frame.

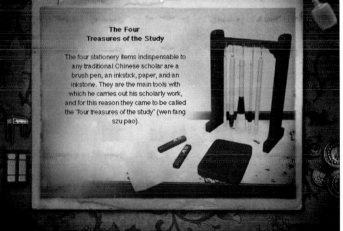

The Four Treasures of the Study

The four stationery items indispensable to any traditional Chinese scholar are a brush pen, an inkstick, paper, and an inkstone. They are the main tools with which he carries out his scholarly work, and for this reason they came to be called the "four treasures of the study" (wen fang szu pao).

PRESENTATION

The CN Tower, located in Toronto, Canada, is the world's tallest building, standing at 1,815 feet/553 meters. In 1998, a $26 million revitalization project was completed, and the tower was transformed into an entertainment and retail destination that includes dozens of multimedia exhibits.

ICE Inc., a Toronto-based design firm, played the leading role in developing all of the multimedia entertainment for visitors. These projects run the gamut from retail music scores, to kiosks, to simulated entertainment experiences, such as the virtual "Tower of Terror Bungee" simulator (small images below).

This CD-ROM showcases ICE's work in conceiving and designing the Tower's user experiences, and gives viewers an interactive look at the processes involved.

The basic structure of the CD-ROM is a clean and user-friendly design that offers an easily navigable interface that complements the design of the CN Tower's architecture by using the blues and greens of the outdoors, accompanied by clouds and sky imagery.

THE CN TOWER PROJECT

In June 1998, the base of the CN Tower was transformed into a world-class entertainment and retail destination.

ICE played a leadership role in conceiving and producing content—creating a rich and unique multimedia experience for visitors.

Click on the ICE logo to check it out!

CN TOWER
LA TOUR CN

THE PROJECT

In June 1998, TrizecHahn Corporation completed a $26 million revitalization of the base of the CN Tower, the world's tallest building. This re-development has transformed the base of the Tower into a world-class entertainment and retail destination.

INTRO
70's ZONE
INTERACTIVE KIOSKS
THRILL ZONE
SKYQUEST

QUIT

Project:	CN Tower Promo
Client:	CN Tower
Design Firm:	ICE Inc.
Design:	Kathy McKechnie
Programming:	Steve Wicks
Authoring Program:	Macromedia Director
Platform Specs:	Macintosh, Windows PC

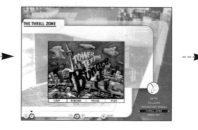

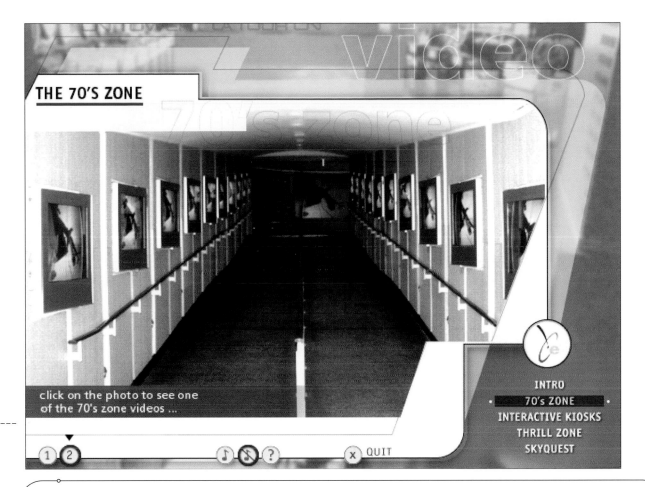

THE 70'S ZONE

click on the photo to see one
of the 70's zone videos ...

INTRO
70's ZONE
INTERACTIVE KIOSKS
THRILL ZONE
SKYQUEST

The 70's Zone (above), is one of the many multimedia exhibits ICE created to enhance visitor's experiences. The hallway is a chronological time tunnel depicting Canadian and International events during the time the tower was being built. To show this on the CD-ROM, ICE included a video segment from the exhibit, layered on top of a screened back image of the hallway. Viewers of the CN Tower CD-ROM have access to many different areas that show-case various architectural elements, such as the interactive kiosks created for the CN Tower (below).

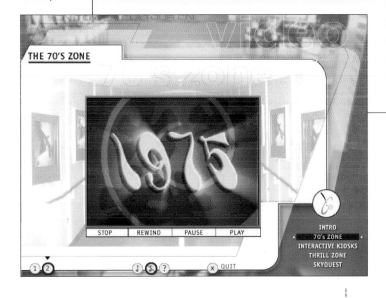

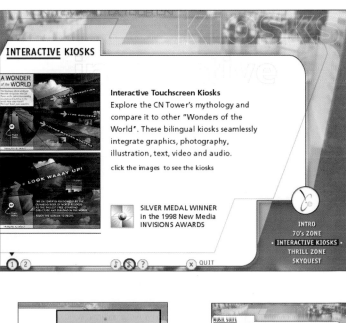

INTERACTIVE KIOSKS

A WONDER of the WORLD

Interactive Touchscreen Kiosks
Explore the CN Tower's mythology and compare it to other "Wonders of the World". These bilingual kiosks seamlessly integrate graphics, photography, illustration, text, video and audio.

click the images to see the kiosks

LOOK WAAAY UP!

SILVER MEDAL WINNER
in the 1998 New Media
INVISIONS AWARDS

INTRO
70's ZONE
INTERACTIVE KIOSKS
THRILL ZONE
SKYQUEST

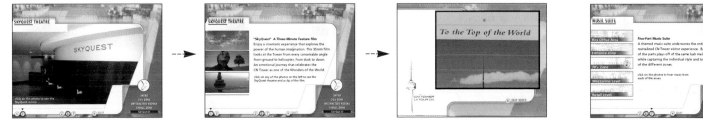

SOFTWARE PROMOTION

Softimage/DS (Digital Studio) is Avid Technology's most completely integrated set of post-production tools available for media professionals. This CD-ROM promotion for the Softimage/DS software, designed and produced by the Canadian design firm Epoxy, gives potential users an in-depth look at the possibilities available to them when using the tools.

The CD-ROM opens with a motion-graphic video composed of moving, blurred images, whippy raster lines, extreme lighting effects, and a blue color palette that sets the tone for the rest of the interface. To continue the look and feel of the opening sequence, the designers created a simple and elegant interface of various soft-edged organic shapes built on backgrounds of the tones and linework featured in the opening video.

Another effective design element is the use of embossing for the main navigation areas, and reverse embossing of the navigational icons located at the bottom of each screen.

To show the gamut of the software's non-linear video- and audio-editing tools and special effects abilities, Epoxy included a gallery of images and a video showcasing commercial work created with the software.

Project:	**Softimage/DS Promotion**
Client:	**Softimage/Avid Technology Inc.**
Design Firm:	**Epoxy**
Design:	**George Fok**
Programming:	**Nitro Édition Digitale**
Music and Audio:	**FM Le Sieur**
Authoring Program:	**Macromedia Director**
Platform Specs:	**Macintosh, Windows PC**

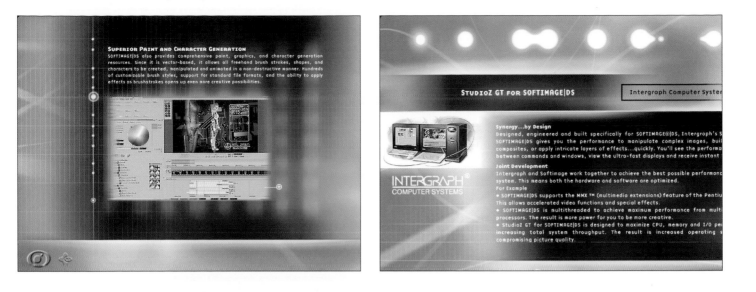

Superior Paint and Character Generation

SOFTIMAGE|DS also provides comprehensive paint, graphics, and character generation resources. Since it is vector-based, it allows all freehand brush strokes, shapes, and characters to be created, manipulated and animated in a non-destructive manner. Hundreds of customizable brush styles, support for standard file formats, and the ability to apply effects as brushstrokes opens up even more creative possibilities.

StudioZ GT for SOFTIMAGE|DS

Intergraph Computer System

INTERGRAPH®
COMPUTER SYSTEMS

Synergy...by Design
Designed, engineered and built specifically for SOFTIMAGE®|DS, Intergraph's S SOFTIMAGE|DS gives you the performance to manipulate complex images, buil composites, or apply intricate layers of effects...quickly. You'll see the performa between commands and windows, view the ultra-fast displays and receive instant

Joint Development
Intergraph and Softimage work together to achieve the best possible performan system. This means both the hardware and software are optimized.
For Example
• SOFTIMAGE|DS supports the MMX ™ (multimedia extensions) feature of the Pentiu This allows accelerated video functions and special effects.
• SOFTIMAGE|DS is multithreaded to achieve maximum performance from mult processors. The result is more power for you to be more creative.
• StudioZ GT for SOFTIMAGE|DS is designed to maximize CPU, memory and I/O pe increasing total system throughput. The result is increased operating s compromising picture quality.

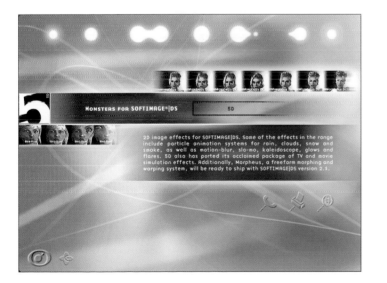

Monsters for SOFTIMAGE®|DS

5D

2D image effects for SOFTIMAGE|DS. Some of the effects in the range include particle animation systems for rain, clouds, snow and smoke, as well as motion-blur, slo-mo, kaleidoscope, glows and flares. 5D also has ported its acclaimed package of TV and movie simulation effects. Additionally, Morpheus, a freeform morphing and warping system, will be ready to ship with SOFTIMAGE|DS version 2.1.

GAME PROMOTION

The *Glitch* CD-ROM game demo, created by Epic Software Group, accompanied a proposal for a fully interactive computer game. To show potential game publishers that Epic had the design strength and ability to deliver on the full project, the firm produced a CD-ROM complete with an animated trailer that opens the demo, character profiles, and information about the development team.

The interface created to navigate the demo gives viewers a feeling of what they might expect in the final project. Beautifully rendered 3-D objects and characters, easy navigation, and game-like music and sound effects make even this short demo an enjoyable experience.

One of the most important aspects of the demo is the gallery section, where viewers can access 3-D graphic images of vehicles, space scenes, and 360-degree rotating views of each main character that will be included in the final game.

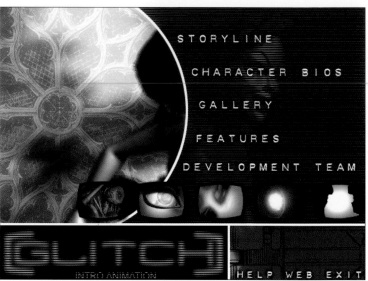

Project:	*Glitch*: Proof of Concept CD-ROM Demo
Client:	Self
Design Firm:	Epic Software Group
Design:	Kurt Larsen, William Vaughan, Tom Jordan, Bobby Ware, Matt Riley
Programming:	Robert Bailey
Authoring Program:	Macromedia Director
Platform Specs:	Macintosh, Windows PC

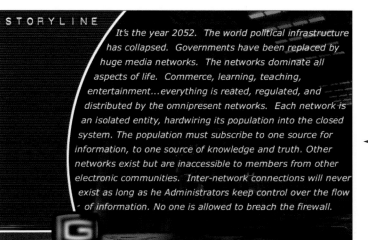

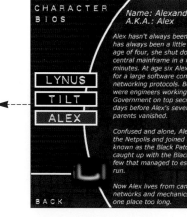

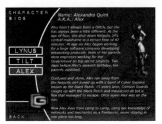

SOFTWARE PROMOTION

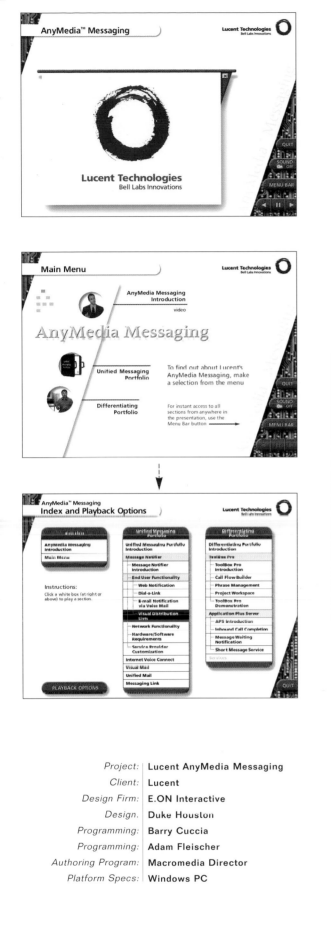

The AnyMedia Messaging CD-ROM was created by E.ON Interactive to showcase Lucent Technologies' voice and e-mail messaging software. The software offers businesses and individuals a wide range of messaging opportunities for controlling and networking their mail. The challenge for E.ON was to integrate all of the elements of the software into a clear and understandable interface, and create an easily accessible way for users to navigate through the many areas of the project.

To accomplish this, the designers developed several different modes of navigation for users to accessing the same information. Using visual icons (middle left), a slider bar with hierarchical pop-up boxes (below), and a complete text-based index, allows users to choose the way in which they viewed the information.

Other helpful aspects of the CD-ROM are video introductions (bottom left), and a voice-over to describe each of the program's product areas.

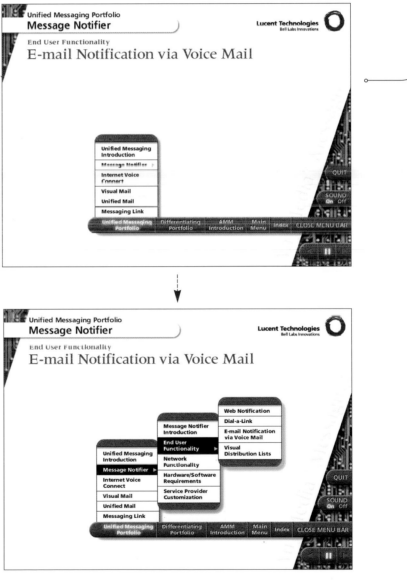

Project:	Lucent AnyMedia Messaging
Client:	Lucent
Design Firm:	E.ON Interactive
Design.	Duke Houston
Programming:	Barry Cuccia
Programming:	Adam Fleischer
Authoring Program:	Macromedia Director
Platform Specs:	Windows PC

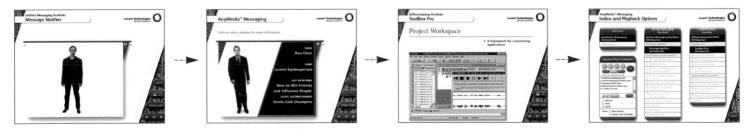

TRAINING

The *Oracle Business Practices: Ethical Leadership* CD-ROM, created by Lightspeed Interactive, serves as an important component of Oracle Corporation's Ethics Training program. At the completion of training, and with continued use of the CD-ROM, managers and individuals are expected to gain the knowledge to be able to make decisions and take actions in accordance with Oracle's "Ethical Code of Conduct."

The designers at Lightspeed created a fun and interesting interface for the ethics training by incorporating a futuristic airplane metaphor throughout the CD-ROM. To give the user a realistic experience, the designers created a number of beautifully rendered 3-D environments, and then incorporated blue-screen video of the instructors.

To introduce the user to the training environments, Lightspeed created a futuristic boarding pass (below) that collects data and personalizes the first entry the user has to the training module. The data card is followed by a number of airline-like elements that help to keep the continuity of the concept, such as the naming of the airline (Oracle Air), a ticket counter, and a creative drop-down televisiom monitor that is recognizable to practically anyone who has gone through an airport.

All of these elements come together to give the user a complete experience that can add to the enjoyment of using the training as well as the learning process itself.

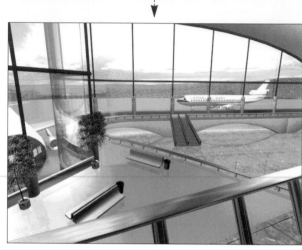

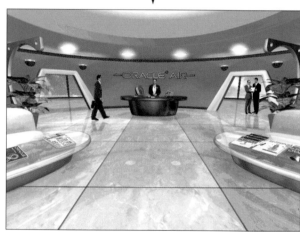

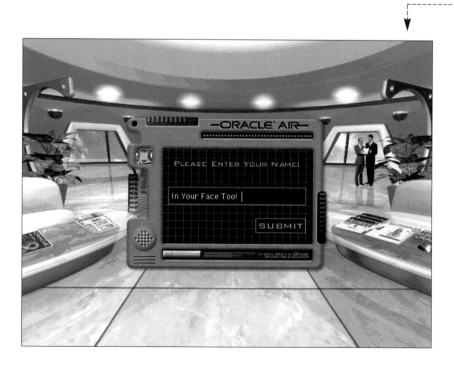

Project:	**Oracle Business Practices:**
	Ethical Leadership
Client:	**Oracle**
Design Firm:	**Lightspeed Interactive Inc.**
Design:	**Team Lightspeed**
Authoring Program:	**Macromedia Director**
Platform Specs:	**Macintosh, Windows PC**

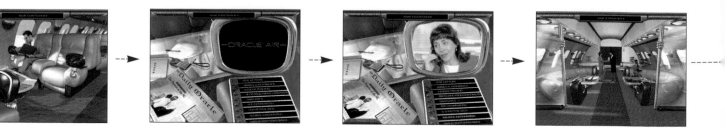

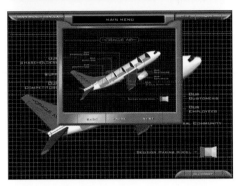

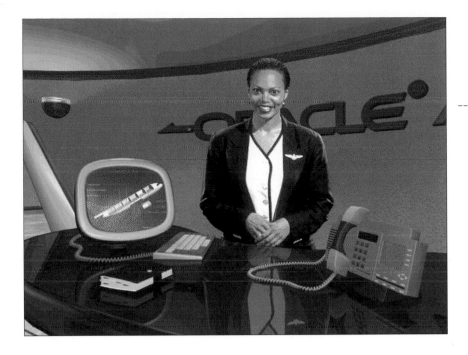

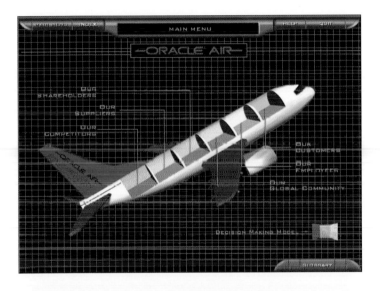

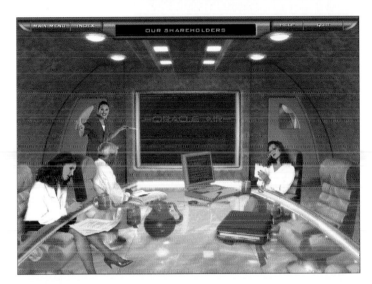

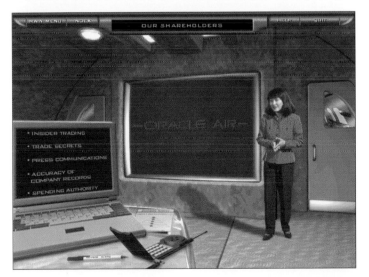

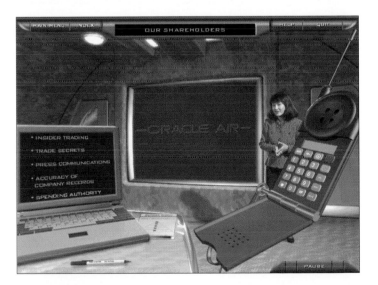

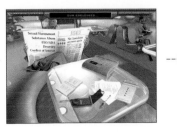

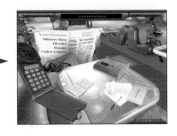

EDUCATIONAL

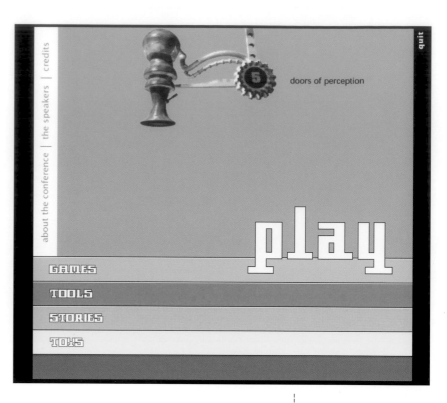

Play is a CD-ROM project developed by a team of graduate design students—the Doors 5 Live Team— majoring in interactive multimedia and attending the Netherlands Design Institute. The project is a companion piece to the design school's "Doors of Perception" conference held each year in the Netherlands. The fifth Doors of Perception conference, held in early 1999, focused on "Play" and gaming, and the creative and playful role of the user in creating and utilizing new media.

The concept behind the CD-ROM was to follow through on the theme of the conference by creating a structure in which the user has to make sense of the given material: find out the rules, make the connections, and play with onscreen material provided in the process. In this way the user plays an active and creative role in the "Game" while navigating the interface.

To create the interaction for the project, the designers implemented a number of programming techniques that allow the user to access the project's information. The first element the user encounters is a bouncing arrow on the contents screen (above). The user must click on a specific, colored navigation bar to make the arrow bounce progressively higher until it is sucked up by the vacuum-like device that waits above. Another device is the movable hand (right), which the user must manipulate to catch the falling "video link" icons, which then transitions to a display of video filmed at the conference.

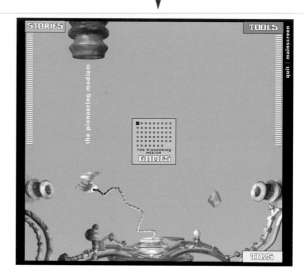

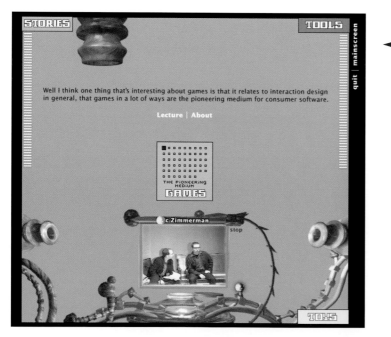

Project:	*Play: Doors of Perception 5*
Client:	**Netherlands Design Institute**
Design Firm:	**Doors 5 Live Team**
Authoring Program:	**Macromedia Director**
Platform Specs:	**Macintosh, Windows PC**

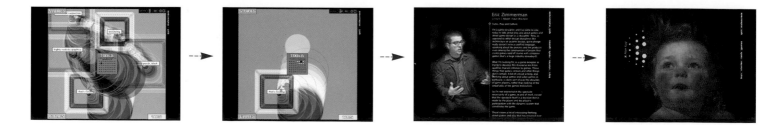

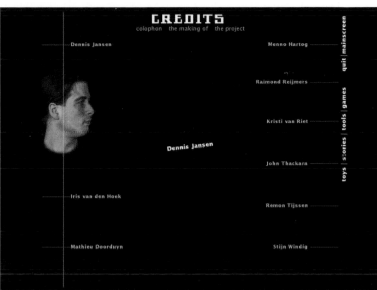

Two of the most dynamic elements implemented in the programming of the project are the "Credit" screen (above, and above left) where the user can watch a video segment of the individual being presented, and also manipulate the person's head using a three-dimensional viewpoint. Letting go of the head puts the head in motion and sets it to bouncing as if on a bungee cord. Second is the "Stories" area of the project that allows the user to choose multiple video segments filmed at the conference by clicking on the floating white titles (left). Each time a title is clicked, a new video image appears and starts floating around the screen, the user must then grab each one and drag it into the loading area, and then watch the clips play in the chosen sequence.

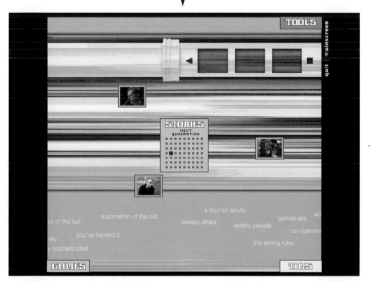

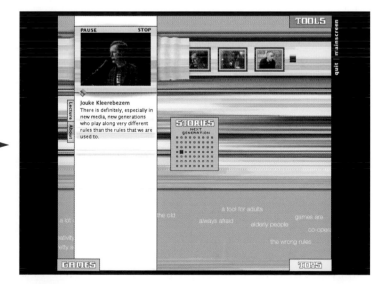

DIGITAL PORTFOLIO

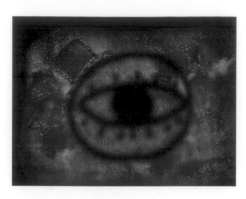

When photographer Jean-François Gratton approached the Canadian multimedia design firm Epoxy with the idea of producing a self-promotional CD-ROM, he could only sum up what he wanted in four words: "something wild and outrageous." And that's exactly what the designers delivered to him. Under a tight deadline and within a limited budget, Epoxy's designers turned out a dark and stimulatingly chaotic interactive portfolio that lends itself perfectly to the artist's work and seems to reveal as much about the photographer's mind as it does his photography.

The first element that sets this project apart from others is the contents screen. With its dark amber palette, peeling, eroded backgrounds, and the lack of any discernible navigational structure, the user is forced to search and discover the links—placed as invisible rollovers on each of the top eyelashes (above and left)—that will lead to various areas of the portfolio.

The atmosphere of the piece flows throughout the project, from the opening eye navigation to the techno and alternative music that plays in the background as the viewer navigates each section.

Project:	Photography Portfolio
Client:	Jean-François Gratton
Design Firm:	Epoxy
Design:	Daniel Fortin, George Fok
Programming:	Nitro Édition Digitale
Photography:	Jean-François Gratton
Authoring Program:	Macromedia Director
Platform Specs:	Macintosh, Windows PC

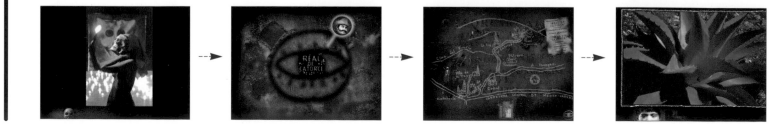

EDUCATIONAL

The *United Space Alliance* CD-ROM, created by Luminant Worldwide, is an interactive, educational project that encompasses the complete history and development of the NASA space shuttle. The project allows users to navigate through virtual tours, explore the chronology of all space shuttle flights, and try their hand at running mission control through a simulator game.

Various sections of the CD-ROM offer users the chance to read about specific missions, the spacecraft, and the individuals who flew them; watch videos showing walk-throughs of the real mission control center; and also watch blue-screened video of controllers from different departments as they instruct the user in managing a shuttle lift-off during the simulation.

The designers kept continuity throughout the project by creating high-tech interfaces similar to control panels that might be seen in a real mission control setting. By including instrument displays, backgrounds, and fully immersive environments, the CD-ROM gives the user a feeling of actually being in the mission control rooms.

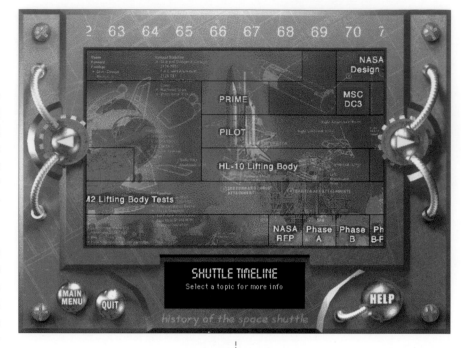

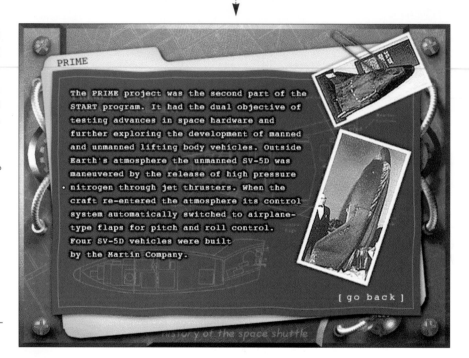

Project:	*United Space Alliance: Space Shuttle Academy*
Client:	**Self**
Design Firm:	**Luminant Worldwide Corporation**
Design:	**Geoff Gibson, Rob Kline**
Programming:	**George Pabich**
Illustration	**Rob Kline**
Authoring Program:	**Macromedia Director**
Platform Specs:	**Macintosh, Windows PC**

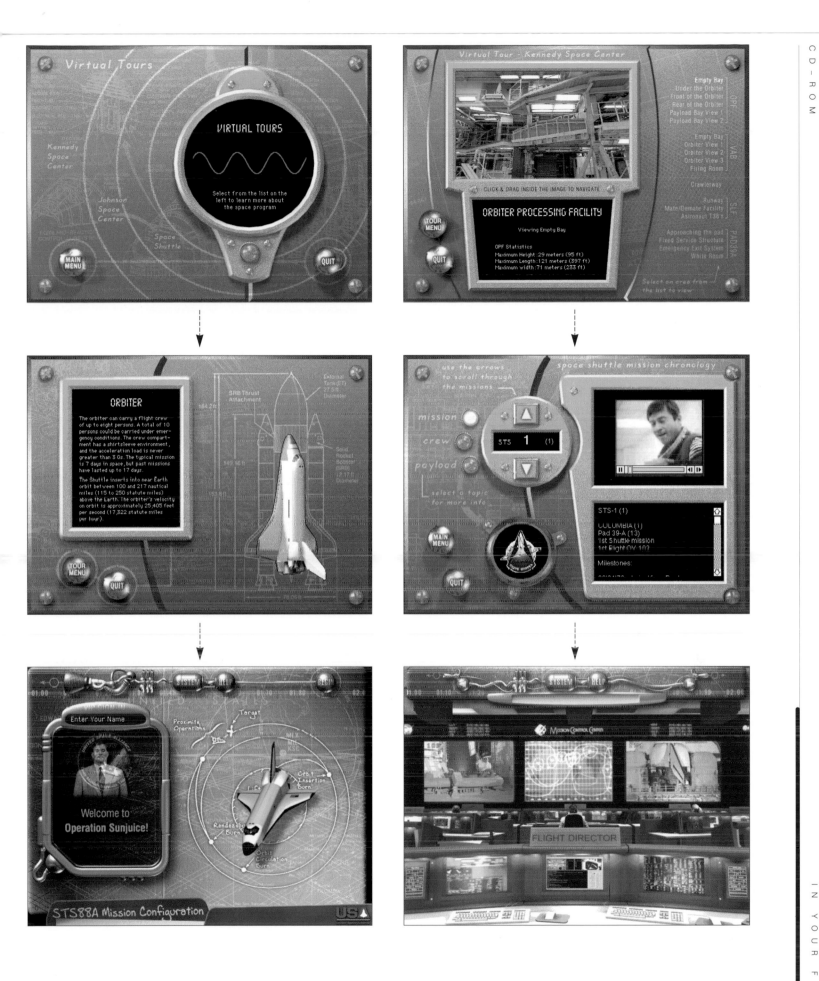

DIGITAL PORTFOLIO

Relic, a promotional portfolio project created by STATmedia, is distributed on a repurposed form of CD-ROM called a CD-Card, which can hold up to 250 MB of information. CD-Cards are full-size CD-ROMs with two edges trimmed off, giving them the look and size of traditional business cards. Though the card may be smaller than the average CD-ROM, what it lacks in dimension has not been transferred to the company's portfolio project, which is not lacking in either depth or substance.

In creating their digital portfolio, STATmedia's designers attempted to produce an interface that felt both futuristic and ancient at the same time. Modern, contemporary imagery is combined with rusted, industrial-looking metal, to create a juxtaposition of the two.

The designers wanted to convey a playfulness that could be felt by the user when exploring the different areas of the project, such as the "Client" section, where users are asked to click on the orbiting spheres (facing page, top). When the user moves the mouse quickly toward the colored spheres they float away from the cursor, but when the user moves the mouse slowly toward the spheres they float toward the cursor.

In creating this artfully designed piece, STATmedia proves the adage that big things come in smaller packages.

Project:	*Relic* Webcard™
Client:	**Self**
Design Firm:	**STATmedia Limited**
All Design:	**Duncan McAlester**
Music:	**Arild Isaksen**
Authoring Program:	**Macromedia Director**
Platform Specs:	**Macintosh, Windows PC**

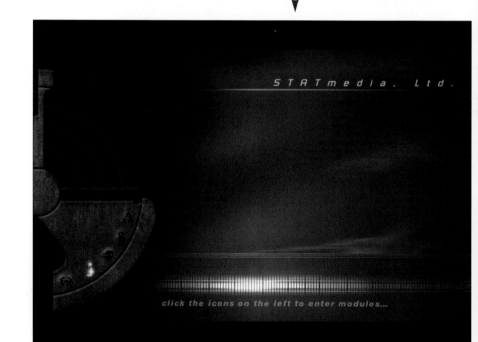

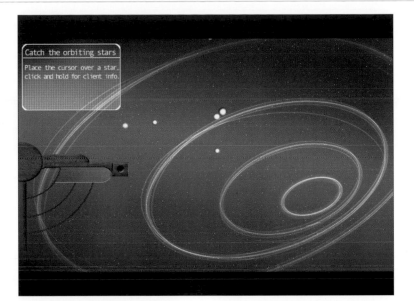

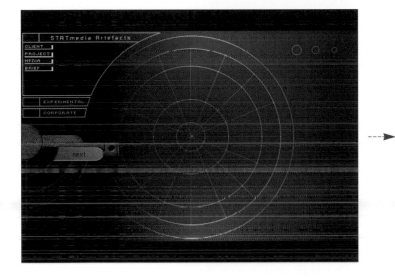 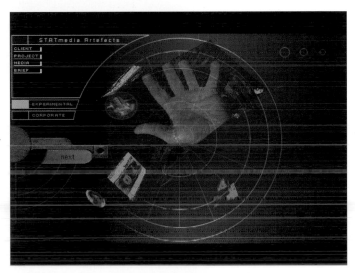

DIGITAL PORTFOLIO

CREATIVE DIRECTION STUDIOS

1997
creative excellence

The *StudioCD* interactive portfolio is an excellent example of taking traditonal print-based material and transforming it into an interactive experience. The portfolio was created using QuarkImmedia, a multimedia authoring program from the producers of the QuarkXPress publishing program. Known for its print design, Creative Direction Studios wanted to show clients its ability to design not only traditional media, but new media as well. The majority of the work showcased in the digital portfolio was originally created as print media using QuarkXPress, which made it a natural progression to use Immedia for this project.

The project begins with a motion-graphics video, created with Adobe AfterEffects, which features words describing the firm's strengths fading and blending onto the screen. Users then navigate through the CD by rolling over one of the four corner highlights on the outer edges of the interface.

Throughout the CD, users are given access to the four main areas: Design Portfolio, Artistic Communication, New Media Strategies, and StudioCD. Each area allows users to view a different aspect of the firm's strengths, including print work, communication through imagery, new media projects, and learning about the firm's communication and business strategies. Throughout the CD-ROM, the firm showcases their ability and desire to incorporate traditional print-based materials into new and emerging technologies.

Project:	*StudioCD* Interactive Portfolio
Design Firm:	Creative Direction Studios
Design:	Christian Memmott
Programming:	Christian Memmott
Authoring Program:	QuarkImmedia
Platform Specs:	Macintosh, Windows PC

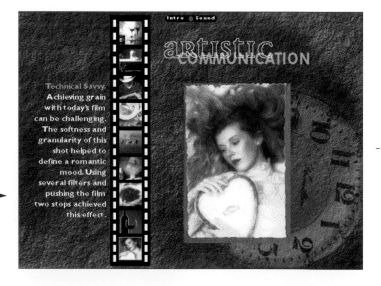

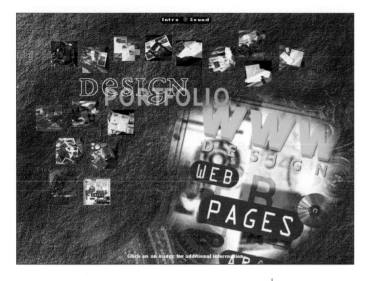

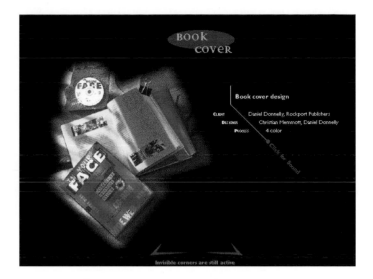

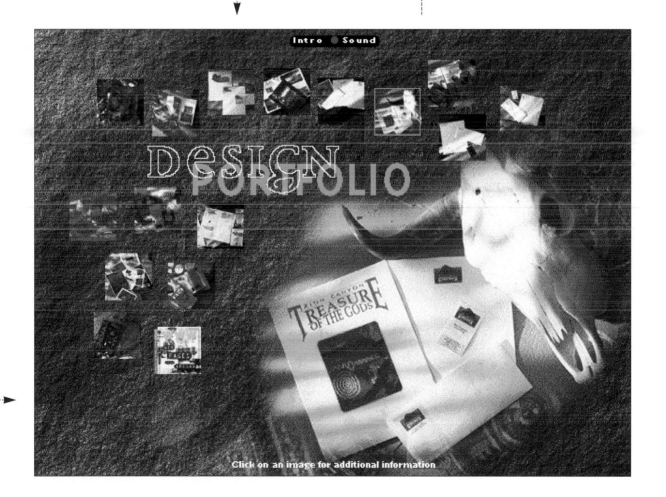

EDUCATIONAL

Beyond Glory: Stories of Mack and Jack Robinson was produced by a team of eighteen faculty and student designers at the Art Center College of Design in Pasadena. This large-scale multimedia project explores the lives and history behind baseball legend, Jackie Robinson, and his brother, Mack Robinson, whose claim to fame was winning a silver medal in track and field during the 1936 Olympic games in Berlin.

The CD-ROM presents viewers with an in-depth look at the lives of the two brothers by capturing the qualities of character, spirit, and drive that helped shape each man's future. The designers took full advantage of the fact that the Art Center is located in Pasadena—the hometown of the two national heroes—and included interviews with family, friends, and associates of the brothers.

One of the most dynamic elements included in the design of the CD-ROM is the navigational timeline that allows viewers to explore Mack and Jackie's history. This graphic timeline is presented to viewers as a horizontally scrolling table of contents. It features important dates, events, video, and a behind-the-scenes look at the making of a bronze memorial sculpture of the brothers.

To complete the educational aspect of the CD-ROM, the design team also included profiles of each member of the team, along with quotes and comments about the processes involved in undertaking this large multimedia project.

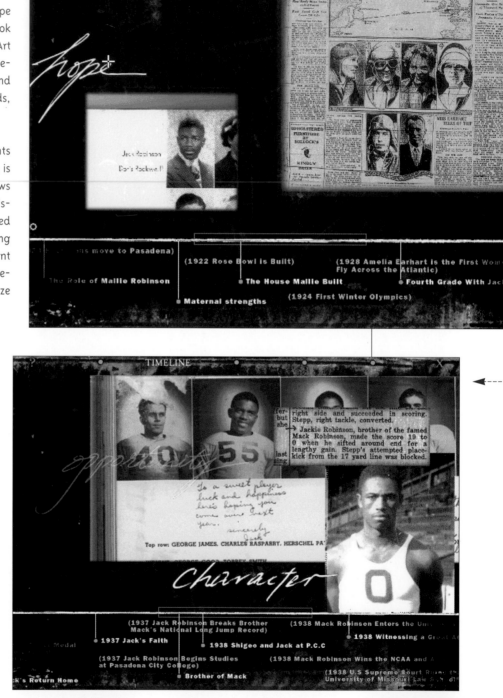

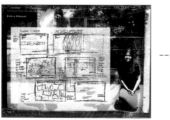
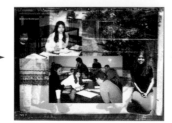
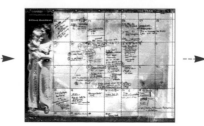

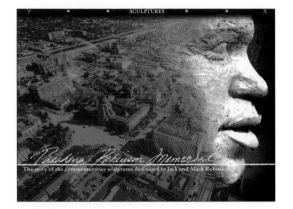

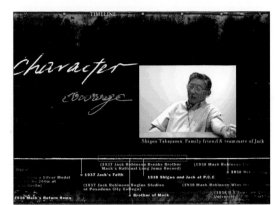

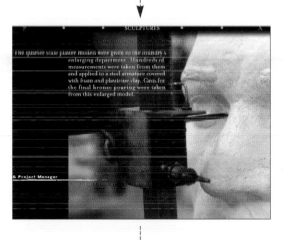

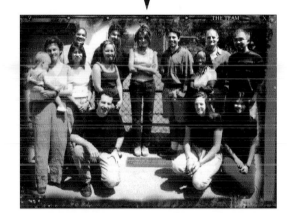

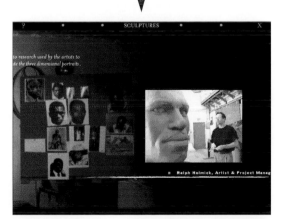

Project:	*Beyond Glory:*
	Stories of Mack and Jack Robinson
Client:	Pasadena Robinson Memorial
Design Firm:	Art Center College of Design
Design:	Faculty: Allison Goodman, Andrew Davidson,
	Laura Silva (see full design credits, p. 159)
Executive Producer:	Greg Thomas
Voiceover:	Martin Pollack
Music Recording:	Daniel Brice, Marc Dabe
Programming:	Scott Seward
Video Editing:	Brooks Harrington
Authoring Program:	Macromedia Director
Platform Specs:	Macintosh, Windows PC

MUSIC CATALOG

Surf This Disc is an award-winning interactive music catalog designed and produced by Enlighten, a multimedia design firm based in Ann Arbor, Michigan. The disc was developed for Rykodisc, formerly one of the top independent music labels in the United States before it sold out to Island in 1999.

As one of the first interactive music catalogs, Rykodisc wanted a promotional piece that would convey its "hip" reputation for being a leader in marketing music to consumers. The company also wanted a promotional item that would increase its corporate visibility among the media.

From the contents screen to the exit screen, Enlighten presents viewers with richly colored backgrounds, artistically designed navigation bars and icons, and fully interactive areas for the user to play with. One such area that stands out among the rest is the "Featured Musical Instruments" section (below) where users can play and listen to various instruments, such as a bass drum, guitar, or keyboard.

As an incentive to keep users returning to the CD-ROM, Enlighten created a scavenger hunt, challenging users to search the titles for clues to qualify for winning prizes.

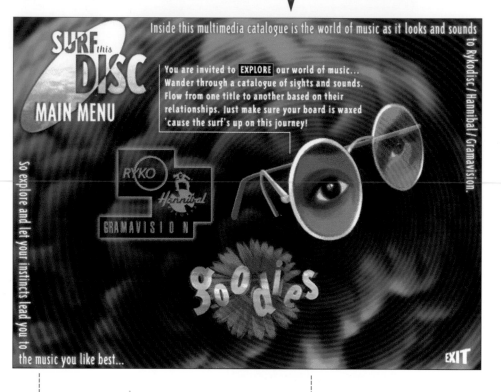

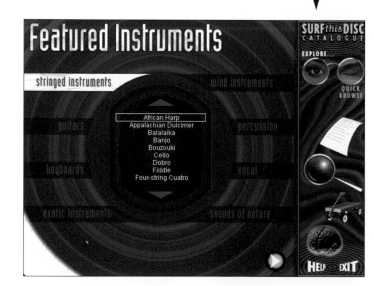

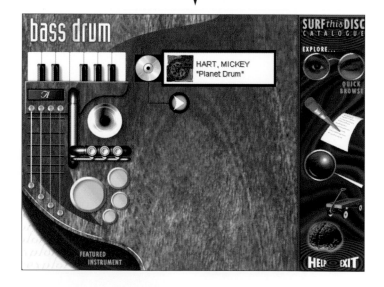

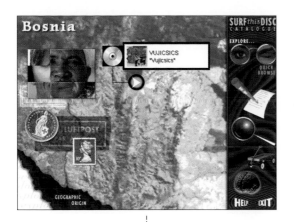

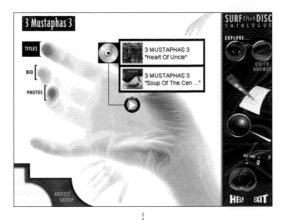

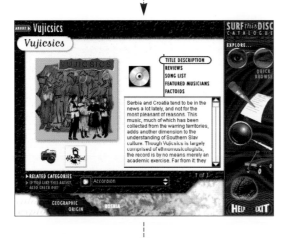

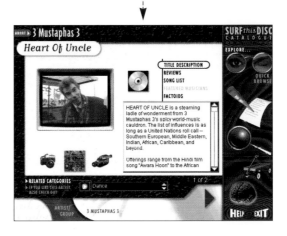

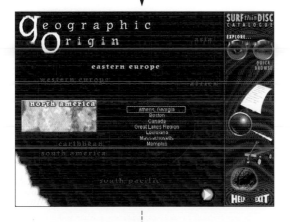

Project:	Surf This Disc
Client:	Rykodisc
Design Firm:	Enlighten
Design:	Parvin Panahi
Programming:	Wendell Wickre, Rod Smith, Chris Hibbard, Hu Hua Wu
Copywriting:	Steve Glauberman, Linda Gardner, Margaret Schlanker
Artwork:	Lesa Monroe-Gatrell, Kurt Wunderlick, Mark Meyer
Videography:	Darius Hubbard, Sean Montgomery, Steve Busch
Authoring Program:	Macromedia Director
Platform Specs:	Macintosh, Windows PC

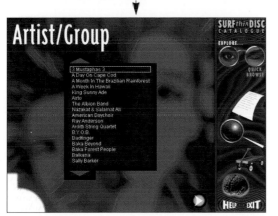

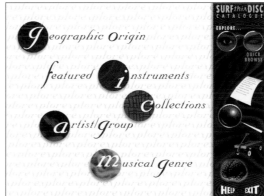

EDUCATIONAL

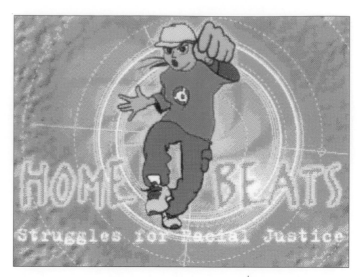

Homebeats: Struggles for Racial Justice is an educational multimedia CD-ROM developed by the Institute of Race Relations, located in the United Kingdom. The CD-ROM is a multimedia journey through time, tracing the roots of black people from Africa, the Caribbean, and Asia, to current day multi-racial Britain. Homebeat's aim is to provide a detailed history of struggles for racial justice—including the fight against slavery and colonialism—throughout the last 500 years, with an emphasis on Britain and its relationships with third-world countries.

The project opens with an animated collage of imagery depicting various eras from African-American heritage and historical figures and icons such as the Black Panthers and Malcolm X as well as figures from British racial struggles, and then transitions into a simple, yet effective contents screen for navigating the five different sections of the CD-ROM. Though the CD-ROM was designed for ease of use, and accessibility to teenagers (sections include "Love Music, Hate Racism," and "Hip Hop & Politics"), the creators felt it essential that enough detailed information be available to those who needed it. To this end, Homebeats offers in-depth material about the people, places, and happenings from the past to current day.

Many important features included in this project—such as the quizzes in the "Visions" area and the hyperlinked text—add to the fact that this is first and foremost an educational experience.

Homebeats is a beautiful, intriguing, and thought-provoking look at the continuing search for racial equality throughout the world.

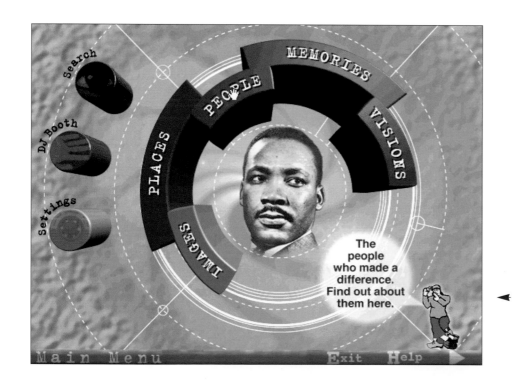

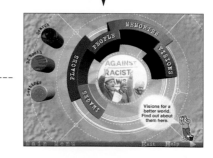

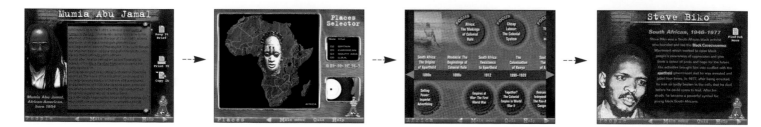

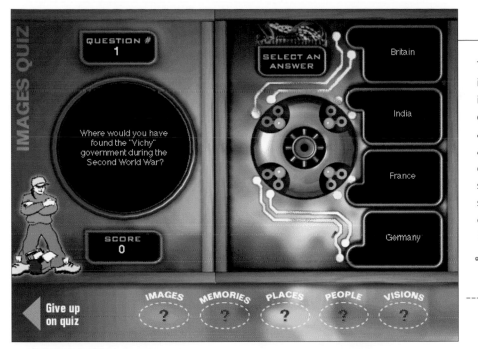

To keep users (especially teenagers) interested in the content, and to further their understanding of past and current events that have an effect on their lives, the designers created a "Quiz" area for each of the five sections (left). Each time a user answers a minimum of seven out of ten questions correctly, a record icon fills the empty space. Once all records are in place, a "DJ" screen (below) appears, which allows users to choose specific audio (record) tracks, and spin the records.

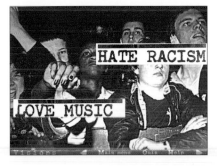

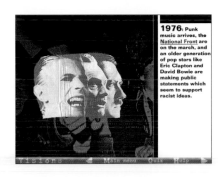

1976: Punk music arrives, the National Front are on the march, and an older generation of pop stars like Eric Clapton and David Bowie are making public statements which seem to support racist ideas.

In normal conversation we categorise people into different races and describe them as black or white, almost without thinking. But the idea of race goes further than skin colour. The terms we use to describe people carry with them a bundle of other meanings, which have nothing to do with the visible distinguishing marks of different groups of people. This can be illustrated by looking at the dictionary definitions for the words 'white' and 'black'. Why have these colours come to be associated with good and evil?

White... Morally or spiritually pure or stainless; spotless, innocent. Free from malignity or evil intent; innocent, harmless.

Black... Characterized by absence of light; Soiled, dirty; Having dark purposes, malignant; deadly, baneful, disastrous, sinister; Foul, iniquitous, attrocious; Dismal, gloomy, sad... Clouded with anger, threatening, boding ill.

Oxford English Dictionary 1959

Project:	Homebeats: Struggles for Racial Justice
Client:	Institute of Race Relations, London
All Design:	Arun Kundnani
Music:	Asian Dub Foundation
Copywriting:	Sujaja Aurora, Jenny Bourne, Harmit Athwal, Liz Fekete, Francis Webber, A. Sivanandan, Hazel Waters, Paul Grant, Asha Goveas, Danny Reilly, Malini Srinivasan
Authoring Program:	Macromedia Director
Platform Specs:	Macintosh, Windows PC

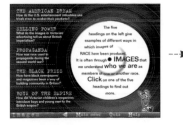

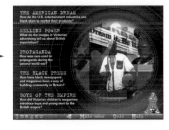

TRAVEL ADVENTURE

The *Cities of Europe* CD-ROM was developed for Netgate Publishing by Domain-Design, a multimedia design studio located in the Netherlands. The project is a virtual tour guide that allows users to explore and discover areas of Europe in an immersive environment of art, architecture, and historical information on more than 700 subjects, including destinations such as the Vatican, Sigmund Freud's house, and even Jim Morrison's grave.

The core interface of the CD-ROM was designed by implementing Apple Computer's QuickTime Virtual Reality (QT-VR), a digital video process that allows users to view 360-degree panoramas (below) of the areas presented on the CD. These QT-VR videos offer users an in-depth view of each area they visit on the CD-ROM, but the designers felt using the technology alone wasn't enough to give a full spatial feeling of the cities, so they linked each panorama to 3-D maps where users could see where they were in relation to the rest of the city.

Music and audio also play an important role in developing the user experience. When users roll their cursors over one of the cities on the main page, music reminiscent of the area begins to play. Perhaps one of the best uses of audio is the ambient street noise that the designers recorded as they filmed each city. These sounds—people speaking and coughing, bells ringing, vehicles moving past—are an exciting element that helps to pull the user into each scene.

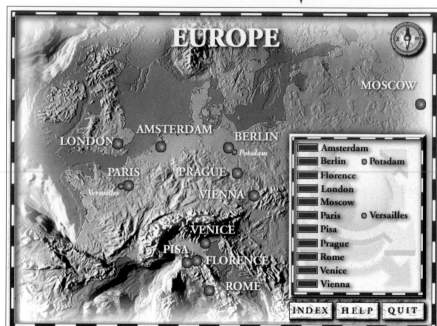

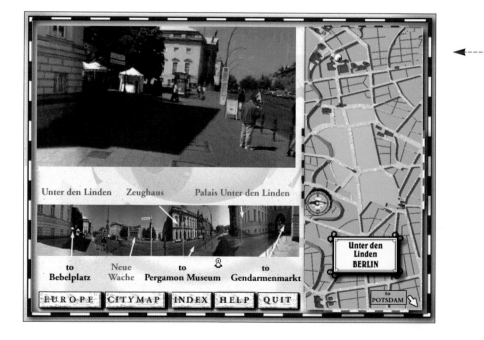

Project: *Cities of Europe*
Client: Netgate Publishing
Design Firm: Domain-Design
All Design: Andy Grogan
Copywriting: Rhonald Blommestijn
Authoring Program: Macromedia Director
Platform Specs: Macintosh, Windows PC

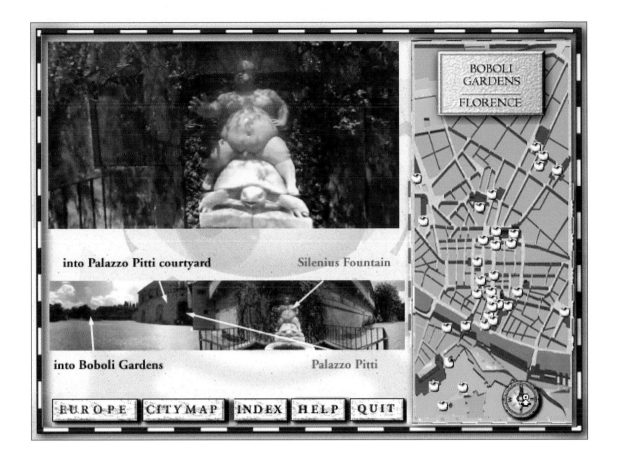

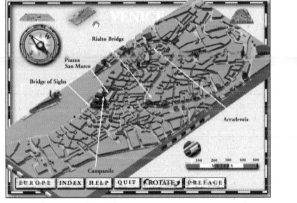

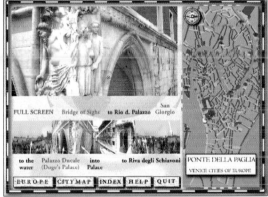

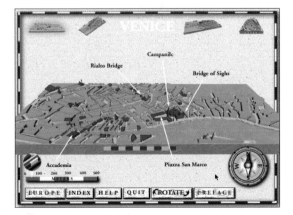

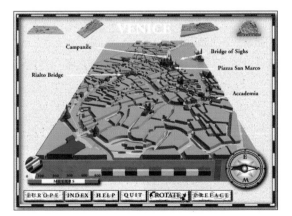

EDUCATIONAL

The *Synthesis* CD-ROM is a digital archive of five faculty research projects conducted through the Digital Media Design Research program at the Art Center College of Design in Pasadena. During a semester-long program, distinguished Art Center faculty were provided with an opportunity to explore digital media technologies in a concentrated and immersive environment. To incorporate the project into a "student" learning environment, the individual instructors brought graduate students into the project to interpret and implement specific design concepts.

The underlying theme that guides the projects is experimentation in each faculty member's field of instruction—graphic design, video, digital media, environmental design, and photography and film.

The interface metaphor of a scientific laboratory was adopted as the primary look that would be used to navigate between the individual faculty projects, and also to be carried through the secondary interface screens for continuity. The design elements allude to cell structures, chemical reactions, and views through microscopes, cleverly embodying the spirit of experimentation in each design field. Specific elements such as the animated, cell-like buttons on the home page (right) where the user must roll the cursor over each button to make it "grow" forward and become active, and the "molecular" navigation bar used on secondary screens, add to the overall scientific feel of the project.

Project:	*Synthesis*
Client:	**Art Center College of Design**
Design Media Chair:	**Andrew Davidson, Chair, Digital Media Dept.**
Design:	**Liuda Kim, Jinhee Park, Sharon Tani**
Videographers:	**Vee Vitanza, Gabe Gerber**
Sound Design:	**Scot Bradford**
Interaction Design:	**Pascal Wever**
Design Consultant:	**Ludovic Schorne**
Faculty Advisors:	**Allison Goodman, John Chamber, Laura Silva**
Authoring Program:	**Macromedia Director**
Platform Specs:	**Macintosh, Windows PC**

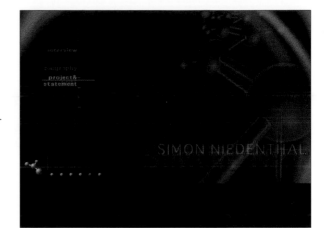

SIX ST. JEROMES

Computer-generated images have become commonplace in recent years; just as commonplace is the absence of rich and compelling illumination and surface definition. The advent of radiosity rendering--which models light behavior much more accurately than existing rendering modes--signals a major advance in the capabilities of computer simulations. "Six St. Jeromes" is a digital recreation of a detail from a painting of St. Jerome in his study by Antonello da Messina from about 1460 (see figure 1), and is comprised of six versions of the scene under different lighting conditions. W.J.T. Mitchell's *The Reconfigured Eye* serves as inspiration for this project, specifically the chapter in which he traces digital image synthesis from the simplest to the most complex with reference to the corresponding changes that occurred in painting from the Renaissance to contemporary

SIMON NIEDENTHAL

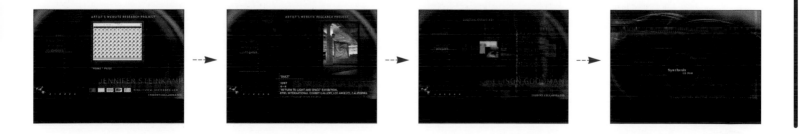

DIGITAL PORTFOLIO

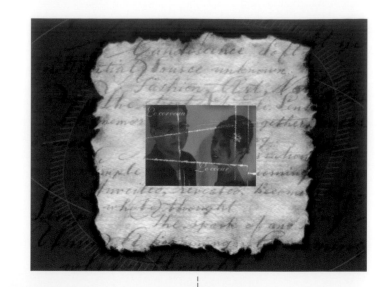

The Ego digital portfolio, produced by the Canadian multi-media design firm, Ego Communications, is an elegant and sophisticated interactive experience that gives potential clients a look at the people, mission of the company, and the projects they produce.

Rather than spend too much time throwing in the "bells and whistles" that some companies feel are needed to express their identities in new media promotion, Ego opted to tone down the user experience, and focus more on giving viewers a subtle, expensive-looking interface to navigate.

Beautiful, simple imagery and navigation are the focus of the interface, with contemporary typographic treatments, and blurred, moving raster lines reminiscent of aged and degraded film incorporated into background images throughout.

An added touch is the multi-lingual option for viewing the portfolio in either French or English, typical of Canadian multimedia projects (below right, and facing page). This element makes it possible for the company to distribute the CD-ROM to both French- and English-speaking clients, without having to develop two separate projects.

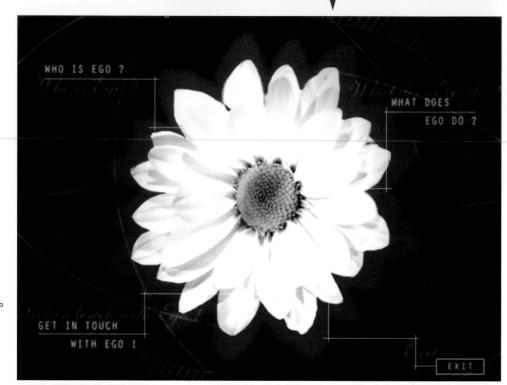

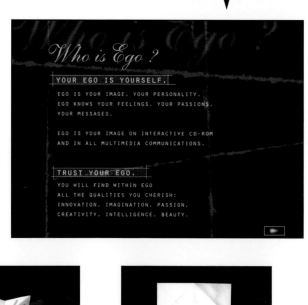

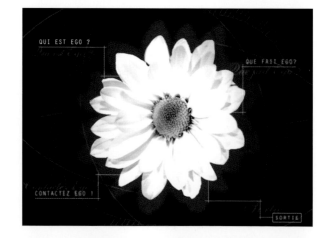

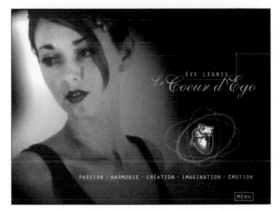

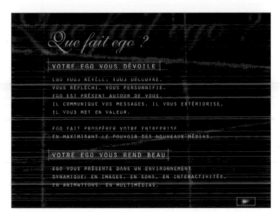

Project: | Design Portfolio
Client: | Self
Design Firm: | Ego Communications
Design: | Eve Legris, Mathiew Larocque
Authoring Program: | Macromedia Director
Platform Specs: | Macintosh, Windows PC

ENTERTAINMENT

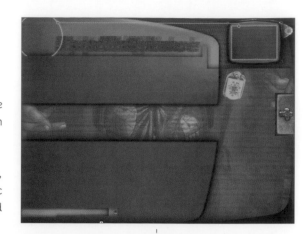

Romeo + Juliet: An Interactive Trip to Verona Beach is a CD-ROM based on the motion picture, which depicts William Shakespeare's tragic love story in an urban landscape that is cast somewhere between the past and the future.

The CD-ROM, produced by Circumstance Design in association with Fox Interactive, combines the classic storyline of the original play and the modern and futuristic visuals of the film—along with original art and exclusive production stills and videos—to create an exciting and captivating interactive experience.

The design of the interface, like the story itself, falls somewhere between high-tech contemporary—with its video monitors and sliding navigation bars—and an ancient and eroding environment of layered typography, rough-hewn background textures, and aged-metal navigation icons.

Specific elements that help pull the user into the story are musical soundtrack selections from popular bands such as Radiohead, One Inch Punch, and Kym Mayzelle, and special animated sequences featuring various segments from the film. Another feature that carries the theme of combining the past and the present is the scene-by-scene comparison of the motion picture screenplay with the complete text of Shakespeare's play.

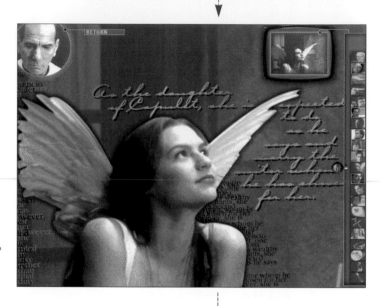

Project:	*Romeo + Juliet: An Interactive Trip to Verona Beach*
Client:	**Fox Interactive**
Design Firm:	**Rare Medium Inc.**
Creative Director:	**Tim Barber**
Technical Direction:	**David Bliss**
Design:	**Josh Lowman**
Engineer:	**Sean Rooney**
Authoring Program:	**Macromedia Director**
Platform Specs:	**Macintosh, Windows PC**

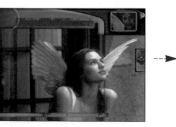

EXT. THE BACK OF CAPULET MANSION. NIGHT

CLOSE ON: A pair of stone cherubs on top of the retaining wall of a terraced garden. Romeo's face appears between them.

Romeo hauls himself up onto the wall. Below is a Greco-Roman style pool area. To the right the darkened rear wing of Capulet Mansion. Suddenly the back of the house explodes with light. Romeo takes cover.

ROMEO
But soft, what light through yonder window breaks?

Romeo's question is answered as out onto the verandah comes Juliet. She is still clad in her angel robe, but without the halo and wings. She slowly descends to pool level.

ROMEO
It is the East, and Juliet is the sun!
Arise, fair sun, and kill the envious moon,
Who is already sick and pale with grief
That thou her maid art far more fair than she.
Be not her maid, since she is envious.
Her vestal livery is but sick and green,
And none but fools do wear it.

Juliet stands on the top step of the pool stairs. She is directly below Romeo as he whispers.

ROMEO (cont.)
Cast it off!

Juliet sits on the edge of the pool, her legs dangle in the water.

 → → →

DIGITAL PORTFOLIO

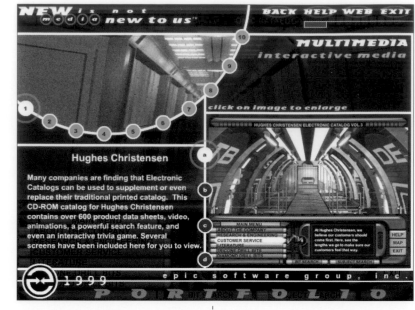

Epic Software Group's portfolio CD-ROM does just what a digital self-promotion should do: it showcases the company's work in an easy-to-use, creative interface that offers viewers an in-depth look at the clients, vision, and capabilities of the design firm.

This portfolio features a rich collection of interface designs created for various client projects over the last few years, and includes work from CD-ROMs, Websites, and interactive presentations.

To demonstrate its skills in a wide variety of applications, the firm included many samples, but the projects that stand out prominently in their portfolio are the 3-D interface designs such as the "Hughes Christensen" CD-ROM catalog (right), and additional interface designs featured on the facing page.

To give users a full overview of its work, the firm also included ten interactive games that are fully usable, and hot-links to actual online Websites and Web content that connect directly to the corresponding Websites.

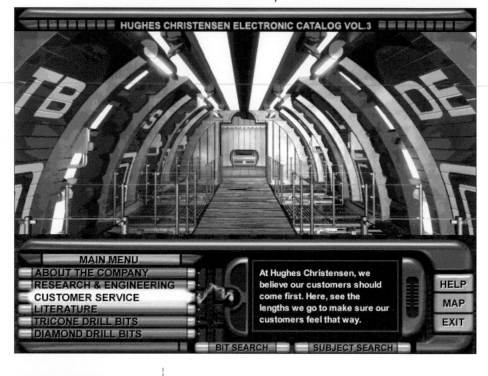

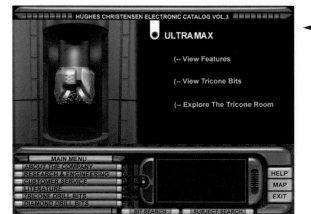

Project: **Design Portfolio**
Client: **Self**
Design Firm: **Epic Software Group**
Design: **William Vaughan**
Programming: **Robert Bailey, Drew Creel**
Production: **Bobby Ware, Vic Cherubini, Kurt Larsen**
Authoring Program: **Macromedia Director**
Platform Specs: **Windows PC**

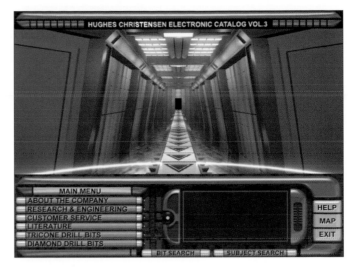

ABOUT THE COMPANY

Marketing Locations

(-- North America Sales Offices
(-- South America Sales Offices
(-- Europe Sales Offices
(-- Middle East Sales Offices
(-- Africa Sales Offices
(-- South East Asia Sales Offices
(-- Russia/China/Japan Sales Offices

HELP
MAP
EXIT
MAIN
BACK
PRINT

North America

Company Headquarters
9110 Grogans Mill Road
The Woodlands, Texas 77380-1130
P.O. Box 2539
Houston, Texas 77252-2539
Tel: 713 363-6000 Fax: 713 363-6009

Canada

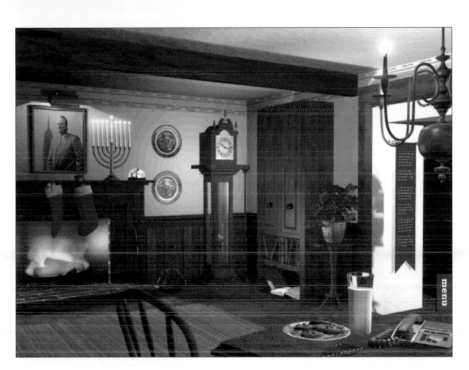

PROMOTION

Dickson's Access CD-ROM, created by Melia Design Group, stands out with its use of a beautifully rendered collage of objects that might be found in the collection of young boy's treasure chest of toys and memorabilia. The main interface, composed of these objects (below), sets the tone for the rest of the CD-ROM promotion for this specialty printing company.

The designers approached the project with the idea of creating a virtual tour of the printing plant, and having viewers meet the people and processes that form the core of the company while interacting with a playful, elegant interface.

Each of the collected objects featured in the wood-framed interface performs a different and unique action when the user rolls the cursor over specific areas: a video plays on the monitor, the magnifying glass enlarges the image below, toy airplanes fly off the screen, and gears begin to rotate.

To contrast with the fun and playful mood of the main screen, the designers created more subdued artwork for the rest of the content. Each of the secondary screens gives users a visual tour—and a clear understanding—of Dickson's prepress and printing processes.

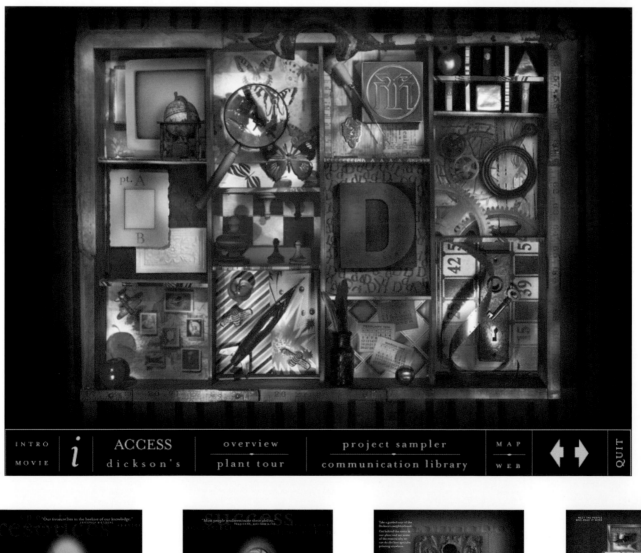

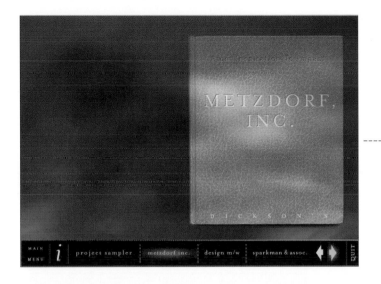

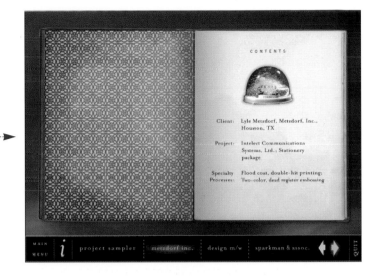

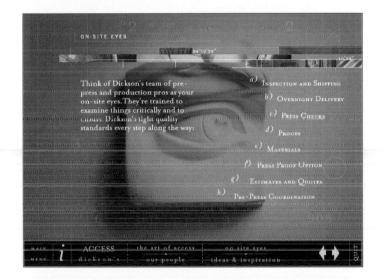

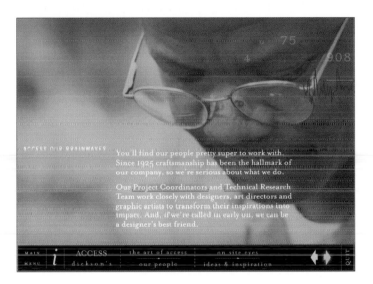

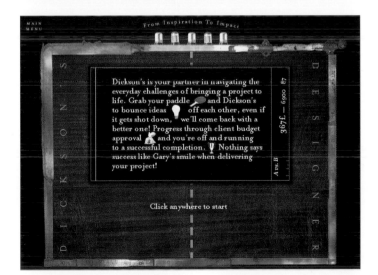

Project:	*Dickson's Access*
Design Firm:	Melia Design Group
Design:	Mike Melia, Nicole Riekki, David Hewitt
Creative Director:	Mike Melia
Copywriting:	Cally Curtis
Illustration:	Gina Binkley
Photography:	David Hewitt, Joel Marcus
Programming:	Nicholas Williams
Animation:	Mathew Bedette
Film/Video:	Cameron Cardwell
Music:	Brian Preston
Account Executives:	Jenifer Cooper, Faye Noble
Authoring Program:	QuarkImmedia
Platform Specs:	Macintosh, Windows PC

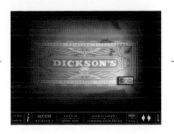

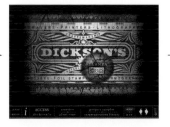

PROMOTION

Natalie Tzobanakis created this self-promotional digital portfolio while attending the Vakalo School of Art & Design in Athens, Greece. Her aim was to provide users with an easy-to-use interface for navigating the portfolio, while also offering viewers a wide selection of her work in print and Web graphics.

A contemporary style imbues the design with a cutting-edge feel, characterized by black backgrounds; sharp-edged graphics; layered and blurred typography; and a palette of subdued grays highlighted by electrifying blues, reds, and purple headers and linework.

Designing the main imagery of the portfolio this way allows Tzobanakis more traditional work of brochures, magazine spreads, and logos to contrast against the radical style of the interface, and perhaps makes each of the pieces more prominent in the viewer's mind.

Project:	**Design Portfolio**
Client:	**Self**
All Design:	**Natalie Tzobanakis**
Authoring Program:	**Macromedia Director**
Platform Specs:	**Windows PC**

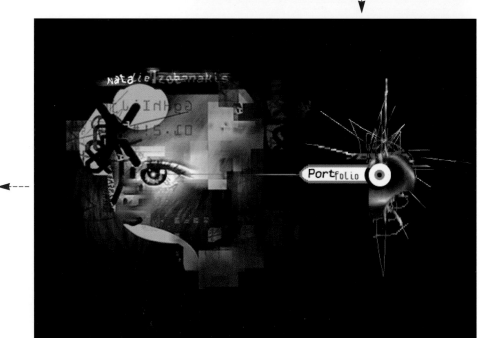

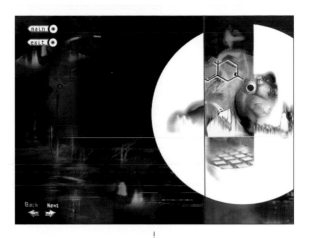

SOFTWARE PROMOTION

The developers of the *Virtual Plant* CD-ROM, Alexander and Tom Inc., were contracted by GSE Systems to create a compelling interactive presentation for an upcoming sales conference that would give attendees a look at the capabilities of GSE's new software product, Virtual Plant. This promotional piece, which showcases software that allows companies to simulate production processes at manufacturing plants, needed to be rich in both graphics and audio to keep the attention of a large audience.

To accomplish this, the designers created an opening animation that features pieces of the CD-ROM interface sliding into place to build a futuristic, game-like navigation screen. The interface then expands one segment at a time to reveal video contols, navigation icons, and introductory text. Once the interface finishes combining all of its parts, an attention-grabbing video montage with hip, techno sound effects begins to play in the main viewing window. A palette of cool blues and greens and a wireframe-rendered animation combine to give a technical and engineered feel to the CD-ROM interface.

For ease of use in individual or group settings, the designers gave users the choice of moving through content in a linear fashion, or skipping to specific content areas. Another element that adds to ease of use is the implementing of two separate paths for navigation. The first allows users to roll over the hieroglyphic icons in the middle of the screen, and the second allows users to navigate by clicking the more conservative elements at the bottom of the screen.

Project:	**Virtual Plant**
Client:	**GSE Systems**
Design Firm:	**Alexander and Tom Inc.**
Design:	**Chris Styles**
Programming:	**Dean Carter**
Authoring Program:	**Macromedia Director**
Platform Specs:	**Windows PC**

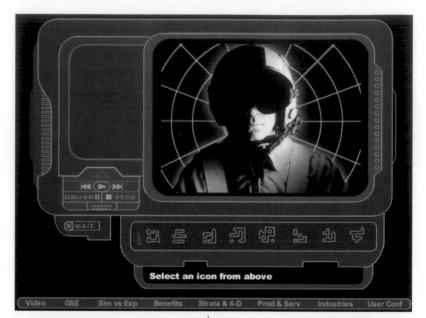

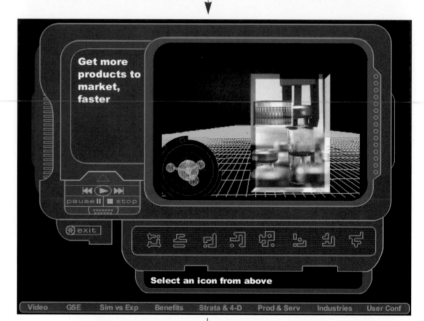

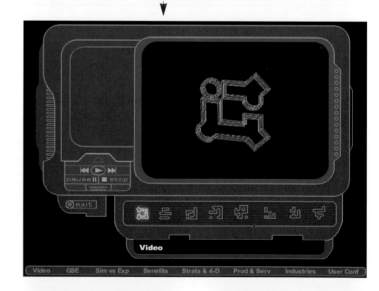

DIGITAL PORTFOLIO

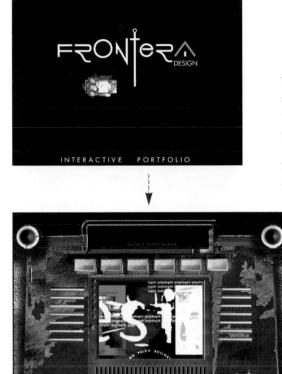

INTERACTIVE PORTFOLIO

The Frontera Design digital portfolio CD-ROM showcases the firm's grasp of multiple design styles, which it executes in this highly creative self-promotional piece. This startup multimedia design firm based in northern California used a combination of high-end design and contemporary audio loops to create an exciting multimedia experience for potential clients.

To show off their design abilities, the designers created separate and unique interfaces for each section of the portfolio, which includes examples of Website development, multimedia, print, and animation. Although each interface design differs from the previous one, the designers maintained continuity by implementing metallic and organic design elements throughout.

To achieve a unique look for each screen, the designers created the shapes for the interfaces with Lightwave, a 3D animation program. The 3D shapes were then "painted" and manipulated in Photoshop to achieve their organic and aged look.

Highlights of the CD include the main navigational interface, which features a fast-moving motion graphics video, and a pulse-pounding audio loop that sets the tone for the rest of the company's portfolio.

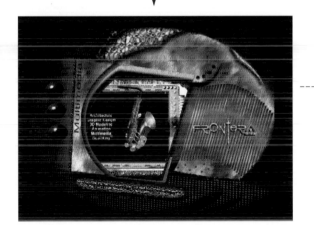

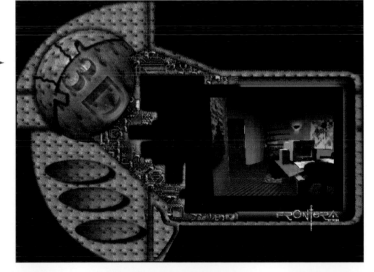

Project:	**Design Portfolio**
Design Firm:	**Frontera Design**
Design:	**Emrul Alto**
Motion Graphics:	**Patrick Lang**
3D Animation:	**Akira Orikasa**
Programming:	**Kemal Erbas**
Authoring Program:	**Macromedia Director**
Platform Specs:	**Macintosh, Windows PC**

PROMOTIONAL

Beetlemania: The Game on CD, is a promotional CD-ROM created for Volkswagen AG by the German multimedia design firm, I-D Media. This promotional project is a successor to a Beetlemania Website designed to promote the new Volkswagen Beetle vehicle. The Website was such a success that Volkswagen decided to have I-D Media repurpose the Website and develop an interactive CD-ROM promotion that could be ordered online for free.

The interface for the CD-ROM presents users with colorful and playful navigation icons and backgrounds that offer an overview of the Beetle's history, videos, and a number of interactive games. Users also encounter highly-rendered 3-D objects, such as video monitors and the inside of a "virtual" touring Beetle vehicle, which takes users on a video tour through selected cities in Europe.

The main navigation for the project is a horizontal scrolling bar that offers links to the various sections on the disc. Using advanced programming in Macromedia's Director, the designers set the scrolling bar to slow down or increase in speed as the user's cursor moves away from the center to the far left or right. As each square on the bar passes beneath the cursor, the currently available image highlights to let the user know a hot-link is active.

Other fun elements are the "Brake Lights" solitaire game; a music selection area—designed into the virtual touring Beetle—for listening to various popular songs from the 1960s and 1970s; and the chance to win prizes as users' "Virtual Tour" points are transferred to an online database from the CD-ROM as the game is played.

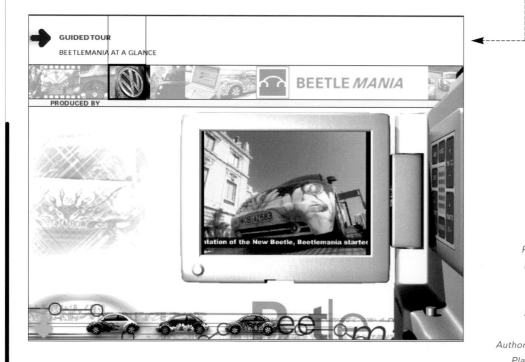

Project:	*Beetlemania: The Game on CD*
Client:	Volkswagen AG
Design Firm:	I-D Media AG
Design:	Nathalie Peruzzaro, Simone Hausch, Henrik Schwarz, Vassili Trigoudis
Illustration:	Ellen Patzschke, Thomas Grünvogel, Andrea Schrade
Programming:	Willy Waibel, Friedhelm Marcardt
Photography:	Norbert
Sound:	Carsten Druck
Video:	Alex Funk, Christoph Schröder
3D Graphics:	Holger Arndt
Speaker:	Nigel Rigby
Authoring Program:	Macromedia Director
Platform Specs:	Macintosh, Windows PC

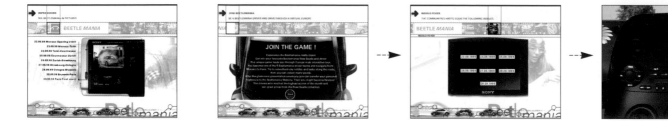

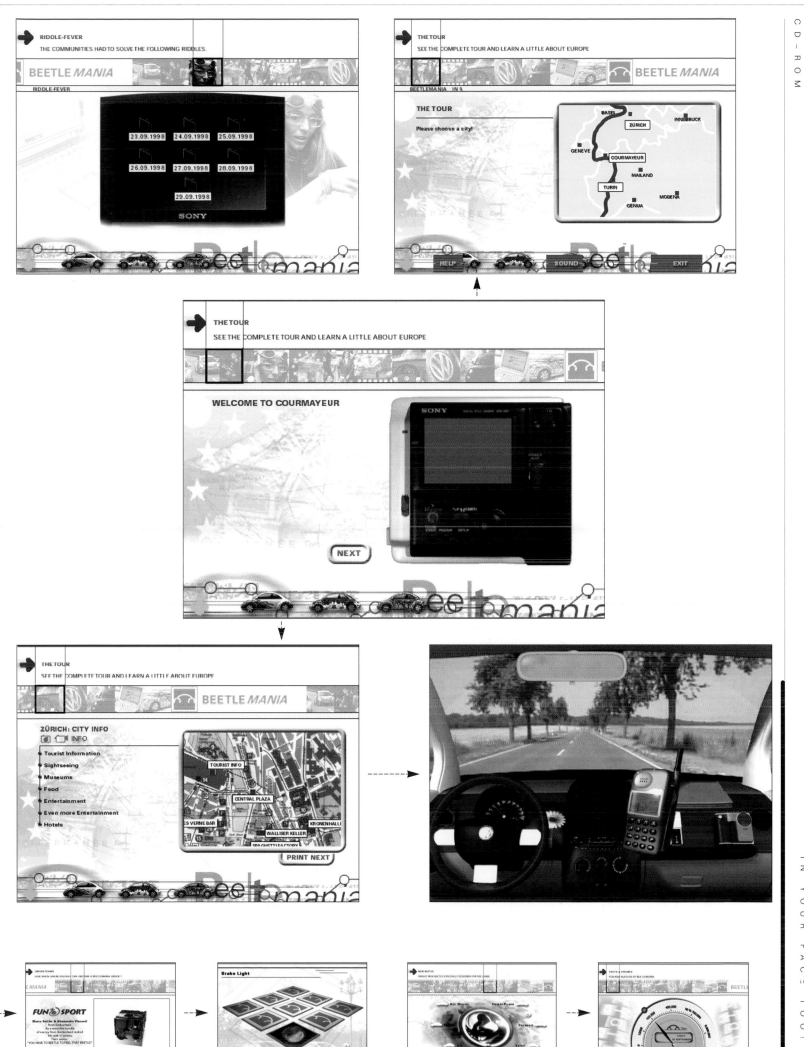

MUSIC PROMOTION

Actual Reality, a music CD-ROM developed by new media design firm Horizons Interactive, gives users the opportunity to listen to various Christian musical groups and to learn about different aspects of Christianity in an entertaining and playful interactive format. The CD-ROM consists of four main sections that users can navigate, each with its own unique and dynamic interface, such as a 1950s style diner, archaeological dig, or a futuristic, *Star Trek*-like transporter bay.

The designers at Horizons gave careful thought to who they felt would be viewing this CD-ROM and created it with its youthful market in mind. The individuals who are interviewed or who give personal accounts of their beliefs are all in their mid-teens to late twenties.

Each section includes a number of blue-screen video sequences that showcase some of the top Christian musical artists in the United States giving personal testimonies and perspectives on their experiences. Creative 3-D graphics are also used in many of the interface screens as either buttons, viewing monitors, or complete 3-D backgrounds for showcasing people and objects.

Project:	*Actual Reality*
Client:	Actual Reality Inc.
Design Firm:	Horizons Companies (Horizons Interactive)
Creative Director:	Kevin Theesen
Producer:	Denise Niebisch
Design:	Jermey Slagle, Doug McGuire
Programming:	Doug Brown, Alex Palmo, Steve Shane
Illustration:	Kevin Reagh, Demetrius Owens
Authoring Program:	Macromedia Director, Media Cleaner Pro
Platform Specs:	Macintosh, Windows PC

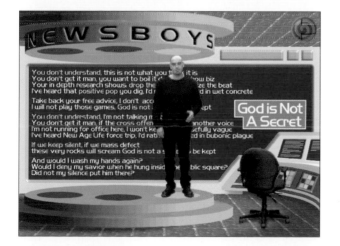

 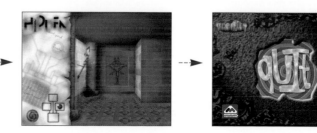

EDUCATIONAL

The Dynamic Typography Symposium companion CD-ROM was produced to help promote the event bearing the same name at the Art Center College of Design in Pasadena, California. The Symposium showcased current typography experiments in motion graphic design, and featured presentations by advanced graduate students from Southern California art and design schools.

The purpose of the CD-ROM was to provide a larger context for the event's presentations, collect information about each presenter at the symposium, and create continued discussion in the future via e-mail addresses provided in each presenter's biography section.

The main challenge for the designers was to create a look that would use elements that comprised the visual identity of the symposium—logos, color scheme, and typefaces—and also function as its own innovative and interactive piece.

The solution was to create a clean and simple interface that provided straightforward navigation and to keep from using too many elements that might detract from the presenter's featured work. To accomplish this, the designers incorporated one elegant image for the background, and used the visual metaphor of an "E" scale type-sizing tool as the main navigation bar, from which viewers can mix and match the main components of each presenter's section.

Project:	**Dynamic Typography Symposium Promotion**
Client:	**Art Center College of Design**
Design:	**(see all credits, p. 159)**
Authoring Program:	**Macromedia Director**
Platform Specs:	**Macintosh**

The Dynamic Typography Symposium

This special showcase of typographic investigations was conceived of and organized by graduate students at Art Center College of Design on February 20, 1999. Sponsored by Art Center's Graduate Program in Communication & New Media Design and AIGA/Los Angeles, the event presented the current state of typography design research being conducted in some of the region's most prestigious graduate programs. This symposium advocated an exchange of ideas between **graduate students** at different institutions and working **professionals** regarding the way we engage with the latest computer technologies and how we can address today's most relevant motion graphic design questions.

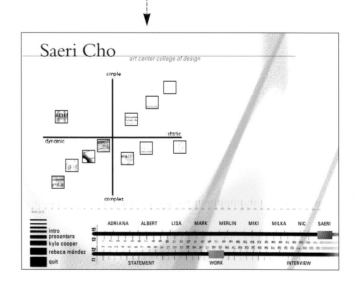

Milka Broukhim
art center college of design

- **SOS**
 A study of typographic explorations
- **I Am Her Interpreter, Part One**
 A study from Form Following Content exercises
- **I Am Her Interpreter, Part Two**
 A study from Content Following Form exercises
- **Abstract typographic experiment portraying the idea of "space"**
- **Film title based on the book,**
 The Stranger by Albert Camus

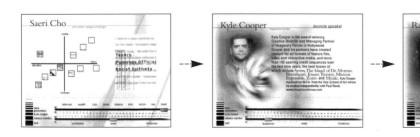

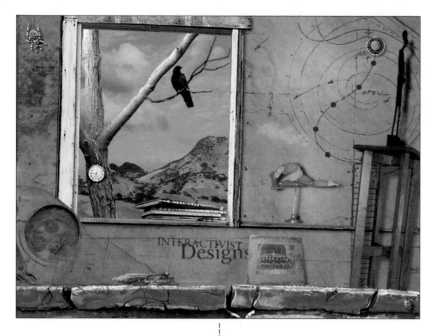

DIGITAL PORTFOLIO

This CD-ROM portfolio for IYF Design was produced to showcase the company's high-quality design work in the areas of CD-ROM, online design, and traditional print-based media. To create a playful and memorable experience for users, the designers opted to stay away from traditional forms of navigation, and instead created a collage of found objects, design studio elements, and items taken from nature.

Each of the items used throughout the interface—insects, clocks, old photos—offer users a dynamic experience before taking them to another area of the CD-ROM. As an example, insect icons such as the praying mantis, spider, and ladybug scurry or crawl away when clicked upon.

One aspect of the CD-ROM that stands out from others is that all of the elements used in the design of the interface were photographed with an Olympus D-600L digital camera. This includes insects, wood and metal, and all of the richly textured backgrounds that help to create this exciting and visually stimulating experience.

Project:	**Design Portfolio**
Client:	**Self**
Design Firm:	**IA Design**
All Design:	**Daniel Donnelly**
Production:	**Christian Memmott**
Music and Audio:	**Patrick Lang**
Design Intern:	**Carolyn Short**
Authoring Program:	**Macromedia Director**
Platform Specs:	**Macintosh, Windows PC**

ART CATALOG

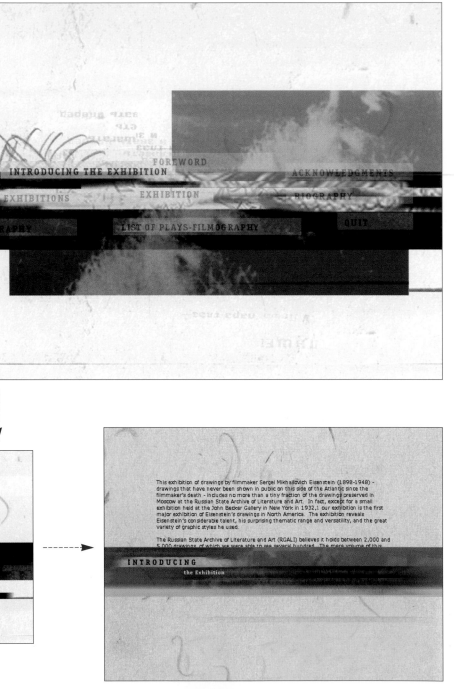

The *Eisenstein* CD-ROM catalog was a project created for the first North American exhibition of Russian filmmaker Sergei Eisenstein's drawings since 1932. Produced for the Daniel Langlois Foundation for Art and Science by the Canadian multimedia design firm Epoxy, this project represents an artistic and thoughtful view of Eisenstein's rarely seen pencil and ink drawings.

The initial entry to the interface presents viewers with the choice of either French or English versions of the CD-ROM, and then transitions to the contents screen (below) and a dynamic navigation bar that is centered vertically on the screen. The hot-links to each section appear on the navigation bar as translucent and multi-layered rectangles that scroll horizontally from either the left or right sides, and appear to pass above and below each other as if floating across the screen.

This navigation technique is used throughout the interface to showcase drawings, photography, and biographical text.

To give users more control over the viewing experience, the designers included a full-size image of each drawing and allow users to enlarge each piece of art to its original size for better viewing.

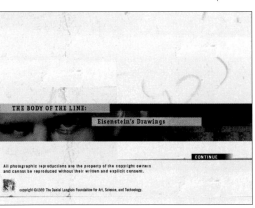

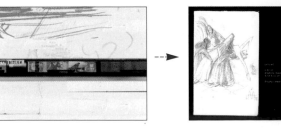

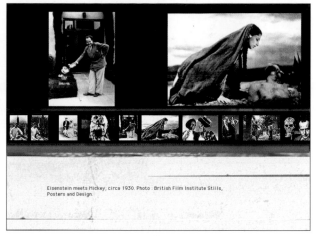

Eisenstein meets Mickey; circa 1930. Photo : British Film Institute Stills, Posters and Design.

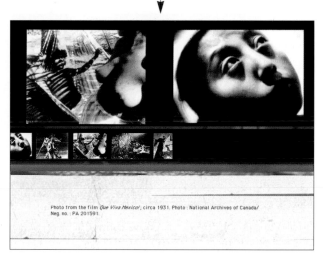

Photo from the film *Que Viva Mexico!*; circa 1931. Photo : National Archives of Canada/ Neg. no. : PA 201591.

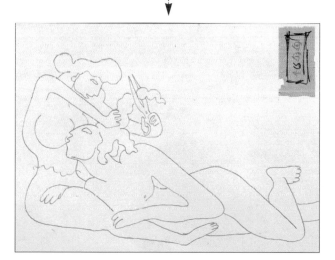

Project: | *Eisenstein: Le Corps de la Ligne*
Client: | La Foundation Daniel Langlois
Design Firm: | Epoxy
Design: | Danielle Gingras, George Fok, Daniel Fortin
Programming: | Nitro Édition Digitale, Gary Laliberté
Authoring Program: | Macromedia Director
Platform Specs: | Macintosh, Windows PC

 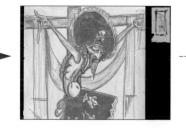

EDUCATIONAL

Junior Nature Guides are a series of interactive nature CD-ROMs for children and young adults, designed and produced by ICE (Integrated Communications & Entertainment). The project featured here gives users an in-depth look at frogs, snakes, turtles, and several other categories of amphibians and reptiles, and also teaches how to locate and catalog—without harming either the creatures or themselves in the process—the different species found within the United States and Canada.

This project includes a well-thought-out navigation that is clear and simple, yet effective in bringing together an abundance of information in the form of video, animation, and hundreds of beautiful illustrations. Users learn about amphibians from many different locations, including their own backyard.

Elements that add to the fun and enjoyment that users will encounter as they explore the CD-ROM are quizzes testing knowledge, videos in the "Nature Television" area that feature children discovering their surroundings and the animals that live there, and a special "Field Kit" (below right), which allows users to print a guide that they can carry with them and keep track of what they've seen and heard on their adventures into the wilds of their own backyard.

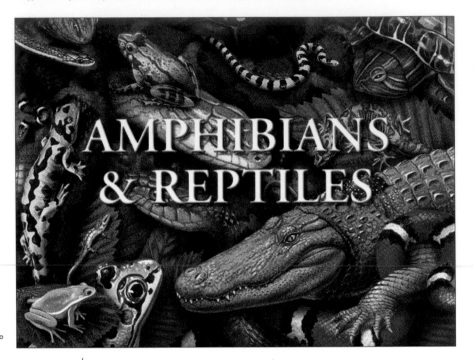

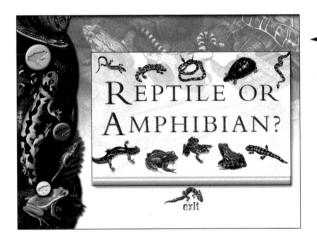

This Field Kit can be printed out in color or in black and white. Simply select 'print' under the 'File' menu. To view another page, use the 'Go to' menu.

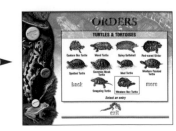

Project:	*Junior Nature Guides: Amphibians & Reptiles*	
Client:	ICE Publishing	
Design Firm:	ICE (Integrated Communications & Entertainment)	
Design:	Sean Patrick	
Programming:	Steven Wicks	
Music:	Simon Edwards	
Authoring Program:	Macromedia Director	
Platform Specs:	Macintosh, Windows PC	

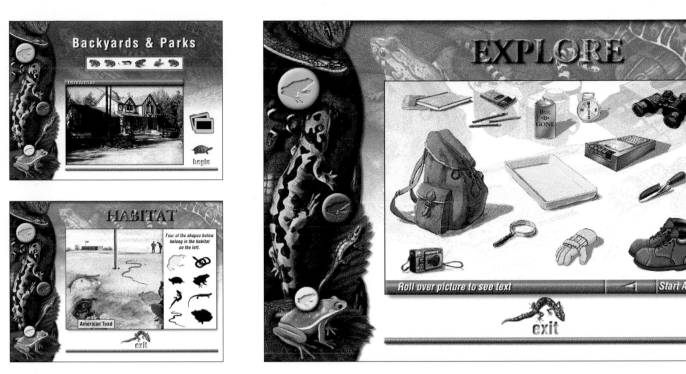

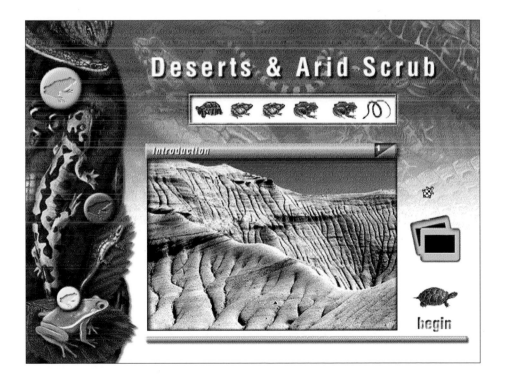

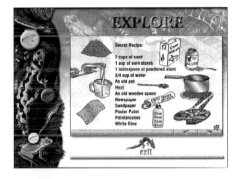

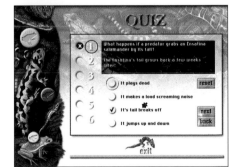

EDUCATIONAL

Flashpoint is an archive of graduate and undergraduate student work produced at the Art Center College of Design in Pasadena, California prior to 1998. This interactive catalog has been used successfully to promote the various disciplines taught at the college to both prospective students and donors.

The concept behind the interface was inspired by the periodic table of elements, with each element-like numeral linking to either an area of design or a student's work. The "table" is split numerically into the different disciplines (located at the bottom of each interface) and highlights to show the projects available in each section, such as the numbers 1, 2, and 3, that focus on "Drawing" in the undergraduate program (below).

To make the interface navigation easily accessible for all users, the designers created several different paths for finding information relevant to a specific area—users can either browse the contents of the disc via student names, departments, or the medium used. As the user navigates through the different areas, dynamic shifts in color are created within the "table."

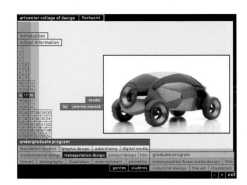

Project:	*Flashpoint*
Client:	**Andrew Davidson, Chair, Digital Media Dept.**
Design Firm:	**Art Center College of Design**
Design:	**Margi Szperling, Craig Ashby, Philipp Zünd**
Authoring Program:	**Macromedia Director**
Platform Specs:	**Macintosh, Windows PC**

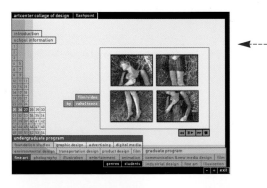

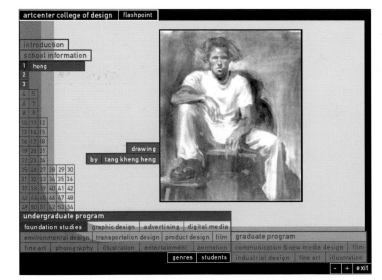

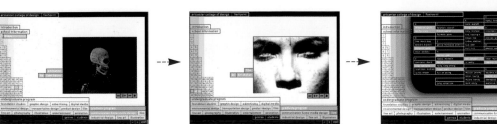

EDUCATIONAL

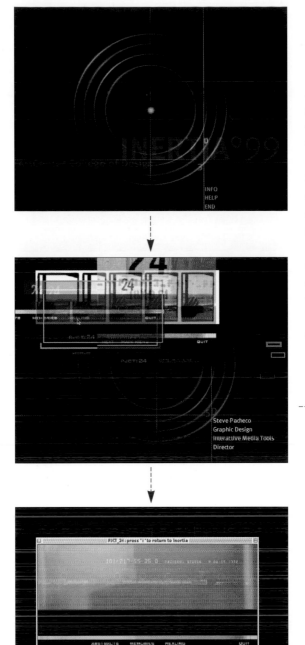

INERTIA is another example of the high-quality work being produced by design students at the Art Center College of Design. This sampler of recent digital work created at the College showcases projects produced in various media, and attempts to expand on the basic metaphor of two- and three-dimensional design.

Using a concentric navigational interface (left), the students have worked with the concept of creating areas of 2-D, 3-D, 4-D, and 5-D work, where each of the dimensions correspond to a specific form of design: 2-D for flat art, 3-D for computer-rendered hics, 4-D for motion graphics, and 5-D being the dimension of interactivity.

Each of the projects has its own navigational structure, some simple and some more complex in the design and programming. As an example, Justin Williams' interface for viewing his 3-D art (below) is programmed to use a dimensional hierarchy. When the user moves the cursor over an image, the chosen image slides forward above the others and becomes the clickable object.

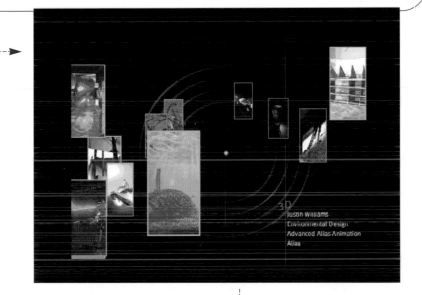

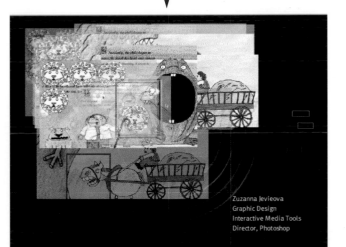

Project:	*INERTIA*
Client:	Andrew Davidson, chair, Digital Media Dept.
Design Firm:	Art Center College of Design Students
Design:	Pascal Wever
Faculty Advisor:	Laura Silva
Package Design:	Tracy Lewis
Sound Design:	Sebastian Frey
Authoring Program:	Macromedia Director
Platform Specs:	Macintosh, Windows PC

ENTERTAINMENT

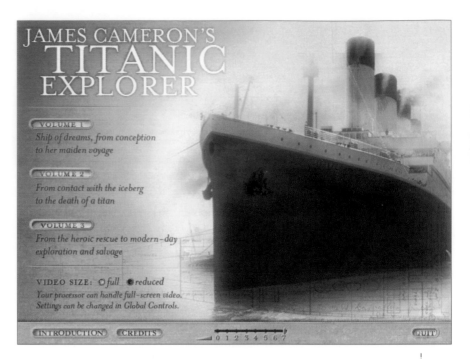

James Cameron's *Titanic Explorer*, by Rare Medium Inc., is a balance of intriguing information, beautiful visual imagery, and a creative and well-thought-out interface for navigating the project. Developed in association with James Cameron and Fox Interactive, Rare Medium Inc. had to sift through six tons of material in twenty-two freight containers that were supplied to them, in order to produce this exciting interactive experience.

Titanic Explorer presents viewers with an intimate portrait of the tragic story surrounding the Titanic, and allows users to interact with every aspect of the story. As an added design element, the designers created a more passive form of the interface where users can simply sit back and watch as the CD proceeds through each section of the presentation in a documentary style.

To accomodate the massive amount of information needed to give an in-depth account of the tragedy, the project required three CD-ROMs. The navigational transitions between these three CDs is presented without too much trouble, and the activity begins again immediately after a new CD-ROM is loaded.

Though the CD-ROM is based on the motion picture by director James Cameron—viewers should not expect to see cameos of the actors in the original film—the designers worked around this by only using sequences where famous faces weren't featured, making the drama of this interactive story more realistic as viewers listen to firsthand accounts, read actual biographies of passengers and crew, and watch videos leading up to the final sinking of the ship.

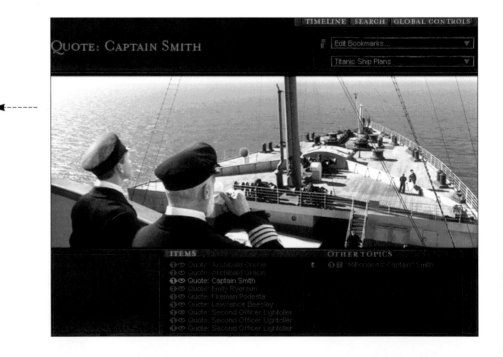

Project:	***Titanic Explorer***
Client:	**Fox Interactive**
Design Firm:	**Rare Medium Inc.**
Design:	**(see p. 159 for full credits)**
Authoring Program:	**Macromedia Director**
Platform Specs:	**Macintosh, Windows PC**

 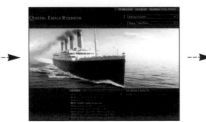

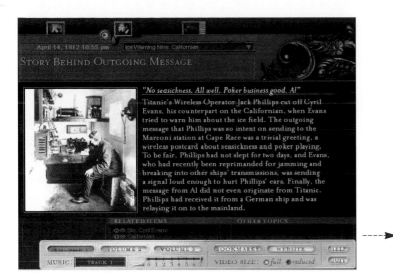

STORY BEHIND OUTGOING MESSAGE

"No seasickness. All well. Poker business good. Al"

Titanic's Wireless Operator Jack Phillips cut off Cyril Evans, his counterpart on the Californian, when Evans tried to warn him about the ice field. The outgoing message that Phillips was so intent on sending to the Marconi station at Cape Race was a trivial greeting, a wireless postcard about seasickness and poker playing. To be fair, Phillips had not slept for two days, and Evans, who had recently been reprimanded for jamming and breaking into other ships' transmissions, was sending a signal loud enough to hurt Phillips' ears. Finally, the message from Al did not even originate from Titanic. Phillips had received it from a German ship and was relaying it on to the mainland.

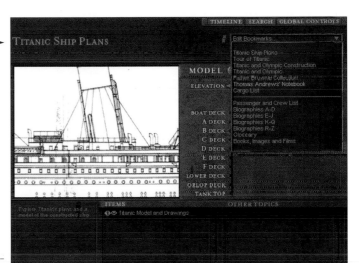

TITANIC SHIP PLANS

BIO: WIRELESS OPERATOR EVANS

Wireless Operator Cyril Evans

Cyril Evans, 20, was born in Croydon, near London. After 10 months at the Marconi school, he joined White Star's Cedric for one trip. His next assignment was Leyland's Californian, which had just been fitted out with wireless equipment in January 1912. The mid-April run from Liverpool to Boston was his second aboard the Californian, and only the third in his career, but he had already been reprimanded for jamming and breaking in on other ships' signals. On the night of April 14, Evans tried to warn Titanic about the ice field, was rebuffed by her operator Jack Phillips, and went to bed before the distress calls came. He was later called to testify at the hearings in Washington.

QUOTE: SECOND OFFICER LIGHTOLLER

MUSIC PROMOTION

Caedmon's Call: Intimate Portrait is an excellent example of what an enhanced CD (ECD) should be. This project by Horizons Interactive allows users to listen to music, review lyrics, and take an intimate look at members of the band, Caedmon's Call. The interface incorporates animation and video into the backgrounds of the main interface, such as a bus pulling up to the curb at the bus stop, or band members walking onto the scene. From this main screen users can roll over objects in the photograph to access other areas of the ECD.

There are four main areas of navigation, the "bus sign," "gallery window," "guitar," and a "manhole cover." Each of these navigation images links to a specific area where users can watch video interviews with band members, view a photo gallery—hosted by a band member that has been filmed and placed into the background as a QuickTime video—play a guitar with the mouse, or watch music videos. Users can also click and be taken to an area where they can watch band members share their beliefs and feelings about various topics regarding life and religion.

This project combines real photos with QuickTime video and animated action sequences to create a subtle, playful, and entertaining interface for learning about the band and its musical sensibility.

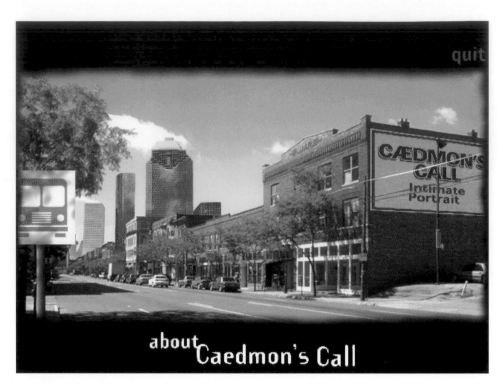

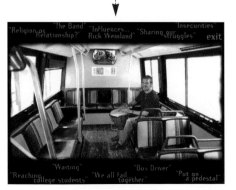

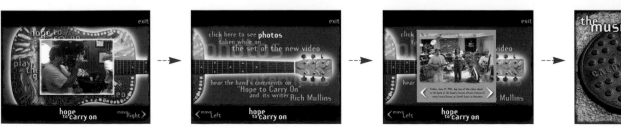

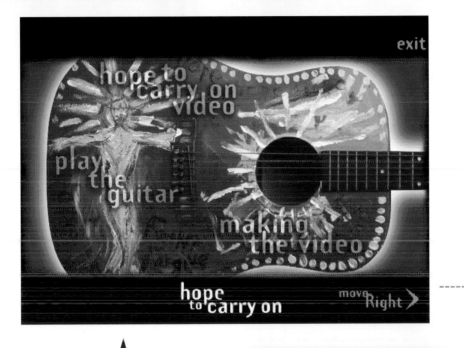

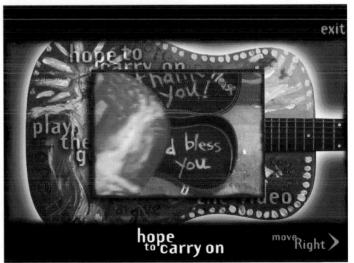

Project: *Caedmon's Call: Intimate Portrait*
Client: Warner Alliance
Design Firm: Horizons Companies (Horizons Interactive)
Design: Kevin Theesen
Creative Director: Eric Mullett
Executive Producer: Jeremy Slagle
Programming: Alex Palmo, Steve Shane
Photography: David Cooke
Authoring Program: Macromedia Director
Platform Specs: Macintosh, Windows PC

MUSIC PROMOTION

Cottonmouth, Texas is an enhanced CD-ROM (ECD) created by Rare Medium (formerly CircumStance Design) to preview a soon-to-be-released album by the band Cottonmouth, Texas entitled *Anti-Social Butterfly*. The ECD opens with a QuickTime music video playing against a black background and continues to play until the user clicks the mouse. Once the user clicks, the video jumps to the main contents screen where it continues to play in a smaller window imbedded in the interface (right). The interface focuses around the music video, offering users the ability to pause, rewind, or fast-forward the video. Users can also choose to view any of nine different sections of the video and adjust the volume.

The design of the interface features rusted metal buttons and an eroded, burnt, and decaying frame held together by tape. To complement this look the designers chose a contemporary grunge font to feature band member biographies, discography, and song lyrics.

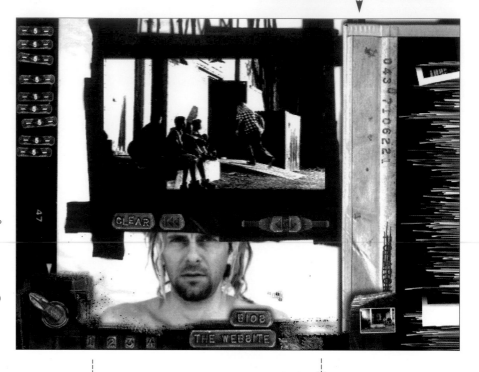

Project:	*Cottonmouth, Texas*
Client:	Virgin Records
Design Firm:	Rare Medium (formerly CircumStance)
Project Direction:	Tim Barber, David Bliss
Sound Production:	Sean Rooney
Video Production:	Lew Baldwin
Art Production:	Jemma Gura
Authoring Program:	Macromedia Director
Platform Specs:	Macintosh, Windows PC

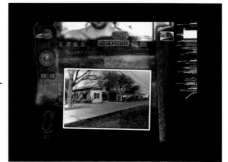

MUSIC PROMOTION

Point of Grace: Steady On is an enhanced CD-ROM single produced for World Records by new media design firm Horizons Interactive. This ECD is an interactive preview of Point of Grace's complete *Steady On* album, and features three special remixes of the title song "Steady On." The project also features a number of elements that offer the band's followers a dynamic look at the band and its music. Included on the disc are a photo gallery, QuickTime videos, a trivia game, and exclusive interviews and profiles with the four female band members.

The main contents screen (left) was designed to give the user a feeling of looking into a small pond, with elements in and around the water being used as navigational icons, such as the water lily's petals, stones sticking in and out of the water, and a ladybug that starts the project exit sequence.

To maintain the continuity of the project only one background image was used for the interface and each of the main elements are integrated into it, such as photos floating at the water's edge and video sequences blending into the ripples of the pond.

Project:	*Point of Grace: Steady On*
Client:	Word Records
Design Firm:	Horizons Companies (Horizons Interactive)
Design:	Rose Irelan, Karma Christiansson
Creative Producer:	Denise Niebisch
Programming:	Doug Brown, Alex Palmo
Illustration:	Kevin Reagh
Authoring Program:	Macromedia Director, Media Cleaner Pro
Platform Specs:	Macintosh, Windows PC

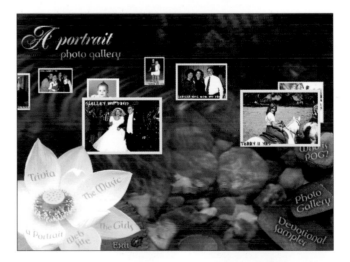

 → → →

MUSIC ENTERTAINMENT

The *Romeo + Juliet* enhanced CD-ROM (ECD), produced by Rare Medium Inc., is similar to the full *Romeo + Juliet* entertainment CD-ROM featured earlier in this book (also by Rare Medium), but the ECD project was much smaller (60 megabytes compared to 600 megabytes) and its distribution was very different. This CD project was aimed directly at a market where the potential user will purchase the disc primarily as a music CD, and secondarily it will be viewed as an interactive (enhanced) music CD. Sometimes this second aspect becomes a distant second when the only way the buyer can figure out there is an interactive project on the disc is a miniscule enhanced-CD logo on the back of the packaging.

The opening to this project differs somewhat from the game project also. An animation with voiceover from the film introduces the project while an aged wooden background featuring the text scrolls vertically up the screen (right). From here the project transitions to the main contents screen (below) where the user has access to draggable icons—the red and blue oval at the top left of the screen—that link to different musical and visual images from the *Romeo + Juliet* motion picture. Another dynamic element is the horizontal movement the designers used to transition from one screen to the next. This movement gives users the feeling of looking at a much larger interactive project that goes beyond the scope of the monitor's screen. One of the main elements that wasn't included on this project because of memory constraints is video from the motion picture.

This project, produced for Capitol Records, was pivotal in Rare Medium's advancement as one of the top multimedia studios in the country. The disc was a commercial and critical success and led to the studio obtaining extensive work from Fox Interactive.

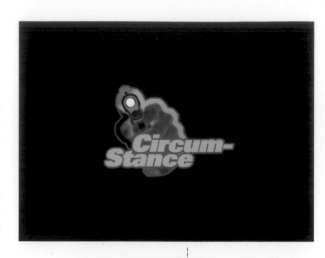

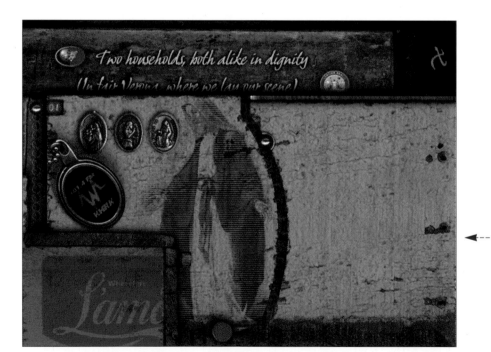
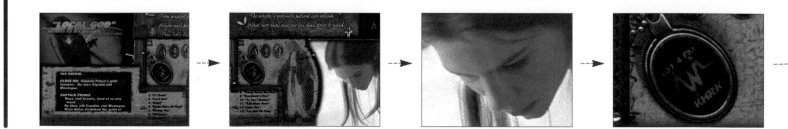

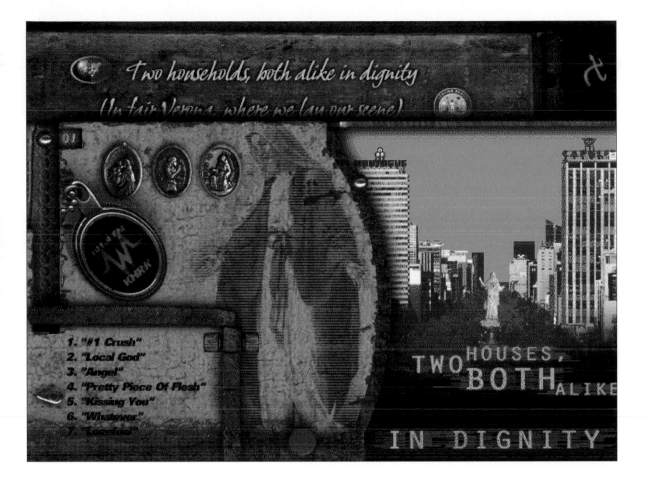

Project:	**Romeo + Juliet**
Client:	Fox Interactive
Design Firm:	Rare Medium Inc.
Creative Director:	Tim Barber
Technical Direction:	David Bliss
Design:	Josh Lowman
Engineer:	Sean Rooney
Authoring Program:	Macromedia Director
Platform Specs:	Macintosh, Windows PC

 → → →

CAPSULE:
PRESCRIPTIONS FOR LIVING

Presented by:
SF Metropolitan & Heavy Rotation
May 1st, 1999
Broadway Studios
San Francisco, CA

Amidst the adult establishments of Broadway and the trendy yuppie bars of North Beach, SF Metropolitan and Heavy Rotation threw a very inspired fashion show with the help of some of the Bay Area's best young designers. A chic crowd gathered at the Broadway studios to see designs by Utopia Planita, Grand, Nnaka, Fife and Deina. Ranging from elegant and simple to more avant-garde, the styles echoed many of the top designers of Europe and New York, but often with a more individual look and feel. The models were stupendous and gave the crowd a peek at what our local designers have to offer. Rounding out the evening were Heavy Rotation resident DJs Julius Papp, Mr. Phonography and Frank Boissy.

So, next time your searching for a new outfit to keep up with the fashionable trends of modern city life, check out these designers and keep your spending dollars LOCAL!

(Photos / Review ::::: David Axelbank)

and win $20,000

"Numerous children,
whom we were receiving"

Irma's Injection

"A large hall -- numerous guests, whom we were receiving. -- Among them was Irma. I at once took her on one side, as though to answer her letter and to reproach her for not having accepted my 'solution' yet. I said to her: 'If you still get pains, it's really only your fault.' She replied: 'If you only knew what pains I've got now in my throat, stomach and abdomen -- it's choking me.' -- I was alarmed and looked at her. She looked pale and puffy. I thought to myself that after all I must be missing some organic trouble. I took her to the window...

INTERFACE PIRATE
WEEKLY SCHEDULE (PST)

MONDAY	9:00A
TUESDAY	9:00A
WEDNESDAY	9:00A
THURSDAY	8:30A
FRIDAY	ALL D
SATURDAY	ALL D
SUNDAY	MIDNI

REAL PLAYER G2 OR 7

he links below to
of Days Trailer:

eo Trailer

me Trailer
640K)
2MB)
MB)

delivering

Read our terms and conditions of use

AMERICAN B

MUSIC FROM THE ORIGINAL MOTION PIC

ding Disco Gangsters
Are Fighting For You

highly realistic graphics

that's missing

websites

FILM PROMOTION

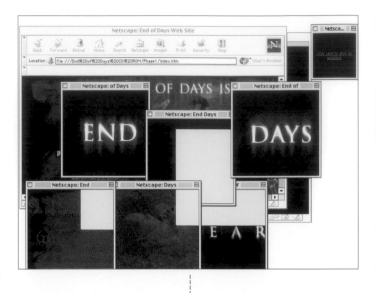

The *End of Days* Website is an online promotion for the motion picture bearing the same name. The site was live before the film was released, and was developed in phases to generate interest in the film and to try and create repeat visits by viewers as they return to find updated information and acquire free downloadable files from the site.

The concept behind the site was to feature a behind-the-scenes apocalyptic online-hacker who is manipulating the site while trying to warn viewers about the upcoming armageddon. To aid in creating this hacker-like atmosphere the designers used html programming in the opening sequence to open and close multi-layered windows (right) on the viewer's screen; each window featured disturbing images of fiery, hellish typography, and images from the film.

Other elements that add to the viewer's experience are downloadable QuickTime video trailers, music from the film, and downloadable Mac and PC screensavers. To find these files the viewer must navigate through a number of screens rendered with highly textured backgrounds of burning imagery, and contemporary typographical treatments, all of which add to the unsettling feeling that the "end of days" is near.

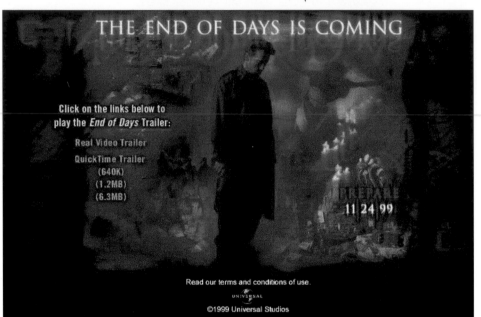

Project:	**End of Days**
Client:	**Universal Studios**
Design Firm:	**CBO Interactive**
Executive Producer:	**Mitchell Rubenstein**
Producer:	**Carissa Hendricks**
Lead Designer:	**Ryan Antista**
Design:	**Parul Sanghai, Scott Wolfe**
Authoring Programs:	**Adobe Photoshop/Illustrator/After Effects,**
	Allaire Homesite, RealVideo, QuickTime,
	Macromedia Director/Flash/Fireworks
URL:	**http://www.end-of-days.com**

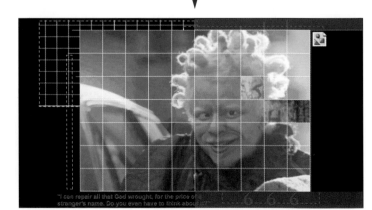

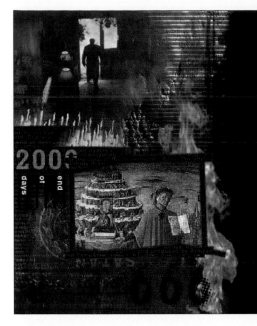

A.D. - Anno Domini

0 - the birth of Christ

c.33 – crucifixion/resurrection

79 – eruption of Vesuvius

96 – the Revelation of John

150 – Christians fed to the lions in the Colosseum

313 – Constantine declares Christianity official religion of Rome

350-450 – fall of Roman empire

1000 – end of the first millenium/ apocolyptic predictions

1095—Crusades

1225-1274 – St Thomas Aquinas

1265-1321 – Dante Alighieri

1348 - the Black Plague

1454 – printing press

1480 –Inquisition

1500 – suspected apocalypse

1566 – Nostradamus

1517 – Reformation begun

1789 – French Revolution

1800 – Napoleonic Wars

1853 – Darwin's Origin of Species

1914 – First World War

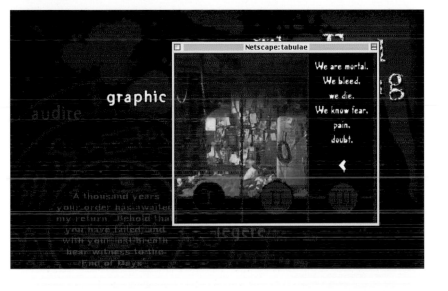

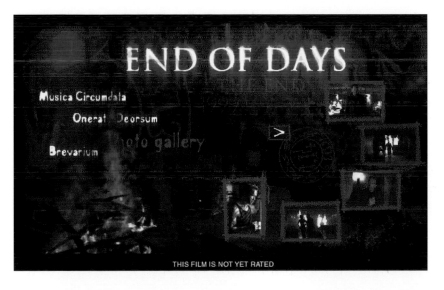

ONLINE PORTFOLIO

François Chalet is an illustrator and Web designer located in Zurich, Switzerland. His portfolio shown here is a showcase of current and past works created for clients and as personal projects. The text for the site (what little is used) is in German, but Chalet uses an international language of icons, and the universal language of humor to help viewers find their way through the different areas of the site.

To capture the attention of visitors to his site, Chalet implemented a number of animated gifs and Macromedia Flash animations, adding a dynamic element to his illustrations. The opening animation which links to the bright red contents screen (below), features two argumentative characters—drawn in Chalet's unique style—pulling guns on one another as the user rolls the cursor across each image. While this is happening another animated gif of a black house cat is roaring at the top of the screen.

The "black cat" image is found throughout the site and is used by Chalet to feature his illustrations, and also as an icon to show users which of the smaller illustration icons they've already clicked on to view. The head or body of the black cat joins with, or covers a portion of each icon after the larger illustration loads in the mouth of one of his iconic illustrations.

Project: | Illustration Portfolio
Client: | Self
All Design: | François Chalet
Authoring Program: | Macromedia Flash
URL: | http://www.francoischalet.ch

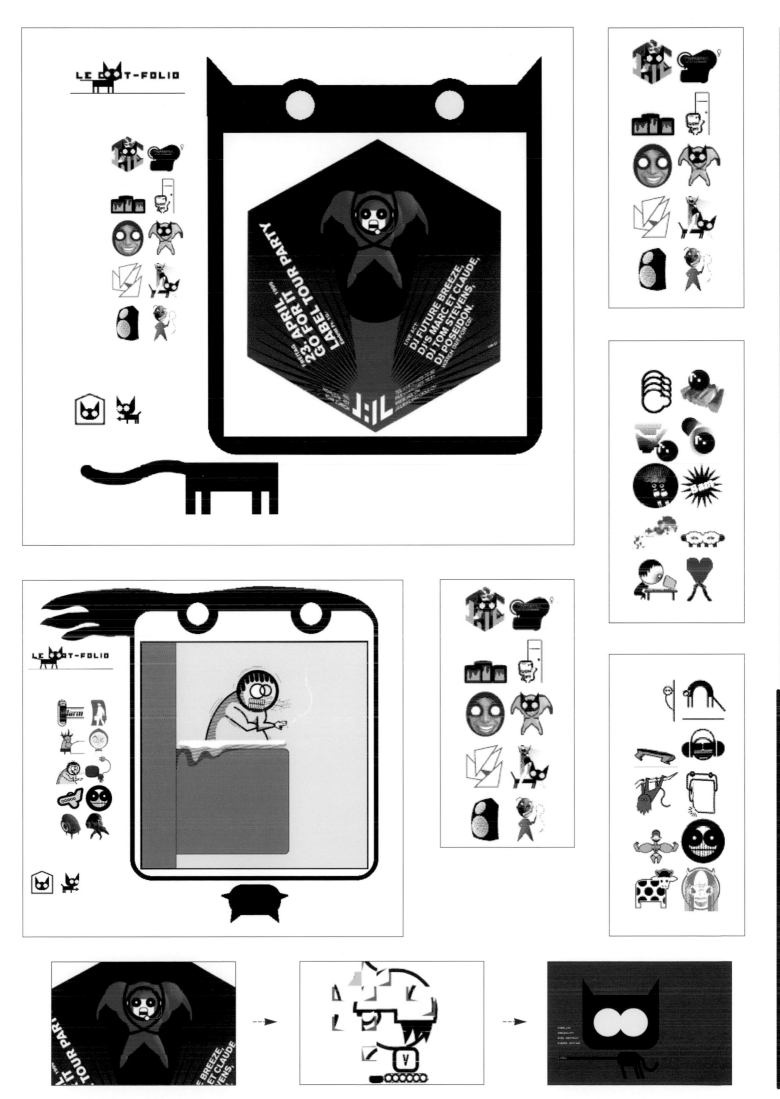

DIGITAL FILM FESTIVAL

The Digital Film Festival Website (D.FILM) approached Akimbo Design, one of the top new media design firms in the United States, to develop a complete redesign of its existing Web presence. The D.FILM site is an online showcase of films made with "new" digital tools available to filmmakers, such as digital cameras, high-end computers, and design and editing software.

Akimbo Design's goal was to create a site that emphasized the ease of use and accessibility of the digital film medium, while also reflecting the exciting, high-tech spirit of the digital film community. Ease of use and accessibility was achieved by, first, the use of a single navigation bar in a frame along the bottom of each screen which allows easy access to all content within the site. Second, and more importantly, the use of new design and programming technologies allowed Akimbo Design to create an interactive filmmaking experience.

Akimbo Design is well-known in the new media industry for using Macromedia tools to develop Web applications. Using Macromedia's Flash, Shockwave, and Generator, the designers incorporated a "build your own movie" section for the D.FILM site (facing page). This impressive feature allows visitors to select characters, write dialog, choose scene locations and music, and then dynamically generate a short animated film on the fly.

Project:	Digital Film Festival
Client:	D.FILM
Design Firm:	Akimbo Design
Design:	Ardith Ibaòez Rigby
Programming:	Ben Rigby
Illustration:	Ardith Ibaòez Rigby
Director of D.FILM:	Bart Cheever
New Venue Creation:	Jason Wishnow
New Venue Scripting:	David Nestor
Strategy:	Nikos Constant
Graphic Design:	David Weissberg
Branding:	Cindy Kawakami
Associate Producer:	Steve Baker
Music from Mixman:	Ricodelphia
Authoring Program:	Macromedia Director/Flash/Shockwave/ Generator
URL:	http://www.d.film.com

ONLINE PROMOTION

Top Cow Productions is one of the top independent comic book producers in the United States. This site, designed and produced by 52mm, is a showcase for Top Cow's comics, and also an online community and fan-base for readers and collectors of comic books.

Many collectors of comics have favorite books and characters they purchase on a regular basis. To accommodate this important buying segment, Top Cow had the designer feature a number of its top characters in a bar across the top of each screen. This works to maintain continuity on each page, as well as continue the branding of specific comics and characters throughout the site.

Other elements that add to the experience are a chat room where comic fans can discuss their favorite comics and characters; an e-commerce site for ordering current and back issue comics; and a collectors area for Top Cow trading cards.

Two important elements that add to the ease of navigation and quick download of the site are the use of frames technology to split the navigation bar on the left side of the screen from the changing content on the right, and the use of "lowsrc" tags in the html coding to preload the low-resolution image before the full-color image loads. This allows viewers to preview the image before the rest of the sites graphics load (top right).

Project: **Top Cow Promotion**
Client: **Top Cow Productions**
Design Firm: **52mm**
Design: **John J. Hill**
URL: **http://www.topcow.com**

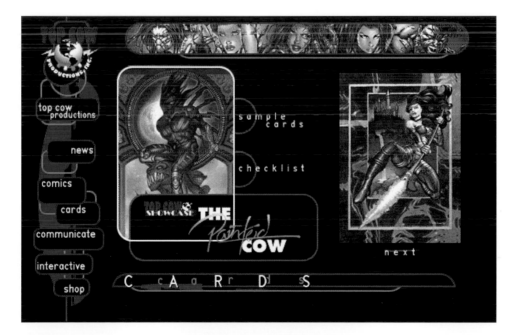

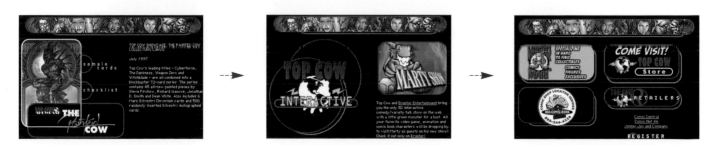

PROMOTION

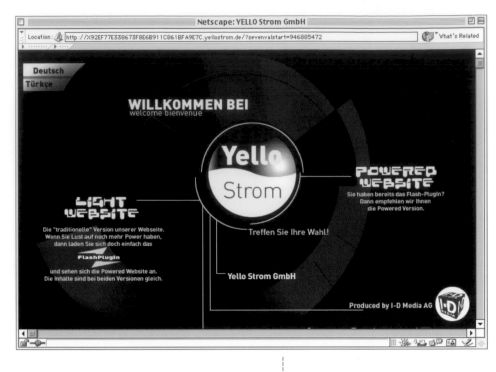

German new media design firm I-D Media AG created the Yello Strom Website for the German based electric utility company Yello Strom GmbH. Yello Strom is a low-cost provider of electricity to households, and a daughter company of the fourth-largest electricity provider in Germany.

I-D Media created the Website to offer Yello customers a complete range of services online: contract signing and registration, discontinuing services, an online customer care center, and a one-on-one chat area where Yello service agents can solve customer problems.

The Yello Strom Website allows users to choose from two different versions of the site for viewing: a "light," static version for users with slower connections, or a "dynamic" version created with Macromedia Flash. Users can also choose to view the site in German or Turkish. The dynamic version of the site features Flash motion graphics, animated fades, button roll-overs, and audio.

The ID-Media designers did an excellent job of turning what might normally be a conservative corporate website into a colorful, user-friendly, customer-oriented online presence.

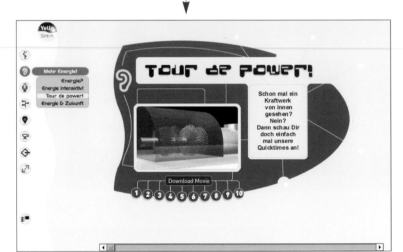

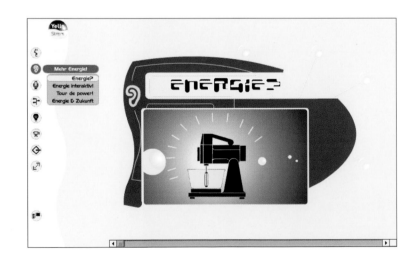

Project: | Yello Strom GmbH Promotion
Design Firm: | I-D Media AG
Design: | Nathalie Peruzzaro, Simone Hausch, Heinz Sondhaus, Vassili Trigoudis
Programming: | Wolfgang Stengel, Petra Minges, Thomas Wolfart, Hannis Herrmann
Illistrators: | Ellen Patzschke, Thomas Grünvogel
Authoring Program: | Macromedia Flash, Shockwave
URL: | http://www.yellostrom.de

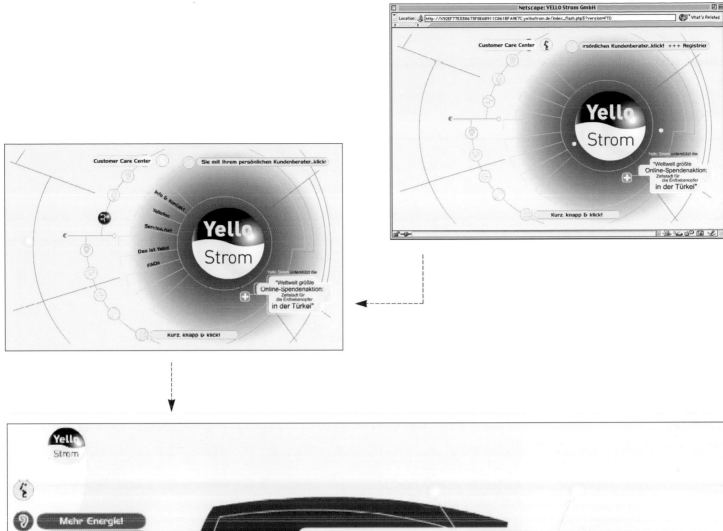

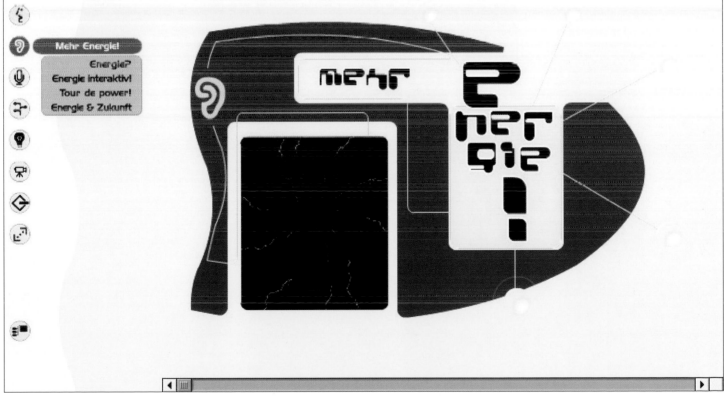

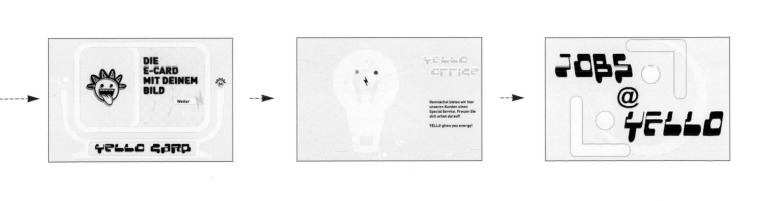

ONLINE PORTFOLIO

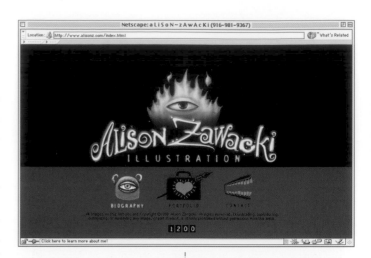

Alison Zawacki's online portfolio offers potential clients a convenient way to view a large portion of her illustration work. The site features visual, icon-based navigation presented in the form of humorous and creative illustrations drawn by Zawacki.

Because the artist wanted to sell her illustration skills and not her Web design skills, she purposefully kept the interface and navigation as clean an simple as possible. This meant creating only four main links that take visitors quickly to each section, and staying away from the bells and whistles of animation or audio that would slow the process and distract viewers from her illustration work.

The biggest challenge to creating any successful Website is what happens after the site is finished—getting traffic to your site so it gets seen.

Zawacki took this challenge head-on, by promoting the site before its launch. Four consecutive mailings of printed promotional materials were sent to art directors and art buyers beforehand inviting them to view her work online.

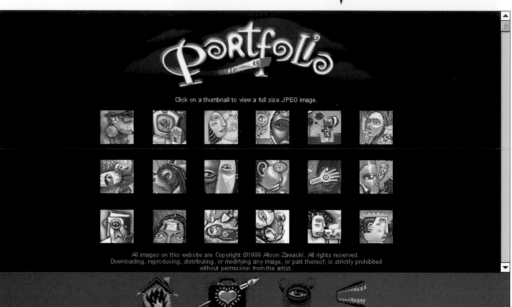

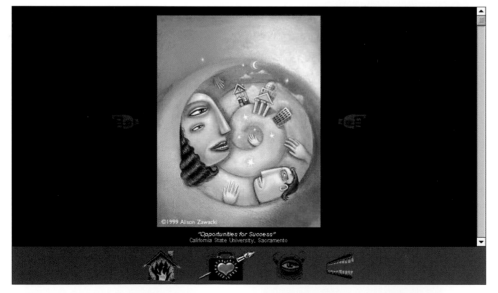

Project: | **Illustration Portfolio**
Client: | **Self**
All Design: | **Alison Zawacki**
URL: | **http://www.alisonz.com**

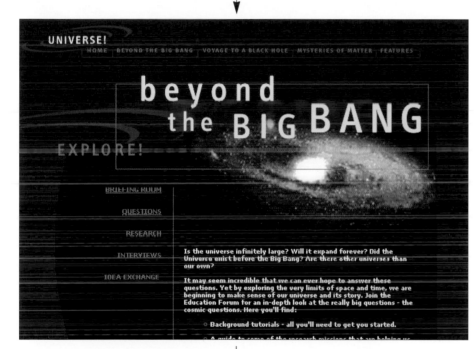

EDUCATIONAL

The Universe! website, designed by Black Bean Studios and sponsored by NASA's Office of Space and Science, is an educational forum for teaching and learning about the scientific study and evolution of the universe. The site fosters an exciting and substantive learning experience for students, teachers, and the general public.

The designers at Black Bean captured the essence of what a space and science site should look like by combining the deep-black mystery of a night sky with an electric blue palette, giving visitors the feeling of looking into the vastness of space. Featuring beautiful nebulae, galaxies, and other astral bodies on each of the screens also helps in creating the "universal" look of the site.

The designers created a stylized, spiral galaxy-like icon for branching off the navigation links for each area, and continued the icon on subsequent pages to create continuity throughout the Website.

Project:	Universe!
Client:	Harvard—Smithsonian Center for Astrophysics
Design Firm:	Black Bean Studios
Design:	Alisha Vera, Jodi Vautrin
Programming:	Jason Giaccone
Production:	Judy Wong
URL:	http://cfa-www.harvard.edu/seuforum

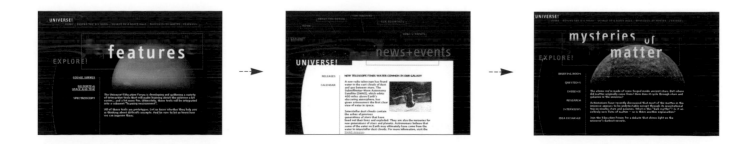

SELF PROMOTION

Final.nu is the product of an online collaboration between two designers, Jay David and Harsh Patel, working in different areas of the United States—St. Louis, Missouri, and Austin, Texas, respectively. The site was established as an open space for their own experimentation, and for the design community to discover the collaborations of various designers besides David and Patel.

The site features extreme visual layouts: Radical graphic imagery, layered grunge type, and decayed images dominate the interface, while text takes a back seat to the design. This can be observed best in the Final Print area (a gallery of design inspired by music, the area formerly titled the Sound of Print) and in the Versus Project where two or more designers take turns remixing one work repeatedly, attempting to finish within a set time limit.

Other areas showcase the two designers' experiments using Macromedia Flash, bizarre type treatments, a collection of dingbat font characters from designers around the globe, and Final Type, a display of typefaces designed by David and Patel.

Perhaps the most interesting aspect of the site is the straightforward navigation used to explore each area. In contrast to the hyper-illustrated backgrounds, and radical experimentation in most sections, the designers implemented a simple, text-based navigation bar across the bottom of most main screens. This allows visitors to focus less on navigation and more on the content of the site.

Project: **Final.nu**
Client: **Self**
All Design: **Jay David, Harsh Patel**
Authoring Program: **Macromedia Flash**
URL: **http://www.final.nu**

94

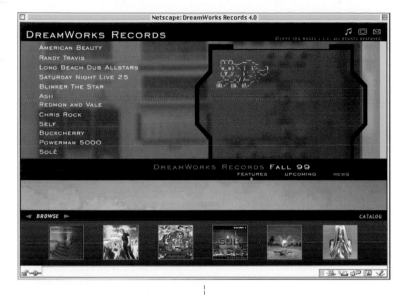

MUSIC PROMOTION

The DreamWorks Records Website, designed by Second Story Interactive, is a successful attempt to revitalize the lost experience of browsing through album racks at a record store—getting a feel for the music featured on a vinyl record inside a 12-inch square cardboard sleeve. Before compact discs, consumers could experience the art, design, and information printed on the album cover. Now, the smaller disc packaging is diminutive and lacking in comparison as far as art and text-based information.

To bring back the browsing experience, Second Story designers implemented full-screen visuals, animation, and text, as well as music that plays when the user clicks on an album. To make all of this happen seamlessly, the designers programmed the site to detect each visitor's browser type, available plug-ins, and monitor resolution before the user begins surfing the Website.

The DreamWorks site rewards customers' curiosity about the music they're looking for by offering dynamic and interactive experiences that include motion graphics, animation, and interaction within each album.

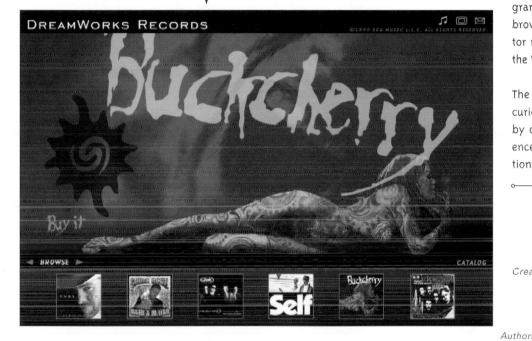

Project:	DreamWorks Records Promotion
Client:	DreamWorks Records
Design Firm:	Second Story Interactive Design
Design:	Julie Beeler, Sam Ward
Creative Director:	Brad Johnson
Production:	Julie Beeler
Programming:	Kim Markegard, Ken Mitsumoto
All Credits:	(see p. 159 for full credits)
Authoring Programs:	Macromedia Flash
URL:	http://www.dreamworksrecords.com

GAME PROMOTION

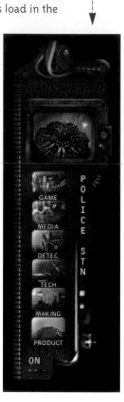

The Blade Runner Game promotional Website, developed by Click Active Media, was created as a means for client Westwood Studios to promote the sale of its *Blade Runner* real-time 3-D PC adventure game. This game follows in the footsteps of the cult-classic sci-fi movie, *Blade Runner*, which was in turn developed from author Philip K. Dick's novel, *Do Androids Dream of Electric Sheep*. Both the book and movie have made solid imprints in the history of science fiction, so the artistic and literary standards of the previous media was important in designing the game and the Website.

Since the game—which closely resembles the dark and foreboding world of the movie—had already been developed, Click Active Media drew upon it when developing the Website. The look and feel of the site is established when viewers first enter. Mysterious music similar to the score from the motion picture begins to play, and futuristic imagery of cityscapes load in the background.

A creative element that adds to the experience of entering a futuristic world is the navigation control bar (right), which resembles the controls of a blade runner police vehicle. This control bar loads in a frame along the left side of the screen and is the main navigational icon set for the Website. Various areas of the game can accessed through this control bar, such as animations, stills, character and game play information. These subsections are composed of animated GIFs and scrolling visual montages that contain beautifully rendered imagery from the game.

Click Active Media created a Website that evokes the dark and brooding world of Los Angeles in the year 2019, and also carries the visual and emotional impact of the 3-D adventure game, book, and motion picture.

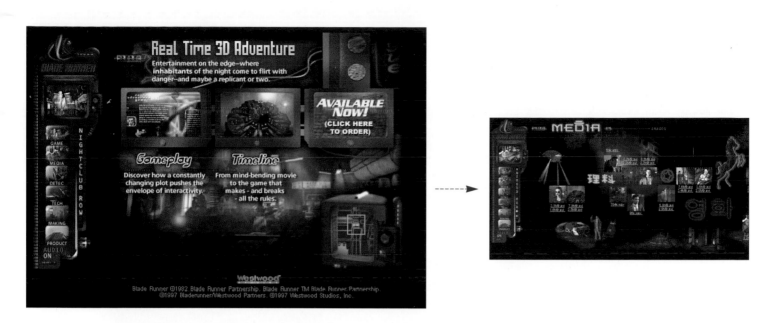

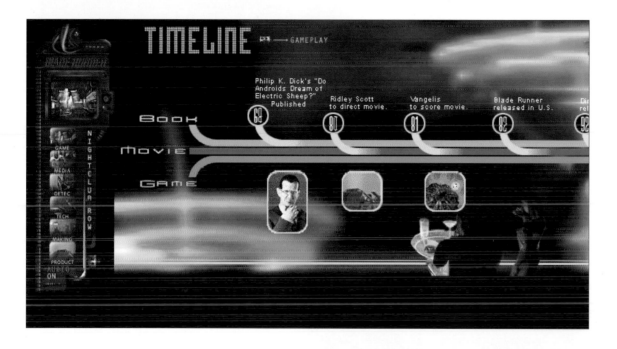

Project:	Blade Runner Game Promotion
Client:	Westwood Studios
Design Firm:	Click Active Media
Creative Director	Claire Krong
Design:	Jennifer Kattler Trilling, Sven Krong, Rhon Manlapaz
Programming:	Sven Krong, Rhon Manlapaz
Copywriter	Deborah Bishop
Project Manager	Cheryl Bennet
Authoring Program:	Macromedia Director
URL:	http://www.bladerunner.net

ONLINE PRESENTATION

The Process is an interactive Web-based presentation that gives viewers an overview of Juxt Interactive's design philosophy "that all projects are designed using unique solutions focused on achieving a client's goals and objectives, while reaching the target audience in an effective and memorable way" This online presentation follows that philosophy, and invites viewers to explore the question of "Who controls the Creative Process?" Using Macromedia's Flash technology and JavaScript programming, Juxt created a thought-provoking and exciting look at the the way these two technologies can be implemented to produce a memorable interactive experience.

Using sliding graphics and animated typography to direct the viewer's attention toward different areas of the screen, the designers have found that they can treat textual and visual information equally within a "Process" where the user and the creator have control over where they go and what they choose to see.

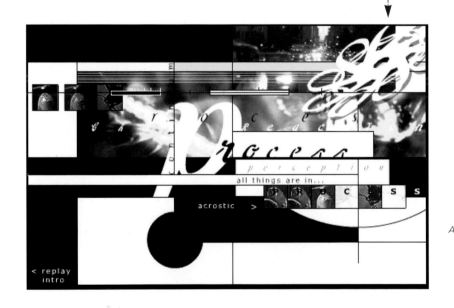

Project:	**The Process**
Client:	**Self**
Design Firm:	**Juxt Interactive**
Design:	**Todd Purgason**
Programming:	**Shaun Hervey, Brian Drake**
Photography:	**Photodisc Stock Photo**
Authoring Program:	**Macromedia Flash, JavaScript**
URL:	**http://www.juxtinteractive.com/theprocess**

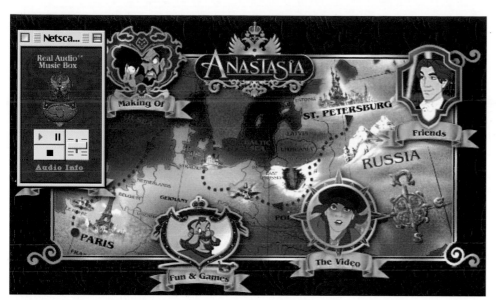

VIDEO PROMOTION

Click Active Media designed the *Anastasia* video Website—based on the animated feature film of the same name—to promote the sales of the Fox Home Video release. This advertising site is an excellent example of a company using the internet to promote a specific product, without the main purpose of the site—sales—being thrown in the consumer's face.

Working with characters and artwork from the film, Click Active Media was able to design a creative, enjoyable interactive experience for both children and adults. The site offers visitors many different areas to discover, such as the Making of the Film, or the Fun & Games area, where users create a digital diary, send postcards, or create a crown.

To add a dynamic element to the site, the designers use two horizontal frames. The smaller frame at top is where animation takes place, and the larger frame is where the main content of the site changes.

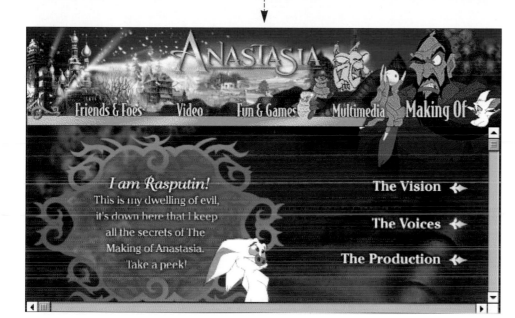

Project:	**Anastasia** Video Promotion
Client:	**Fox Home Video**
Design Firm:	**Click Active Media**
Creative Director:	**Claire Krong**
Design:	**Christina Cardoso**
Programming:	**Rhon Manlapae, Sven Krong**
Technologist:	**Chuck Ivy**
Programs:	**Macromedia Flash, Video**
URL:	**http://www.anastasiavideo.com**

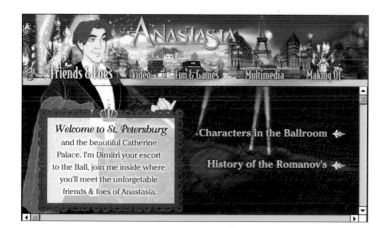

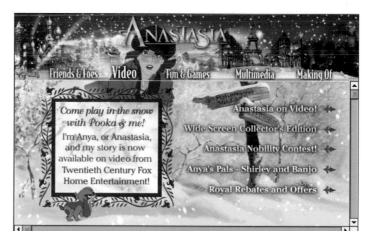

ONLINE PORTFOLIO

The designers at Pantapoiein Multimedia, a new media design firm located in Portugal, lavished many hours of design and production into the creation of their online portfolio. The site opens with a splash page that allows visitors to choose from either an English or Portuguese language version of the site, and then transitions to a Flash intro animation. These two elements alone would add numerous hours to the production, but then add in the fact that every screen within the interface implements a Flash-based navigation, and each main screen features a completely unique design from the previous one—and the result is a major undertaking. This is a portfolio that offers many exciting avenues of exploration and discovery.

Certain dynamic elements within the portfolio stand out among others, such as the contents screen (right) where blueprint-like grids pop in and then fade away slowly as the cursor passes over each of the main navigation links. Another is the display of an award-winning 3-D design shown at Micrograf's Imagine 98 conference (across spread). Though the 3-D animation is displayed as flat, static frames, the designers used Flash to allow viewers to scroll through the design.

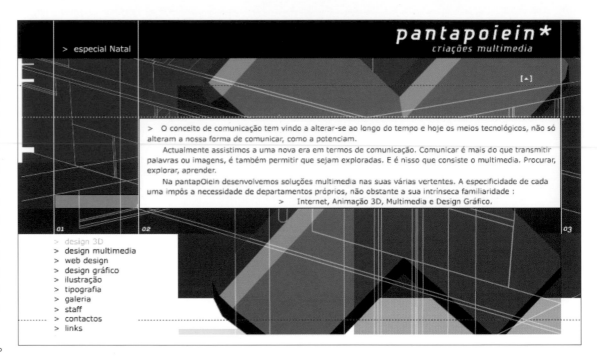

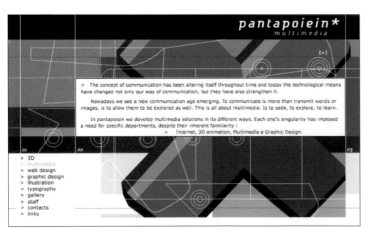

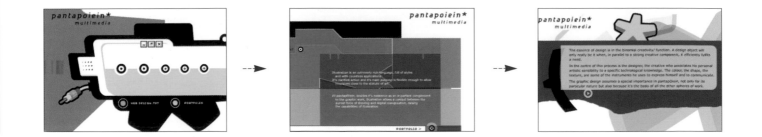

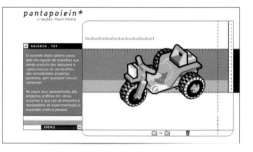

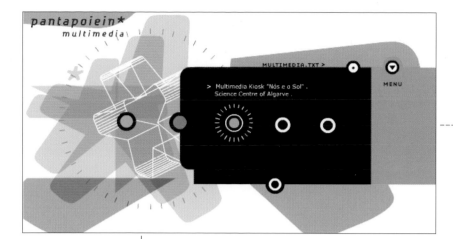

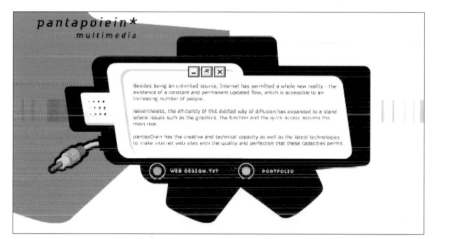

Project:	Design Portfolio
Client:	Self
Design Firm:	Pantapoioin Multimedia
Design:	Nuno Costa, Jorge Olino
Programming:	Nuno Costa
Illustration:	Jorge Olino
Copywriting:	Nelson Martins
Translation:	Catarina Jâcome
Authoring Programs:	Macromedia Director/Flash
URL:	http://www.pantapoiein.com

MUSIC WEBZINE

The Skinny, a Webzine designed and produced by Ketch22 Design, provides news and information on music, fashion, technology, extreme sports, and the arts. The site is updated weekly and is geared for a new generation of readers who seek their information online.

Scott Ketchum, lead designer of *The Skinny*, believes "fresh," "thought-provoking," and "progressive" are adjectives that can and should describe both content and design.

The Skinny features a contemporary design style that blends layered typography, avant-garde imagery and manipulated photography to create slick photo-collaged layouts for each of the main feature articles. This design technique generates a hip and impulsive, MTV-like feel as viewers browse through the site. To keep download times to a minimum Ketchum stays away from using too much animation and audio, and uses flat art within frames for the large features. This allows easy access to the drop-down menu "Quick Access" navigation located in the top frames.

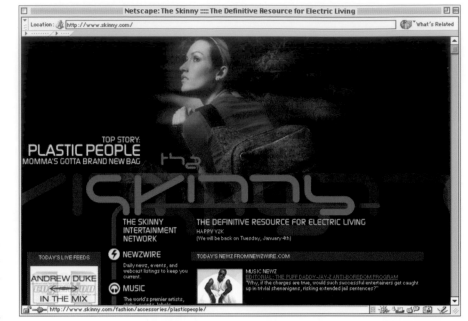

Project:	The Skinny
Client:	The Skinny Intertainment Network
Design Firm:	Ketch 22
Design:	Scott Ketchum
Programming:	Scott Ketchum
Production:	Scott Wamsley
Editor:	Darren Keast
Arts Editor:	RJ Hawkins
Authoring Program:	Macromedia Flash, BBedit
URL:	http://www.skinny.com

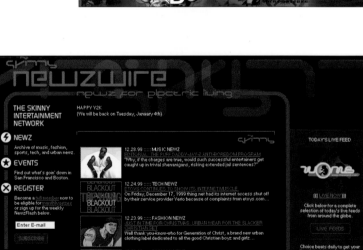

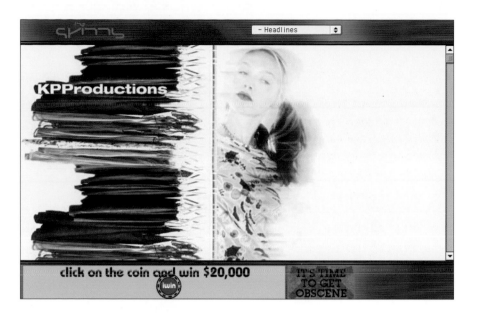

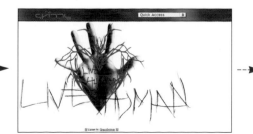

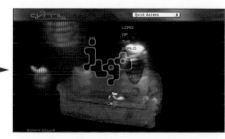

WEBSITE

IN YOUR FACE TOO!

PROMOTION

Saul Bass on the Web is the personal project of Brendan Dawes, owner of the U.K.-based multimedia design firm Subnet. The late Saul Bass was a renowned print and film-title designer whose work for such projects as *Psycho* and *Man with the Golden Arm* made him a legendary figure in the design community. It was Dawes' admiration of Bass' work that led him to create this Website.

Dawes wanted to produce the ultimate Website about the life and work of Saul Bass. Toward this end he incorporated the look and feel of Bass's graphics and title sequences, and built interfaces that are inspired by some of Bass's more famous film titles such as *North by Northwest* and *Anatomy of a Murder*. At the same time Dawes wanted to showcase his own talents at utilizing new technologies and tools for Web design, such as Macromedia Flash. Noticing that many of Bass' title designs were Flash-like in their movement, Dawes decided to use Flash technology throughout the various sections of the Website, using animated titles, sliding graphics, and interactive rollovers on each screen.

Other dynamic elements within the site are RealVideo and QuickTime video sequences, Java-Script for launching pop-up windows to showcase the video, and Flash animation and interactivity. By using Flash for the navigation of the site, Dawes left slow-loading Web pages behind and created an interface that resembles a CD-ROM experience more than a Website.

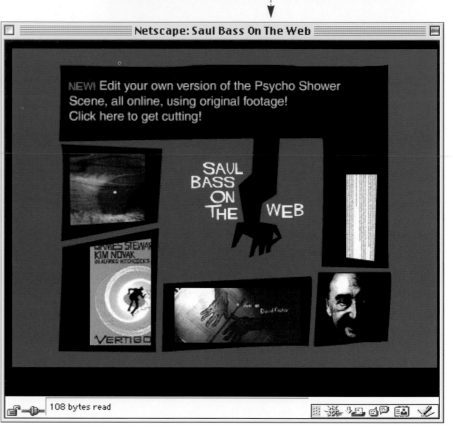

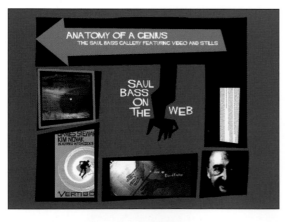

Project:	**Saul Bass on the Web**
Client:	**Self**
Design Firm:	**Subnet**
All Design:	**Brendan Dawes, Rhon Manlapaz**
Authoring Program:	**Macromedia Flash**
URL:	**http://www.saulbass.co.uk**

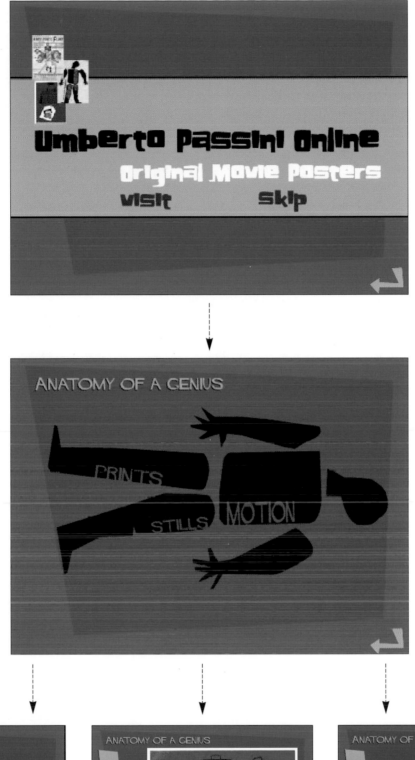

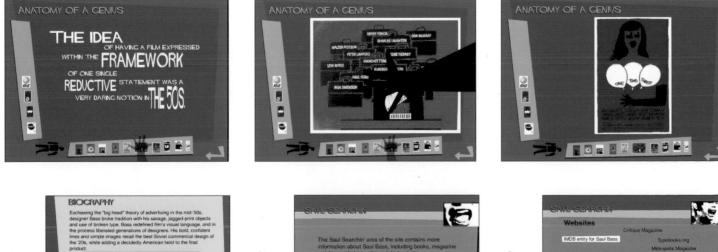

PROMOTION

The design of the LundstromARCH (Lundstrom and Associates) Website presented a challenge for the new media design firm, Juxt Interactive. The architecture firm had decided to move into the field of education technology and wanted a presence that would convey this immediately to potential clients visiting the Website. The main challenge was to convey Lundstrom's technological capabilities to university architects, a market segment that expects unusually high design standards.

Juxt approached this challenge by defining the two main messages Lundstrom wanted conveyed through the site. The first was to communicate through copy that no matter what the project, Lundstrom is always concerned with listening to the needs of their clients. Juxt accomplished this using highlighted text and prominent color blocks to showcase statements from the company's credo. The second, and more important item, was to present Lundstrom as a technologically savvy company. It was important to create a "smart Website" that would be emblematic of the "smart classrooms" Lundstrom was interested in developing.

To showcase the technology of the site, the designers implemented 3-D animation, QuickTime VR in pop-up windows, and Flash to create animated text and sliding boxes that present the content in a dynamic interface. Another element that adds to the uniqueness of the site is a vertical nav-bar that slides down from the top of the screen on the right-hand side. Unlike most Websites that usually place navigation on the left of the user's screen, this departure from the norm helps set the site apart from others.

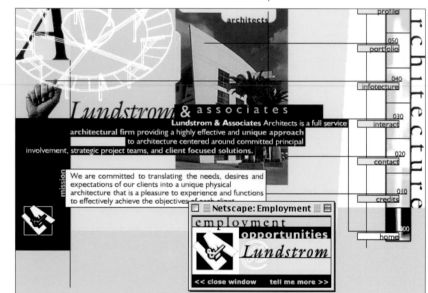

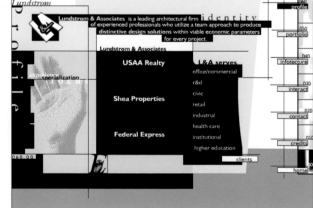

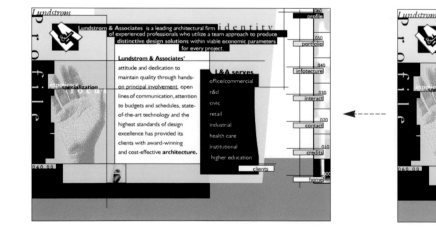

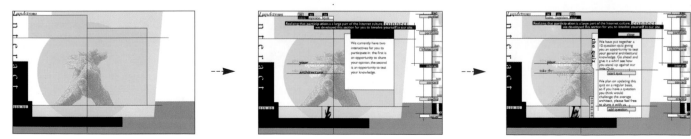

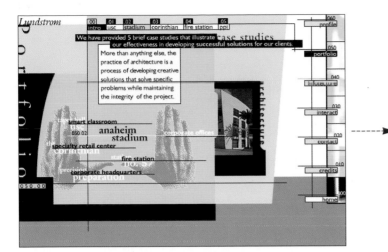

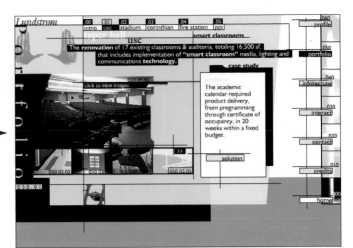

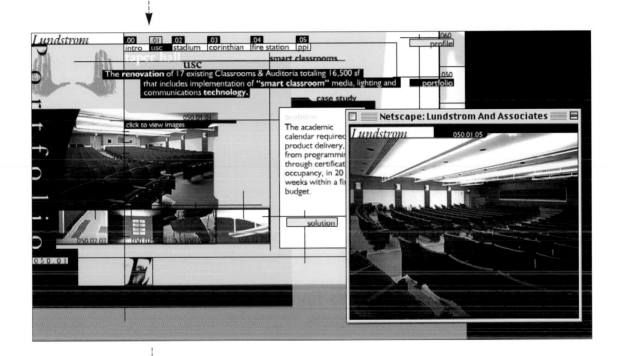

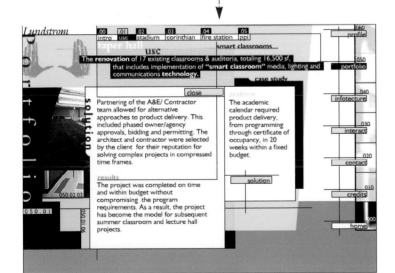

Project: | LundstromARCH
Client: | Lundstrom and Associates
Design Firm: | Juxt Interactive
Design: | Todd Purgason
Programming: | Shaun Hervey
Photography: | Larry Falkie
Authoring Program: | Macromedia Flash, NetObjects Cold Fusion
URL: | http://www.Lundstromarch.com

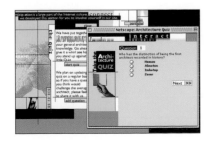

ONLINE PROMOTION

The WebSpective site, produced by Black Bean Studios, was designed as part of a new corporate identity package for the server software company formerly known as Atreve Software Inc.

The site comes divided into two distinct sections—products and services—each of which is distinguishable by a rich vibrant color palette of deep blues and purples. All text content for each page appears inside of a large white oval (right), which expands vertically depending upon the amount of text for that page. Subsection navigation is included at the bottom of each scrolling page, so site visitors can quickly jump to the desired section.

A highlight of the site is a popup window (right) that provides a tour of WebSpective's services. This floating window maintains the continuity of the site through color scheme, and creative use of ovals and curves to display each screen's content.

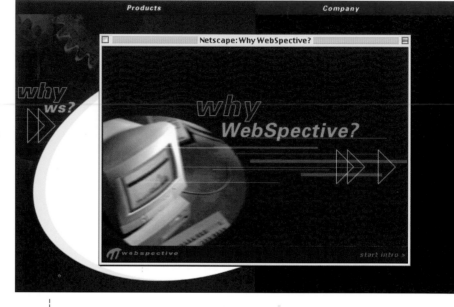

Project: **Webspective Promotion**

Client: **WebSpective Software Inc.**

Design Firm: **Black Bean Studios**

Design: **Alisha Vera, Jodi Vautrin**

Programming: **Hugh McDonald, Jason Giaccone**

Producer: **Judy Wong**

Authoring Program: **JavaScript**

URL: **http://dev1.blackbean.com/webspective**

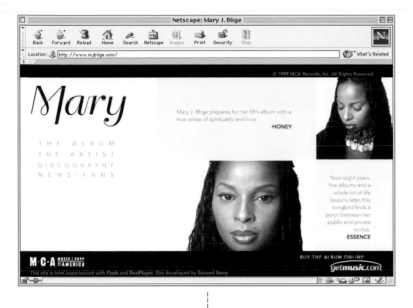

MUSIC PROMOTION

To promote Mary J. Blige's most recent album, Second Story Interactive created a promotional Website that reflects Blige's beauty and elegance, and also gives viewers an in-depth look at the singer and her music.

The site opens with a motion graphics-like animation—produced with Macromedia Flash—that consists of slowly moving and dissolving imagery of the artist, which then transitions to the contents screen (right). The side navigation (below left) again uses the technique of smooth Flash transitions by gracefully expanding when the mouse is near any of the four section titles. Each main title slides apart to reveal subsections, and smoothly collapses when the mouse is moved off the title text.

Other features of this Flash-driven site include news, tour dates, photos, fan club info, and bulletin boards, as well as a selection of RealAudio music from the discography section.

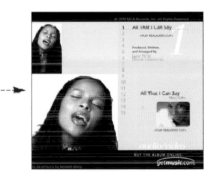

What's up Everybody!

I'm very excited about the launch of my new web site. I hope you all find it informative, fun, exciting, entertaining and interesting. We worked hard to create something unique and special for you to keep you coming back for more.

For my friends and fans, who want to stay in touch with the real Mary, and keep updated with my busy career as my new album project "Mary" develops and unfolds, just visit my new site. This is the place to get all the information you need about my music, touring schedule, history, old & new videos, fan club information, interviews, photos, bios, chats and more. There will also be some interesting things from my career I will share with you, that you've never seen or heard before and will never see or hear anywhere else!

Share my world and discover Mary!
Peace & Blessings

Project:	Mary J. Blige Promotion
Client:	MCA Records
Design Firm:	Second Story Interactive
Creative Director	Brad Johnson
Design:	Julie Beeler, Sam Ward
Programming:	Julie Beeler
Production	Julie Beeler
Authoring Program:	Macromedia Flash, RealMedia
URL:	http://www.mjblige.com

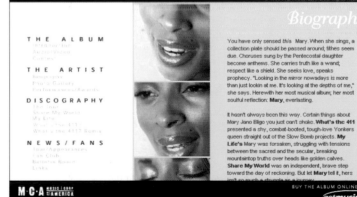

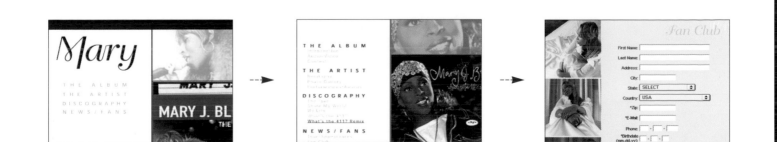

ONLINE PORTFOLIO

Goblin Design is a graphics and new media design firm located in Lenzkirch, Germany. In creating this new and updated version of his site, firm owner Silas Toball wanted a design that would showcase his skills at blending the high-tech medium of Web design with his more traditional fantasy art drawings. To accomplish this, Toball scanned an image of an aged book and designed an interface around it that is a combination of art nouveau, Celtic design, and more modern influences such as 3-D—rendered typography and polished metal.

To maintain the continuity of the site, Toball features the majority of his work on the faded yellow pages of the book. Other work, such as CD cover art, is shown in frames bordered by Celtic-like designs that also continue the look and design of the interface.

Frames technology is used to update content on the larger, right side of the book, while the book-like "Contents" navigation listing stays in the left frame at all times. This saves on download times, and also makes it easier for users to access the site's content.

Project: | **Design Portfolio**
Client: | **Self**
All Design: | **Silas Toball**
URL: | **http://www.goblindesign.com**

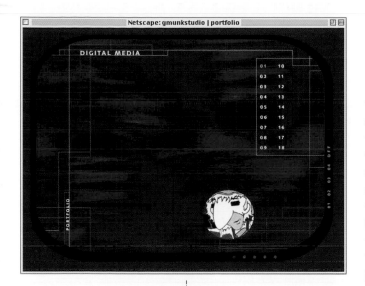

ONLINE PORTFOLIO

Visitors entering the Gmunkstudio online portfolio are asked to choose either a low-, medium-, or high-bandwidth site (shown). Choosing one of these three options opens the site to a browser window that will allow users to navigate through the studio's content. The differences in the low and medium versions are not small, with the main changes being the exchange of a 45K Macromedia Flash animation for a 200K animation, and text-based titles as compared to image thumbnails for each portfolio piece respectively. But the jump from a 45k or 200k Flash animation to a 440k download for the high-bandwidth site takes the interface for navigation to another level. Those users who have the time, connection, and patience to wait for the high-end site will be rewarded with an even more dynamic Flash interface, that includes different background images for each main screen, viewable thumbnail images of projects before clicking to the full project, and a more intuitive and less crowded interface for navigating the site.

Whether users choose to enter a low-, medium- or high-bandwidth site, they still gain access to Gmunkstudio's large selection of portfolio pieces—over one hundred in all. To view the various pieces within the portfolio, the designer implemented pop-up windows for each individual piece. This element allows the user to view many different projects, including illustration, animation, and photography, while waiting for larger files, such as QuickTime videos, to finish loading.

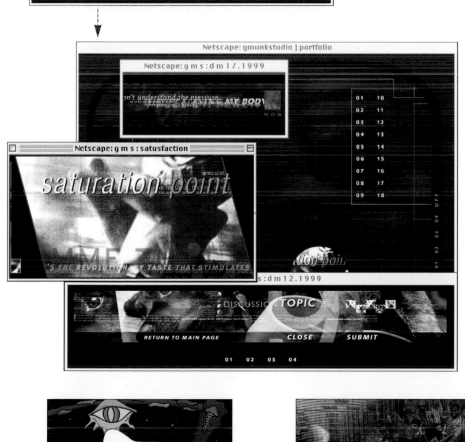

Project:	Design Portfolio
Client:	Self
Design Firm:	Gmunkstudio
Design:	Bradley Grosh
Authoring Programs:	Macromedia Flash
URL:	http://www.gmunk.com

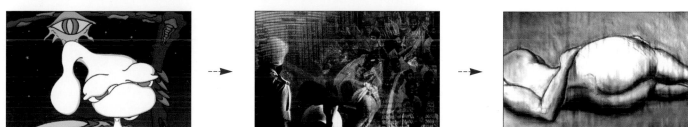

SOFTWARE PROMOTION

Discovertoys is a fictitious e-commerce toy site developed by 415 Productions for Macromedia, maker of some of the top multimedia tools being used by new media designers, including Director, Flash, Shockwave, and Generator. Having worked with 415 Productions on previous projects, Macromedia asked the design firm to build a site that would show a Web-savvy audience just what Macromedia development tools could do. To promote Macromedia's software in an original project, 415 Productions developed the site without following any preexisting concept or design. From the corporate branding to the design of the toys, each element of the online presence is built around an original concept.

A bright and playful color scheme of yellows and oranges sets the tone of the site, and the designer's sense of humor can be seen in many of the design elements—such as a collection of fantastic toys, including a Home Cloning Kit, Mr. Mutato Head, and a Cold Fusion Kit.

The designers at 415 Productions carefully built their virtual toystore from the ground up. Users can browse virtual aisles, search for toys using a special drag-and-drop feature, and add any of the creative 3-D toys to a wish list that can be e-mailed to a friend.

Perhaps the most exciting area is the Playroom, where users can design their own racecar (facing page bottom). Using Macromedia Generator, users can dynamically create their own racecar on the fly and then race it on a track they also build.

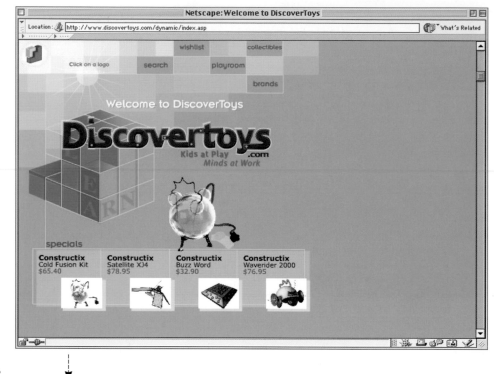

Project:	Discovertoys Fictitious Toy Site
Client:	Macromedia
Design Firm:	415 Productions
Creative Director:	Jeff Southland
Art Director:	Eun-Ha Pack
Programming:	Chris Xiques, Julie Colhoun
Illustration:	Dug Stanat, Karl Ackermann, Christoph Klotz, Ruport Adley
Executive Producer:	Ulla Hald
Sound Designer:	Andy Cowitt
Toy Design:	Steven Russell, Benny Rasmussen
Logo Designer:	Esther Baek
Integrator:	Mimi Ozawa
Copywriter:	Lane Foard
Authoring Program:	Macromedia Flash 3 & 4
URL:	http://www.discovertoys.com

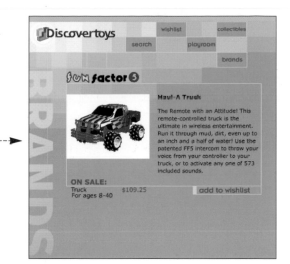

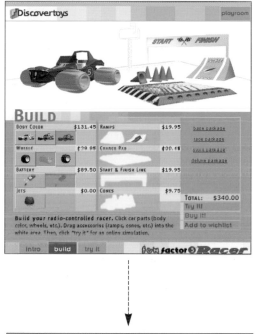

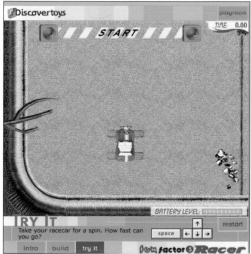

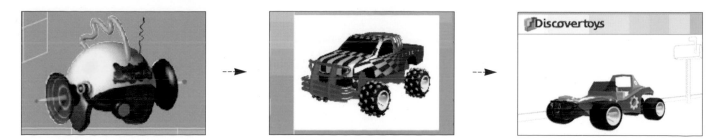

ONLINE PROMOTION

The Sony Europe Websites, created by German design firm I-D Media, feature several products from Sony Europe. The splash image at right introduces "Sonya," a virtual spokesperson/avatar for Sony Europe. I-D media refers to her as a "digital ambassador" of the cyberspace world.

In creating this site, I-D Media implemented Macromedia Flash 3 technology for the main navigational interface, but it also created a parallel, HTML-only version.

To promote the VAIO PC note-book computer, I-D's designers used Flash-animated, saucer-like television screens (right) which spin into place, and then slide forward and dock when viewers roll a cursor over a specific saucer. Each saucer links to a separate area of Sony's digital products, and explains how the different elements can work together.

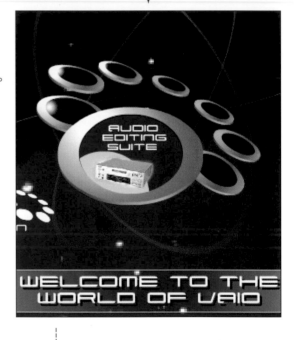

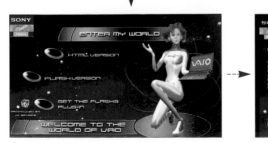

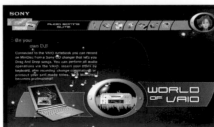

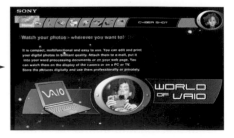

· DRC-PC100 · DCR-TRV10
· DRC-PC3 · DCR-TRV890/900

MS Benefits
Compatible Products

Laptop / Camcorder

The Memorystick can transform your Camcorder into a digital camera. Just save your best shots on DV-tape as jpegs, upload them to your Memorystick, and then download them to your VAIO laptop. Now you can send them to friends and family via Email, edit them or organize a photo album.

I-D Media also utilized Flash 3 in the Sony Memory Stick Website to create the dynamic navigation bar (above). This navigation tool offers users the ability to view all of the Memory Stick-compatible appliances, products, and capabilities at a glance. Two product bars scroll left or right with two items available at any given position. When two matching items are selected in the center, the images come forward, increasing in size, and a text block explaining the compatibility appears in the lower right area of the screen.

The Sony digital8 site (below) also uses Flash 3 to showcase various elements of the products. A scrolling, transparent navigation bar features rollover links that refresh the main viewing area with new content.

Project:	Sony Europe Promotions: VAIO, Memory Stick, Digital8
Client:	Sony Europe
Design Firm:	I-D Media
Design:	Kathy Mckechnie
All Credits:	(See p. 159 for full credits)
Authoring Program:	Photoshop, Flash 3, Lightwave, Maya, Homesite
URL:	http://www.sony-europe.com

ONLINE PORTFOLIO

52mm's promotional Website features a Macromedia Flash intro page (top right) that transitions to the main contents page, where past and current client projects are featured. To keep downloads as quick as possible, the designers only used Flash on the intro page and kept to the more traditional HTML and JavaScript programming for subsequent pages. The company also features an experimental area within its site where photography, writing, and illustration from each of the designers can be viewed.

The designers wanted their own site to exemplify the "non-computer-based" approach they attempt to use for client sites, implementing the styles and techniques that make their Web designs seem tactile and cinematic, rather than letting the technology of Web design dictate the final outcome of their designs.

The result is a pleasing blend of high-tech computer graphics and the low-tech feel of print-like, multilayered imagery and typography.

Project:	Design Portfolio
Client:	Self
Design Firm:	52mm
All Design:	John J. Hill, Marilyn Devedjiev
Authoring Program:	Flash, JavaScript, QuickTime
URL:	http://www.52mm.com

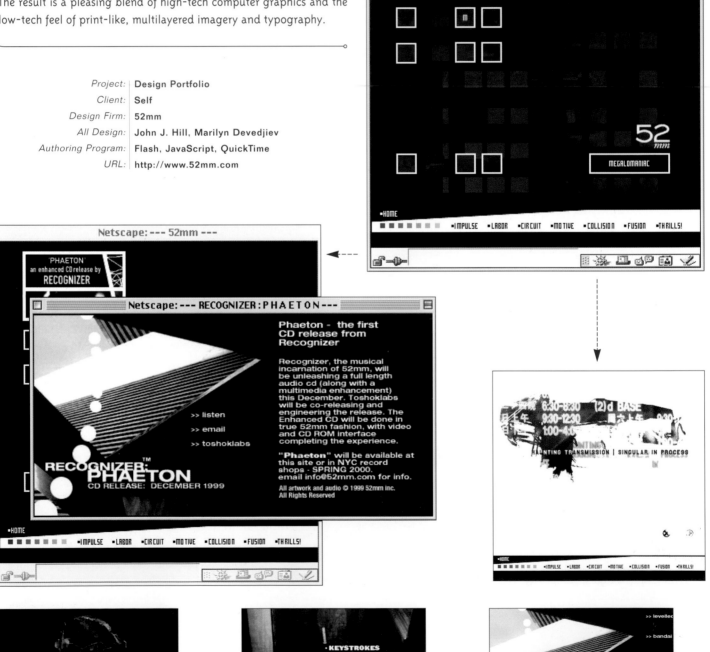

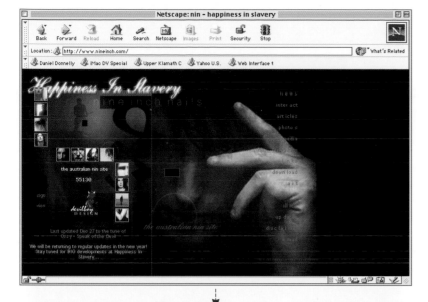

MUSIC PROMOTION

Happiness in Slavery is the title of this e-zine produced by Australian Web developer John Raptis for Trent Reznor's Nine Inch Nails. The site features news, articles, and biographical information about NIN, as well as photos, downloadable screensavers for Windows PC computers, and an online store for purchasing official Nine Inch Nails merchandise.

The interface features a contemporary design of layered typography combined with beautifully rendered photo-collages of band members and other music-related imagery.

The dark, brooding quality of the main images sets the tone of the site by creating an atmosphere of mystery. The navigation bar of small icon images taken from albums, and close-up photos of the musicians adds to the "MTV-like" feel of the Website.

One effective element that designer and artist Raptis incorporated into the site is the Gallery section, a collection of sophisticated photographic work that showcases NIN and also hints at the extent of Raptis' artistic abilities.

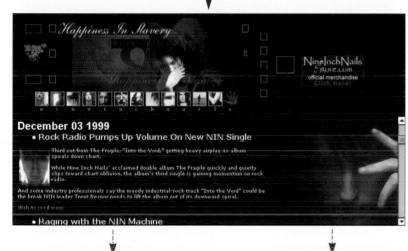

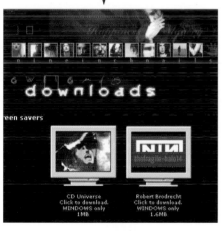

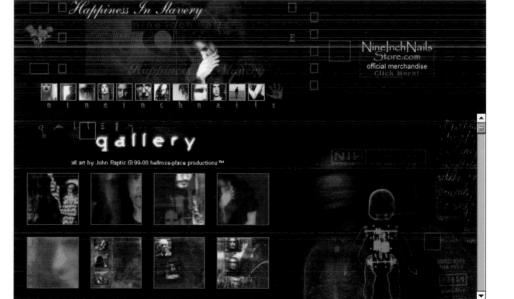

Project:	*Happiness in Slavery*
Client:	Nine Inch Nails
All Design:	John Raptis
Authoring Programs:	Dreamweaver, Photoshop, Sound Forge, Ulead GIF Animator
URL:	http://www.nineinch.com

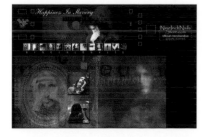

ONLINE PORTFOLIO

Hollis Design had several objectives in mind when creating its online portfolio: The first was to demonstrate to potential clients Hollis's grasp of new media technologies and showcase its competency in implementing them; the second was to create an interface that could easily be navigated and that would also reflect the firm's clean design style; and the third was to create a site that could be used as an online media kit and portfolio preview.

Each of these objectives was obtained by creating this functional and dynamic Flash-generated Website. Using Macromedia FreeHand, the designers created a clean and colorful interface that allows users to access information about their company and clients.

The main navigation is based on a metaphor of the periodic table of elements (top right) where elements such as "Au" and "Lb" stand for "About Us" and "Lab" respectively. Clicking on any of these "element" icons transports the viewer to another area of the site, using sliding graphics and animated text created with Flash technology.

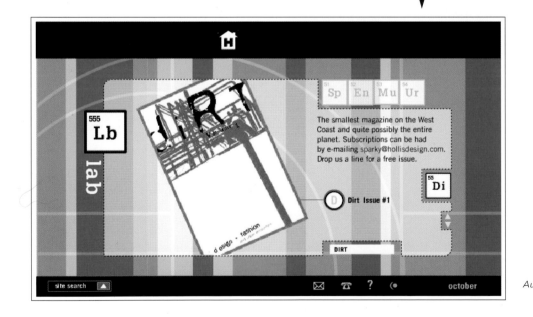

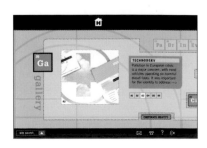

Project:	**Design Portfolio**
Client:	**Self**
Design Firm:	**Hollis Design**
Design:	**Dan Hollis, Heidi Sullivan**
Illustration:	**Dan Hollis, John Hofstetter**
Programming:	**John Dennis**
Photography:	**Craig Tomkinson**
Authoring Program:	**Macromedia Flash/FreeHand**
URL:	**http://www.hollisdesign.com**

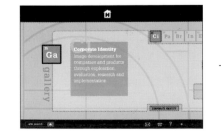 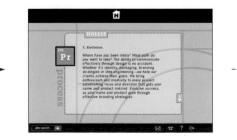

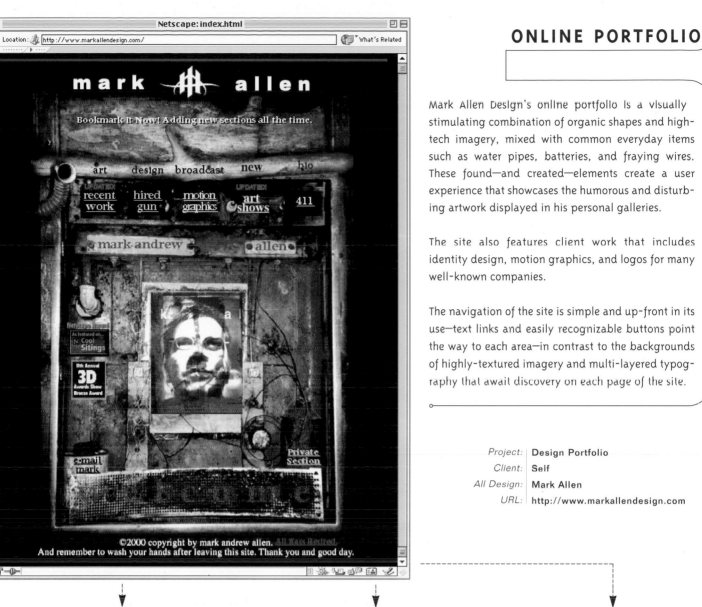

ONLINE PORTFOLIO

Mark Allen Design's online portfolio is a visually stimulating combination of organic shapes and high-tech imagery, mixed with common everyday items such as water pipes, batteries, and fraying wires. These found—and created—elements create a user experience that showcases the humorous and disturbing artwork displayed in his personal galleries.

The site also features client work that includes identity design, motion graphics, and logos for many well-known companies.

The navigation of the site is simple and up-front in its use—text links and easily recognizable buttons point the way to each area—in contrast to the backgrounds of highly-textured imagery and multi-layered typography that await discovery on each page of the site.

Project:	Design Portfolio
Client:	Self
All Design:	Mark Allen
URL:	http://www.markallendesign.com

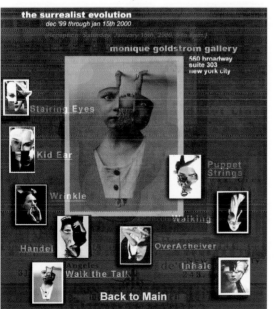

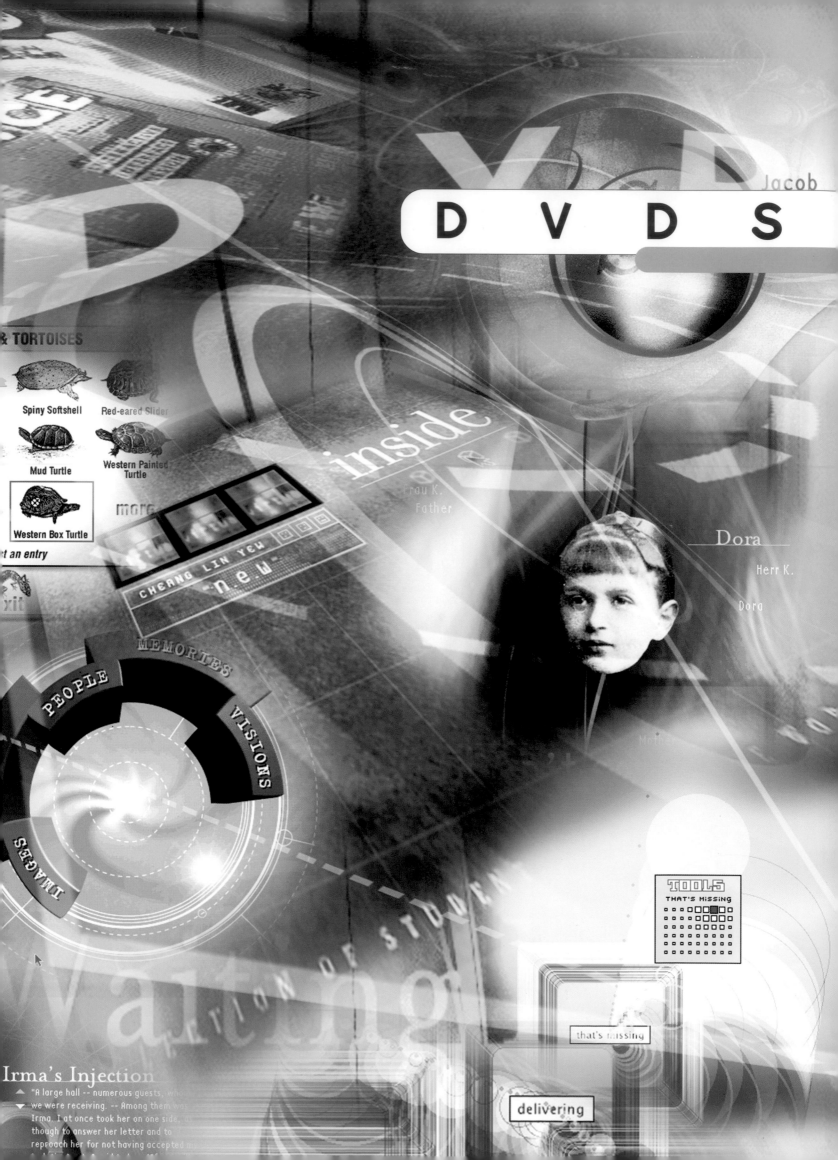

2

dvds

Pick-up Lines Small Talk

Old Boyfriends

Choose

BLADE

THE MOVIE

BLADE

RE

THE MOVIE

OPENED

OU ARE NOT THE ONE

MOTION PICTURE

The *Blade* DVD was designed and produced for New Line Cinema/Home Video by Angry Monkey, a San Francisco, California-based multimedia design firm.

The *Blade* motion picture focuses on a "Daywalker" vampire—actor Wesley Snipes—who can survive in daylight or darkness. To maintain the dark mood of the film on the DVD, the designers placed the opening sequence of the television set-top DVD interface in a dungeon-like background (series right), and continued the effect by using a black background with touches of blood-red color throughout the PC DVD interface.

The set-top navigation features a horizontally scrolling three-part interface (right) consisting of three distinct photo-montages of stills captured from the film. To navigate, the viewer clicks on one of the three main links—"Special Features," "Scenes," or "Languages"—and watches as the image automatically scrolls to the chosen area of the scene. The user can then choose from a number of special sections, such as "Cast and Crew," "Theatrical Trailer," or "Origins of *Blade*."

The PC DVD interface offers computer users access to the full film and its set-top interface, as well as a more in-depth look at the Blade comic book series, the film's screenplay, a vampire bible, and a Macromedia Flash *Blade* novel.

Project:	*Blade*
Client:	New Line Cinema/Home Video
Design Firm:	Angry Monkey
Design:	Ben Olander, Jean-Paul Leonard, Tomas Apodaca, Nicole Weedon, Sean Brennan, Jennifer Martinez
Producer:	Kim Lenox
Graphics/Audio:	Rand Waetherwax, eMotion Studios: Paul Lundahl, Dave Rauch
Authoring Program:	Macromedia Flash, Adobe After Effects
Platform Specs:	Set-top DVD player, PC DVD-ROM Drive

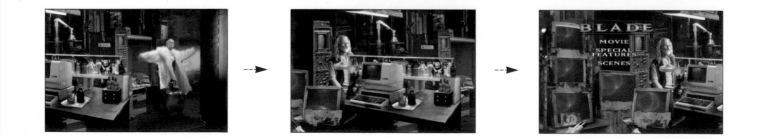

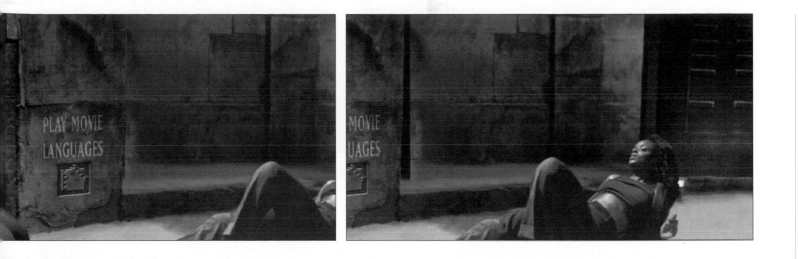

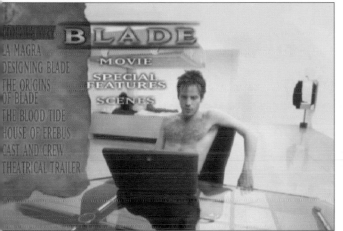

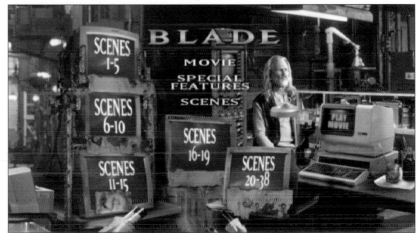

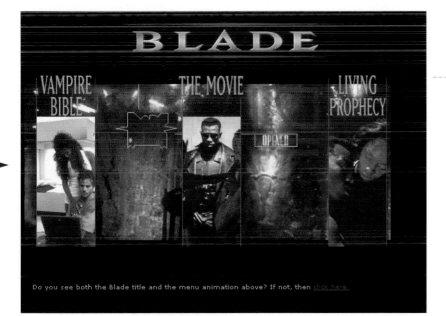

Do you see both the Blade title and the menu animation above? If not, then click here.

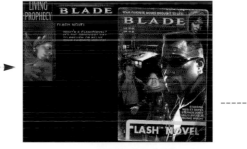

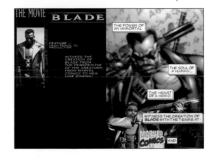

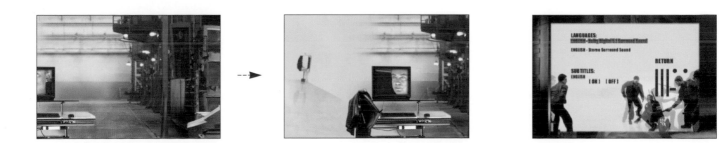

MOTION PICTURE

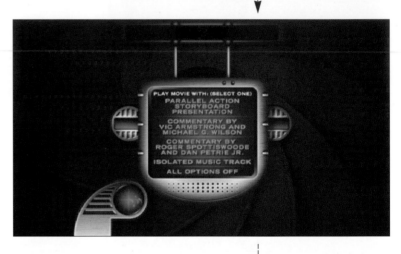

James Bond is a motion picture icon who has made a solid place for himself in the history of the super-spy movie genre. First played by Sean Connery, and later by George Lazenby, Roger Moore, and Timothy Dalton, and currently by Pierce Brosnan, James Bond, Agent 007 has become synonymous with the word "spy." MGM Entertainment first approached 1K Studios with the idea to have the firm design the Special Edition menu navigation for the *Tomorrow Never Dies* DVD (this page), and then decided to have the firm continue designing the full series of discs. The remaining interfaces shown are designs 1K Studios produced for the James Bond 007 Collection.

The *Tomorrow Never Dies* DVD features a futuristic, high-tech 3-D gadget that serves as the interface icon and transition element for the navigational menu bar. Because this James Bond film is a more recent release, this type of menu worked well, but the designers felt older films—such as *Thunderball* (facing page top) and *Live and Let Die* (facing page bottom)—would benefit from a navigation design with a slightly more organic feel, while adhering to the spy gadgetry-look that is so much a part of the Agent 007 atmosphere.

Each of the interfaces begins with a beautiful motion graphics animated opening combining layers of still imagery, 3-D— rendered elements, and video clips reminiscent of the era of the specific title. Along with these elements is a musical score and audio track that brings viewers into the world of James Bond long before they select the "Activate" button to enter the DVD.

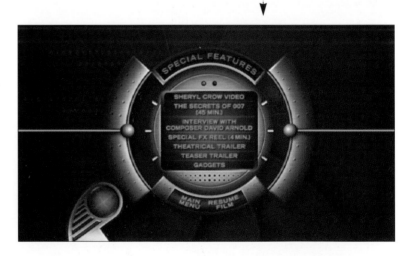

Project:	***James Bond 007 Collection Special Edition Boxed Set***	
Client:	**MGM Home Entertainment**	
Design Firm:	**1K Studios**	
Creative Direction:	**MGM Home Entertainment: Sharon Braun**	
	1K Studios: Matt Kennedy, Jayson Won	
Art Direction:	**Greg Sheldon, Nick DiNapoli**	
Production:	**Rylee-Ann Romero**	
Editorial/Compositing:	**Greg Sheldon, Marco Bacich,**	
	Nick DiNapoli, Jerry Steele	
3D Animation:	**Stan Brandenberger**	
Director of Photography:	**Jim Belkin**	
Sound Design:	**Terry Dwyre: Wild Woods Sound**	
Design:	**Ryan Won, Marilou Ang,**	
	Marta Ribeiro	
Production Coordinator:	**Russ McFarland**	
Authoring Program:	**Adobe After Effects, Alias	Wavefront Maya,**
	Quantel Harry	
Platform Specs:	**Set-top DVD**	

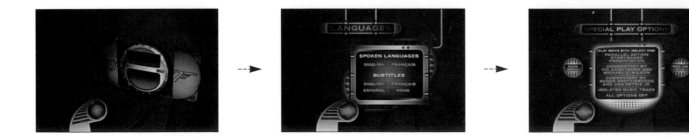

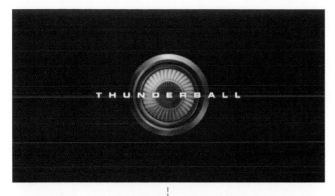

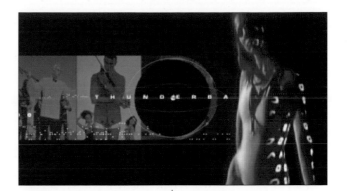

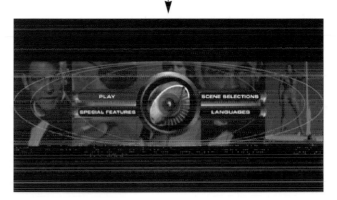

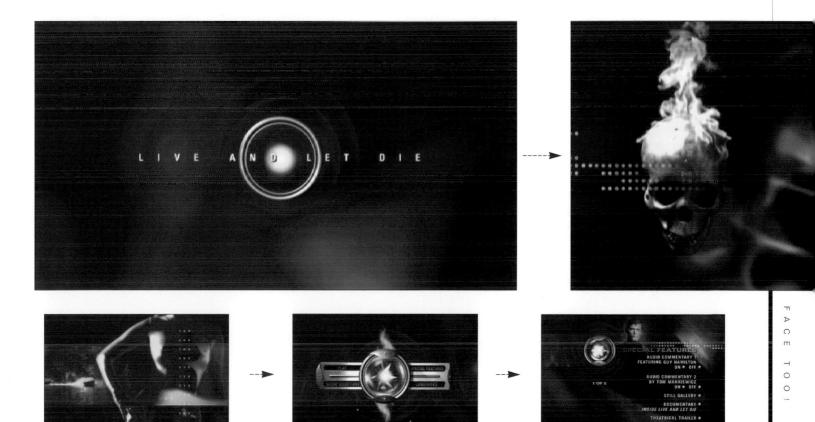

MOTION PICTURE

The James Bond DVDs featured on these pages include *For Your Eyes Only* (below), *GoldFinger* (bottom and small images), *Licence to Kill* (facing page top), and *Goldeneye* (facing page bottom). Each DVD in the series (including future releases) features a unique interface design with elements such as the circular "Activate" button, and moving, layered motion graphic openings, as well as the unmistakeable Bond opening credit choreography.

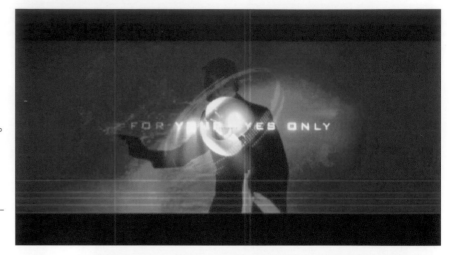

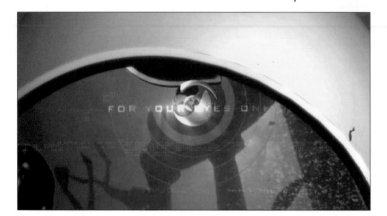

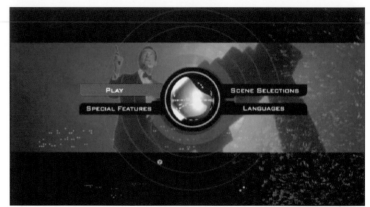

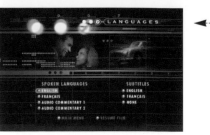

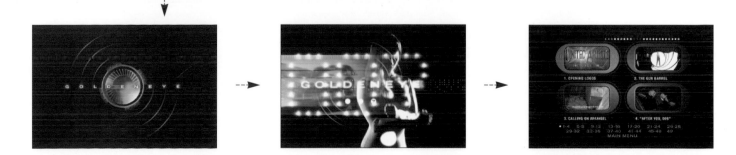

MOTION PICTURE

The Corruptor DVD was created for New Line Cinema/Home Video by Angry Monkey, a multimedia design firm located in San Francisco, California.

The Corruptor motion picture is a crime drama set in the Chinatown district of New York City. One of its main themes is that "You don't change Chinatown, it changes you." To portray this theme within the DVD the designers built an interface that leads the viewer through different areas of Chinatown using scenes from the film. The viewing experience begins with a contents screen that features an aerial view of the city (top). From this macro perspective, the viewer is taken to micro views of Chinatown's streets and building interiors using video clips as interface transitions.

To engage users and give them the full experience of traveling through the Chinatown of the film, the designers made links to specific areas out of cardboard boxes, storefront windows, taxicab doors, billboards, and the dark interior's of buildings. Viewers can also check out content such as a music video and the musical score to the film.

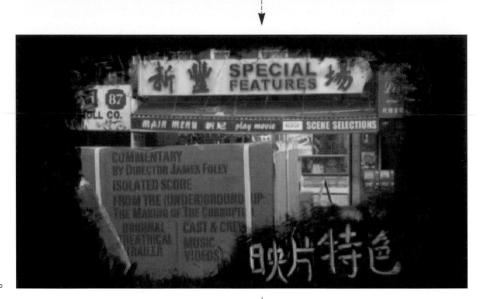

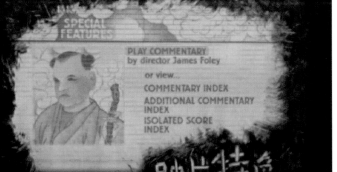

Project:	*The Corruptor*
Client:	New Line Cinema/Home Video
Design Firm:	Angry Monkey
Design & Illustration:	Jean-Paul Leonard, Kazandra Bonner
Producer:	Jeanne Reynolds
Photography:	David Brisbane, Jean-Paul Leonard, Kazandra Bonner
Motion Graphics:	Paul Lundahl, Dave Rauch: eMotion Studios
Audio Design:	Michael Becker: eMotion Studios
Authoring Program:	Adobe After Effects
Platform Specs:	Set-top DVD, Mac/PC DVD-ROM Drive

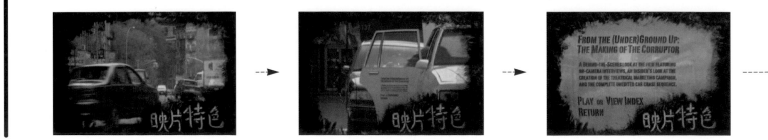

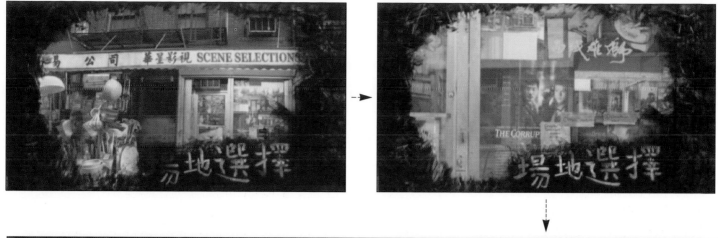

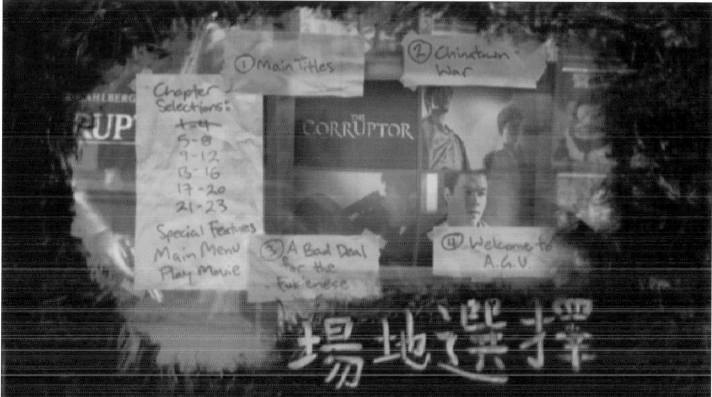

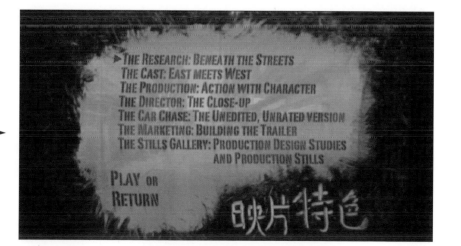

MOTION PICTURE

Austin Powers 2: The Spy Who Shagged Me DVD, designed and produced by Canned Interactive, is one of the first DVDs to use a star character fom a movie to introduce the sections of a DVD menu. Typically, studios provide design firms with footage and stills from the film to work with when creating the DVD menus. For the set-top DVD project, Canned shot custom green screen footage of actor Mike Myers (Austin Powers) to be integrated into the DVD menu designs. The filming session was brief and consisted of small segments—Myers pointing at titles as they appear on the viewer's screen, and Myers as a floating head introducing each area of the DVD.

Because set-top DVD menus are navigated with a basic up-down, left-right movement of a remote control the designers needed to keep the set-top navigation clean and simple. In contrast to this menu design is the interface used for the PC DVD-ROM version of the disc (facing page). This interface showcases the characters, original Website, cast and crew biographies, and games, but does not use full-motion video. The interface was also designed for mouse navigation, with smaller buttons and text links for navigating the project and is very reminiscent of a Web interface design. Another element that distinguishes the two interfaces is the stark white background used for the set-top menus, and the PC DVD menu's bright, psychedelic patterns and color palettes reminiscent of the 1960s fashions and Pop Art designs.

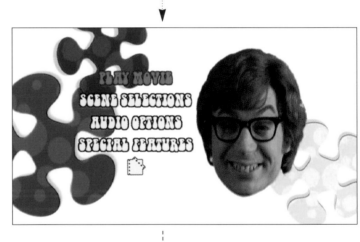

Project:	*Austin Powers 2: The Spy Who Shagged Me*
Client:	New Line Cinema/Home Video
Design Firm:	Canned Interactive
Design:	Jay Papke, Josh Lingenfelter
Production:	Allan Hellard
Authoring Program:	Adobe After Effects
Platform Specs:	Set-top DVD Player, PC DVD-ROM Drive

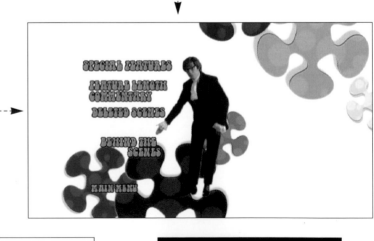

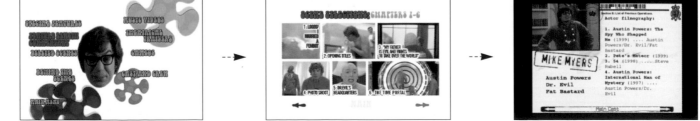

MOTION PICTURE

The King and I DVD is an animated feature film remake of the motion picture classic of the same name, originally starring Yul Brynner and Deborah Kerr. The multimedia design firm AIX Media Group, located in West Hollywood, California, produced this set-top DVD version of the animated film for Morgan Creek/Warner Bros.

The design of the interface features beautiful background stills from the film, and incorporates full-motion video clips into each section of the DVD. The design of the project, like the film itself, was created to entertain and engage children more than adults. The large lettering and spinning gold icons in front of each title show viewers where they need to click to view each section, and bright colorful imagery is used for each screen.

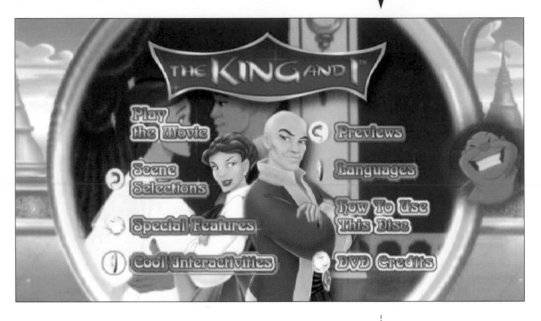

The DVD offers viewers a larger experience using various dynamic elements such as a movie sing-along, games, and interactive step-by-step sequences showing how the animation is transformed from pencil roughs to finished animation. All this is in addition to traditional scene selections and theatrical trailers. These elements combine to make this DVD project an entertaining experience for children and adults who enjoy animated films.

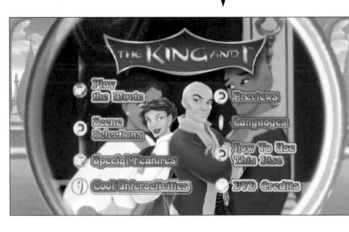

Project: *The King and I*
Client: Morgan Creek/Warner Bros.
Design Firm: AIX Media
Design: John "Fitz" Fitzpatrick
Authoring Program: Lightwave 3D, Adobe After Effects
Platform Specs: Set-top DVD player, PC DVD-ROM rive

MOTION PICTURE

The Matrix DVD was designed and produced by Canned Interactive for Warner Home Video. *The Matrix* motion picture is a cyber-thriller based on the concept of the main characters attempting to free themselves and humankind from computers that have taken over in the future. The film offers a disturbing portrait of the future if technology were to race out of control. The designs of *The Matrix* DVD interfaces—for TV set-top players (facing page and smaller images bottom) and Windows PC DVD-ROM drives (this page)—are good examples of incorporating a film's premise into an interactive experience.

The look of both the PC and set-top DVD interfaces captures the dark, high-tech tone of the film by using stills from the film and a CRT monitor-like color palette of electric greens on black backgrounds. The project offers viewers an interactive tour through the minds of the film's creators by showcasing over 200 of the film's 800 original storyboards.

Many dynamic elements were introduced into the PC DVD project such as the "Programmed Realities" area (below) that allows viewers to choose from six different martial arts scenes in the "Do You Know Kung Fu" section. This "Kung Fu" area and "The One" trivia game both integrate streaming video which directly references video segments from *The Matrix* DVD.

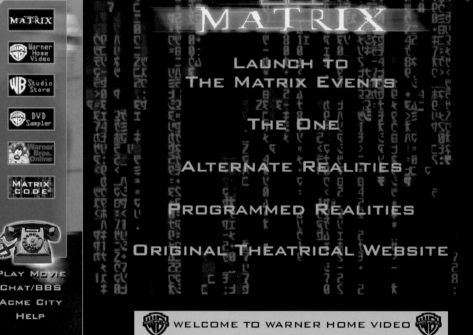

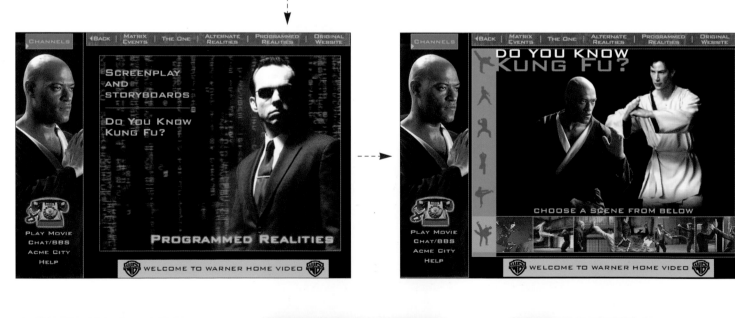

Project:	*The Matrix*
Client:	Warner Home Video
Design Firm:	Canned Interactive
Design:	David Levinson
Programming:	David Levinson
Production:	Jay Papke, Doug Textor,
	Mark Austin, Ricardo Diaz,
	Mark Daggett, Tony Mendoza
Authoring Program:	Macromedia Director,
	Adobe After Effects
Platform Specs:	Set-top DVD Player, Windows PC

MOTION PICTURE

The *Blast from the Past* DVD is a New Line Cinema/Home Video release, designed and produced by Canned Interactive. The motion picture is about culture shock and features a main character who was born and raised in a bomb shelter in the 1950s and 60s, and who one day emerges from this shelter into the modern world of Los Angeles.

The Canned Interactive designers wanted to maintain the look and feel of the innocent 1950s and '60s when designing the set-top DVD interface. To maintain a visual continuity between the navigation and the film, the designers removed the color from the full-motion video that plays in the small circular areas on the contents screen (top). This toning down of the looping video clips adds a dated look to the material and evokes the days before color television was available in the United States.

Classic 1950s and '60s icons—a martini glass and a radiation symbol—add to the overall retro look of the interface. The typography and classic hand-drawn graphics complete the feel of the era, back when television was young.

Viewers see color video and photographs once they enter the secondary screens where they can jump to specific scenes in the film, view cast and crew biographies, or watch the theatrical trailer. A humorous interactive "Love Meter" game is also featured on the disc. To play the game viewers are asked to place their thumb on the TV screen when prompted. This action simulates the result of the screen recognizing the thumb print and a random answer to the question "How explosive is your love?" appears on the screen.

Project:	**Blast from the Past**
Client:	**New Line Cinema/Home Video**
Design Firm:	**Canned Interactive**
Design:	**Jay Papke, Josh Lingenfelter**
Programming:	**Jay Papke, Josh Lingenfelter**
Authoring Program:	**Adobe Photoshop/After Effects**
Platform Specs:	**Set-top DVD Player**

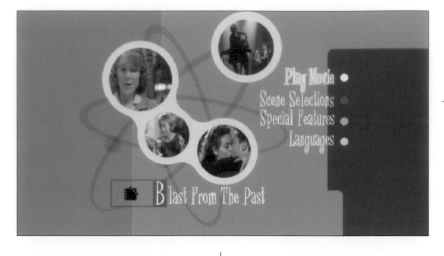

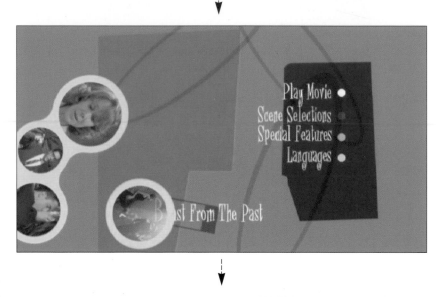

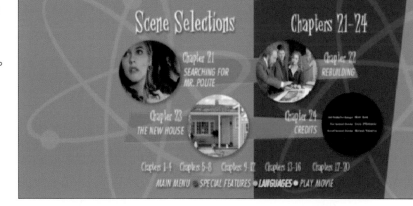

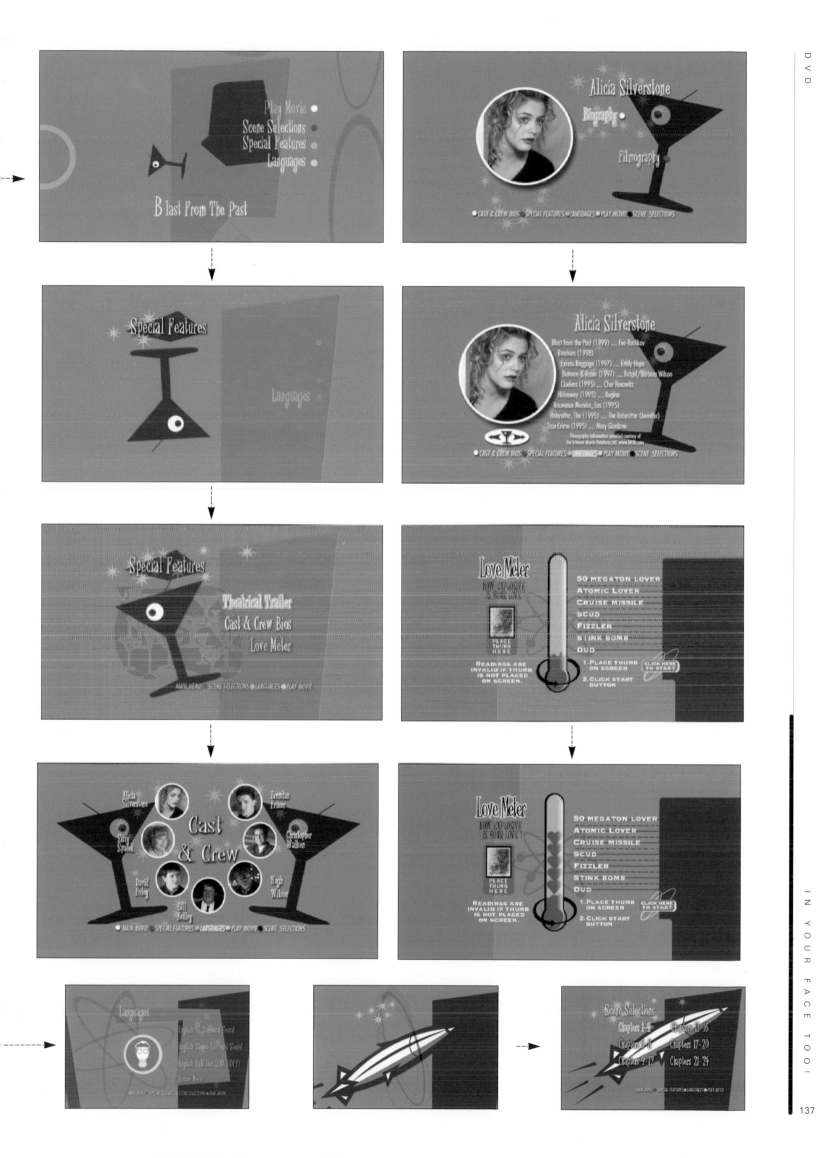

MOTION PICTURE

Detroit Rock City is a coming-of-age film that has the four main characters setting out on a wild road trip across the United States to see a KISS concert. The film is set in 1978, a time of bell-bottom pants, lava lamps, and Day-Glo posters.

Most DVD interfaces use a "highlight and click" design for navigating the information featured on the DVD, but the Angry Monkey designers wanted to break away from this structure and experimented with a buttonless/textless menu system for the set-top DVD interface (below). The designers made use of the simple up/down, left/right arrows built into the set-top DVD player's remote control, and used split-screens to feature the content. To aid in this type of navigation, the designers also used audio cues, many of which are read by the film's actors.

To keep the look of the era and maintain continuity with the film's theme, the Angry Monkey designers produced a Windows PC DVD interface (smaller images bottom) that features a day-glo color palette and shag carpet backgrounds. The designers also included a number of entertaining and humorous elements such as the Boob Tube movie trailer, KISS collector cards that can be emailed to friends, and a series of "M.A.T.M.O.K." newsletters (Mothers Against The Music Of KISS).

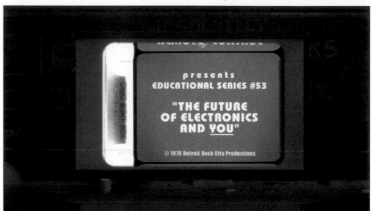

Project:	**Detroit Rock City**
Client:	New Line Home Video
Design Firm:	Angry Monkey
Design:	Jean-Paul Leonard, Nicole Weedon,
	Kazandra Bonner, Juanmi Bauza, Sean Brennan
Photographers:	Nicole Weedon, Sean Brennan, Frank Chiavino
Producer:	Jeanne Reynolds
Copywriting:	Menu Script: Jean-Paul Leonard, Nicole Weedon
	MATMOK Newsletters: Tessa Rumsey
Motion Graphics:	eMotion Studios: Paul Lundahl, Dav Rauch,
	Justin Graham
Audio Design:	eMotion Studios: Michael Becker
	Three Legged Cat Studios: Mark Rance
Authoring Program:	Adobe After Effects, Macromedia Flash
Platform Specs:	Set-top DVD Player, PC DVD-ROM Drive

Another humorous element of the DVD is a parody introductory sequence (above) that resembles a public education filmstrip from the 1970s. This filmstrip, together with its monotone voiceover and loud "beep" to alert the projectionist to move to the next image teaches viewers how to access and use the textless menu system.

2

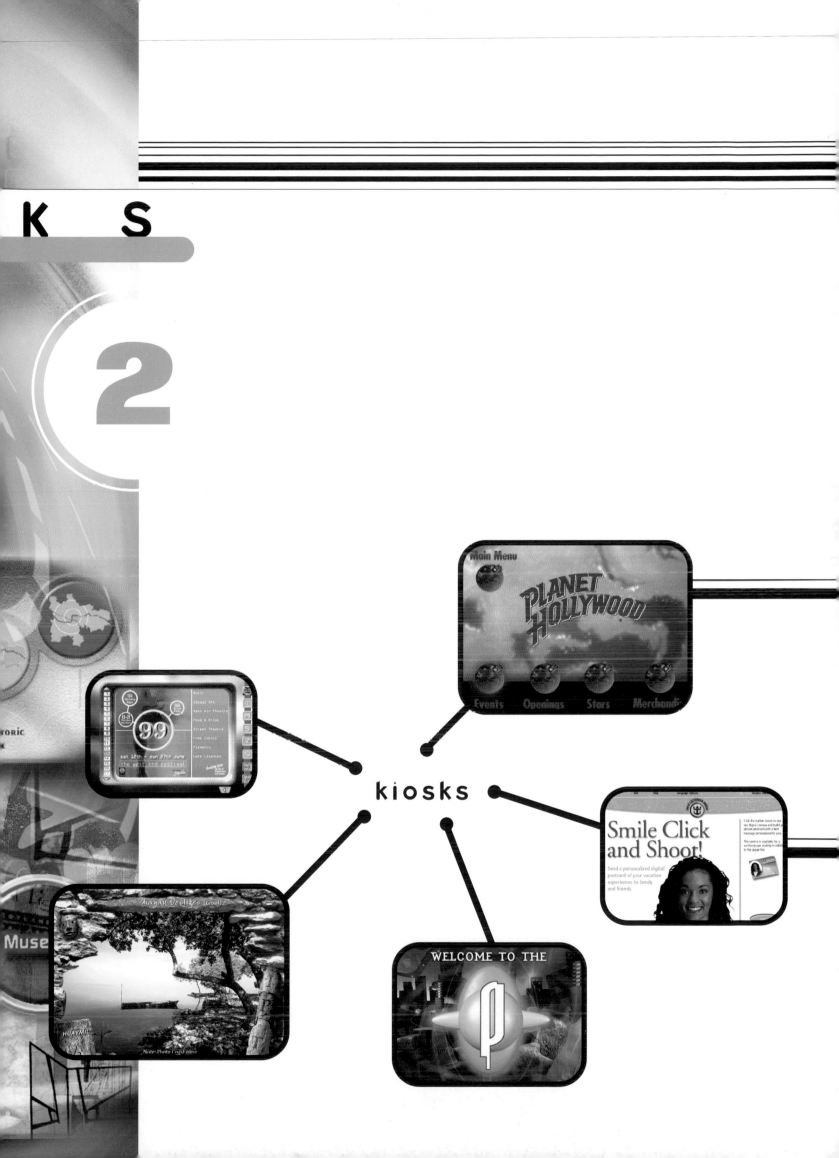

kiosks

STUDENT PROJECT

The Interactive Kiosk for Glasgow was designed and produced by Timea Bradley, a student attending design school in Glasgow, Scotland. This school project, one of the first-full length interactive projects created by Timea, shows a keen grasp of the tools and techniques needed to produce a high-quality interactive experience. The kiosk is a virtual tour of Glasgow's museums, and a local tourism directory that features upcoming events throughout the year. The kiosk also includes a number of maps showing how to get to specific areas around Glasgow.

Vibrant colors and textured backgrounds compliment a navigation that is simple and direct. Clearly labeled buttons and links offer users easy access from one area to another, and a single icon-based navigation bar on the right side of each screen is accessible at all times.

Project:	Interactive Kiosk for Glasgow
Client:	Self
All Design:	Timea Bradley
Authoring Program:	Macromedia Director
Platform Specs:	Macintosh, Windows PC

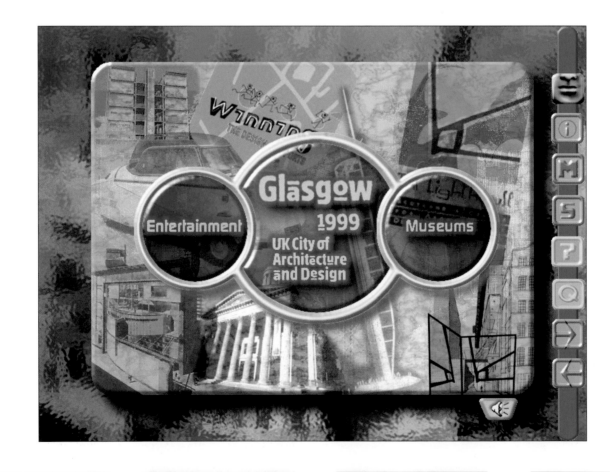

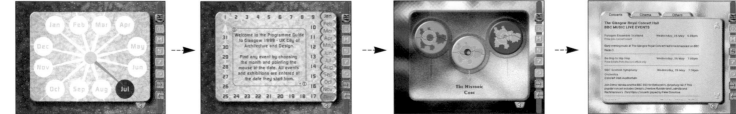

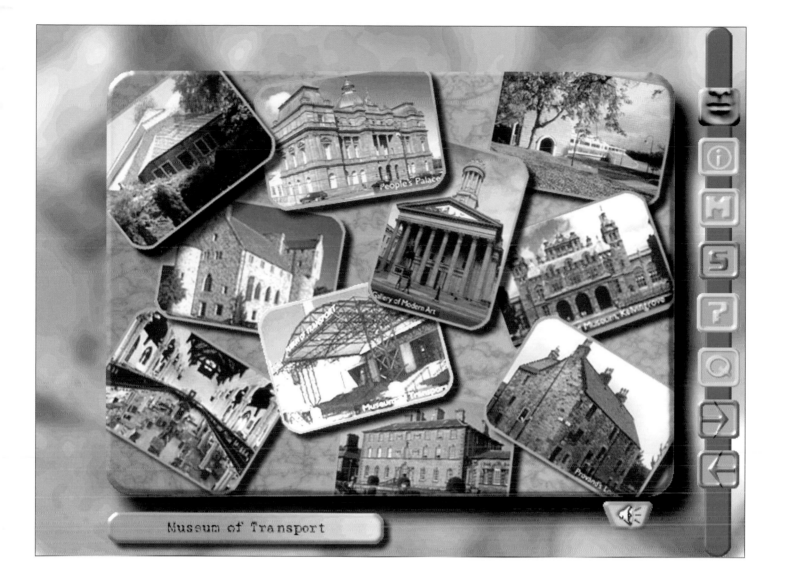

MUSIC ENTERTAINMENT

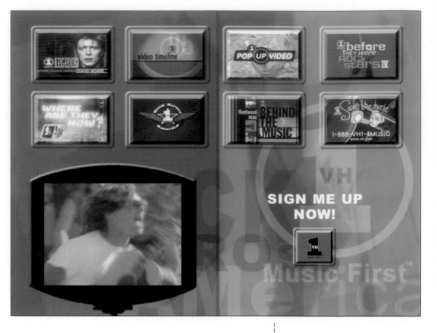

The VH-1 "Rock Across America" kiosk was a collaborative effort by Madison Design & Advertising and the Questa Corporation to create a touch screen kiosk that promoted the Rock Across America Concert Tour. The kiosks were featured during the 1998 and 1999 United States tours. Madison Design was in charge of the design and art direction, while the Questa Corporation handled the video capture, interface programming, and the final production of the kiosk.

VH-1's goal for the kiosks was to give concertgoers a taste of the touring experience while at the same time using the kiosk as a marketing device. Its objectives included a look at the bands currently touring, showcasing ads for the tour's sponsors, collecting names for future mailings, and most importantly, increasing awareness of VH-1 and its programming.

The designers' challenge was to deliver on these goals and create a user experience that would be both easy-to-use and memorable, while incorporating a large number of resources such as full-screen video, animation, and still images. The designers accomplished this by using large, easily recognized navigation icons and buttons, a clean and uncluttered interface for displaying music videos, and using a minimum amount of text for reading. This allowed users to visually navigate through the interface and get through the experience quickly so the next user could begin the process.

To catch the attention of concertgoers, the designers created an attract-loop animation that played until a user touched the screen. Once users touched the screen the loop transitioned to the main contents screen (top right) where they were given a number of choices for navigating and exploring the content. The designers created different screen designs for each of the main areas but maintained continuity by using the same button treatments for each screen, and similar type treatments and photo-collaged imagery throughout.

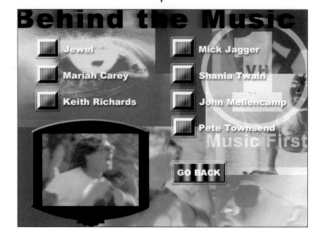

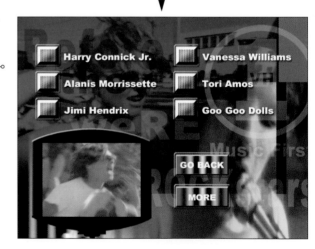

Project:	VH-1 "Rock Across America"
Client:	VH-1
Design Firm:	Madison Design & Advertising
Kiosk Manufacturer:	Questa Corporation
Design:	Juan Carlos Morales
Illustration:	Juan Carlos Morales
Programming:	Greg Green
Project Manager:	Greg Green
Authoring Program:	Touchman Kiosk Authoring Software
Platform Specs:	Windows PC

 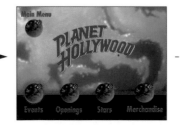 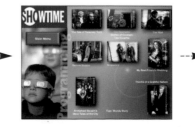

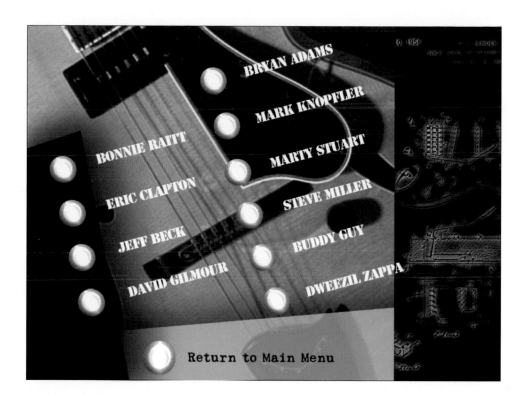

BRYAN ADAMS

MARK KNOPFLER

MARTY STUART

BONNIE RAITT

ERIC CLAPTON

STEVE MILLER

JEFF BECK

BUDDY GUY

DAVID GILMOUR

DWEEZIL ZAPPA

Return to Main Menu

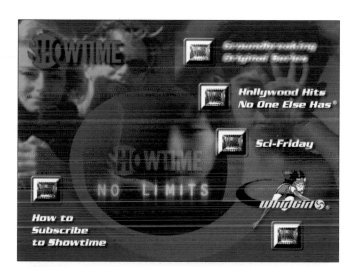

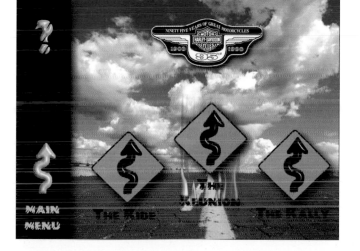

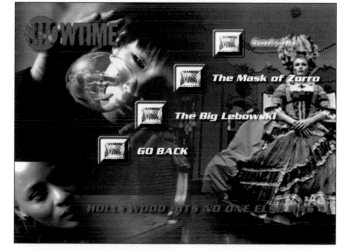

EDUCATIONAL

Mundo Maya and *Ciudad Museo* are two interactive projects designed and produced by Opera Multimedia in Querétaro, Mexico. Both of these projects were produced as kiosks and also distributed as CD-ROMs for the Campeche State Cultural Patrimony Sites and Monuments organization. The Mundo Maya, (Mayan World) project explores the geography and history of Mayan civilization, and presents viewers with a look into the political, ethnic, and religious relationships between the Mayan people and other cultures. The second project, Ciudad Museo, is an interactive tour of Campeche City, which offers viewers an in-depth look at the history, architecture, and people who have played prominent roles in the city's past.

Each kiosk interface follows a design template, including contents screens (right) that lead viewers to maps, text, and photo tours. To further keep continuity between the two interfaces, the designers used a theme of arched entryways—rock and stone for Mundo Maya and adobe-like archways for Ciudad Museo (facing page).

Project:	**Mundo Maya/Ciudad Museo**
Client:	**Monumento del Patrimonio**
Design Firm:	**Opera Multimedia**
Design:	**Javier Mier, Karin Delgado, Alejandra Heras**
Illustration:	**Javier Mier, Karin Delgado, Alejandra Heras**
Programming:	**Ricardo Figueroa**
Photography:	**Patricia Tamés**
Production:	**Carlos Rangel**
Authoring Program:	**Macromedia Director**
Platform Specs:	**Macintosh, Windows PC**

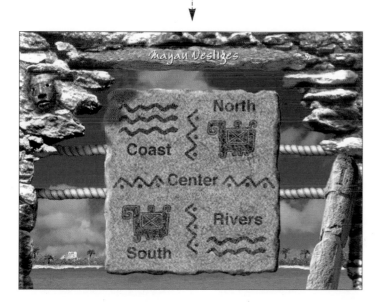

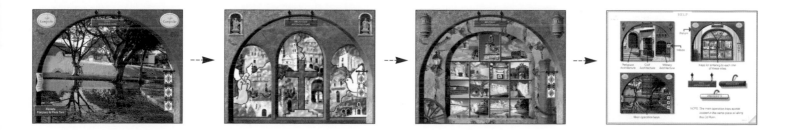

RESTAURANT KIOSK

The Playdium Diner menu kiosk was designed and produced by the Canadian multimedia design firm Integrated Communications and Entertainment (ICE) for the three Playdium gaming centers located in Toronto, Canada. The gaming centers are state-of-the-art arcades that feature high-tech virtual reality games for children and adults.

The project was designed as a tabletop kiosk that offers customers at the Playdium Diner—located in the gaming centers—an interactive experience while ordering their food and beverages. The menu opens with 3-D animation that leads the viewer to a help screen explaining how to use the kiosk, and then transitions into an interactive menu for ordering food and beverages. When the user is done ordering they can either send the order directly to the kitchen or call for a human waiter to come to the table. After the order has been placed the user can check out different background screens in the "Gallery" to watch while waiting, or continue and play various games available on the kiosk.

To complement the excitement and frenetic energy released by the game players at the center, the designers implemented a bright, colorful palette of electric blues and greens for the main interface, and futuristic video sequences of spaceships zooming in and out of the viewer's screen; the transitions lead to each area of the menu.

To navigate the interface, customers use the "Thingamajig" remote control attached to the underside of the table. This device uses a basic up-down, left-right navigation, and six preprogrammed buttons that activate specific functions on each menu screen, such as the number "4," which brings a waiter to the table.

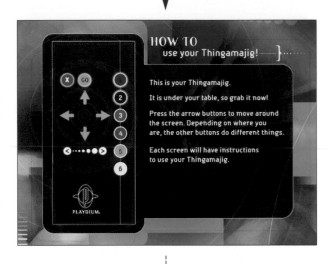

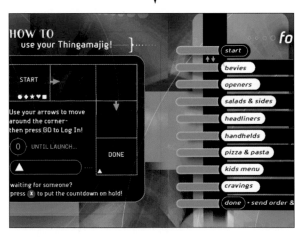

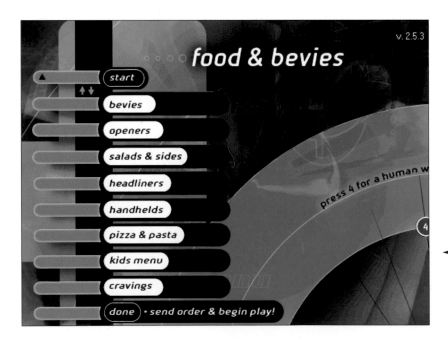

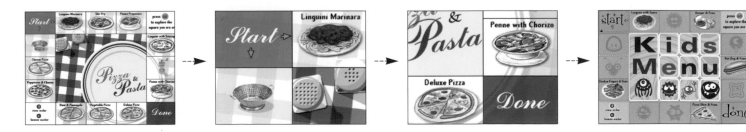

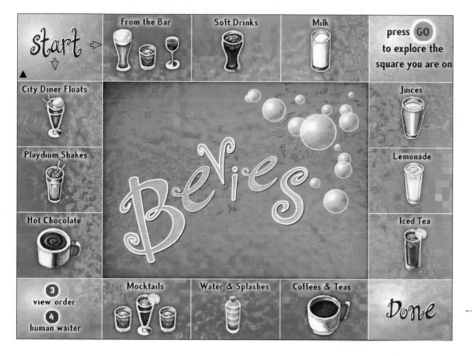

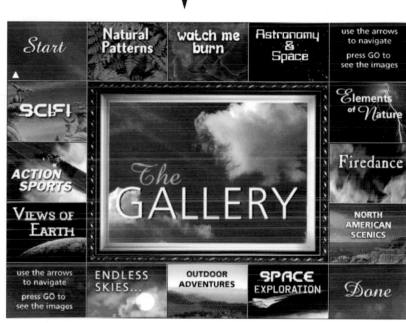

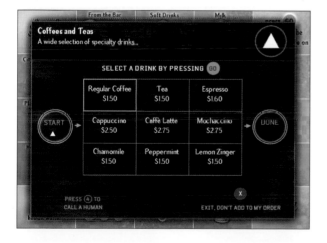

Project: Playdium Menu Kiosk

Client: Playdium Entertainment Corporation

Design Firm: Integrated Communications and Entertainment

Design: Kathy McKechnie, Sean Patrick, Dave Luxton, Pete (Pon) O'Neil

Illustration: Rolly Wood

Programming: Joe Garofano, Juri Toumi, Chris Romero, Sean Rooney

Sound: Matt Jesson, Simon Edwards

3D Animation: Pete (Pon) O'Neil, Ken Reddick

Authoring Program: Macromedia Director, Adobe After Effects

Platform Specs: Macintosh, Windows PC

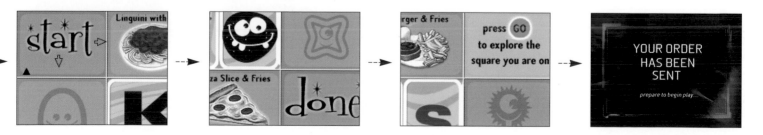

PROMOTION

The owners of the CN Tower, a Toronto-based entertainment and retail complex, wanted visitors to the building (the tallest in the world) to understand how large the buiding is in comparison to other places in the world, discover the entertainment venues in the building, and be able to view past special events that had been held there.

ICE Inc., a Toronto design firm, took the leading role in developing many of the Tower's experiences, including the bilingual interactive kiosk exhibits shown at right.

Fifteen interactive touchscreen kiosks offer viewers a dynamic and exciting view of architectural and environmental design elements, the evolution of the building's construction, and a look at past events such as a person hang gliding from the top of the Tower.

The navigation of each of the kiosks sequences was designed for easy access to anyone's using it: large touchable areas such as the three links on the main screen (below right), and photographic buttons for quick recognition, add to the overall ease of use.

A limited palette of blues and greens, and cloud backgrounds lend the design a lofty and outdoorsy feeling, adding to a viewer's experience of being in the tallest building in the world. To give visitors a sense of scale, ICE created a section of the kiosk titled "The Tower on Tour" where viewers can see what the tower would look like if placed in different areas of the world (below).

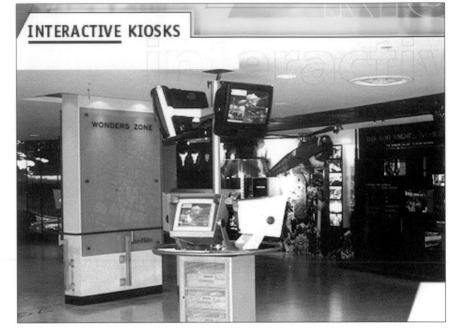

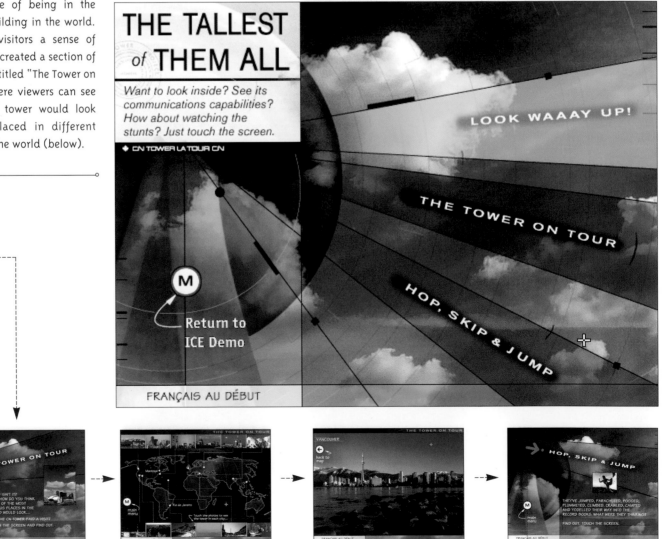

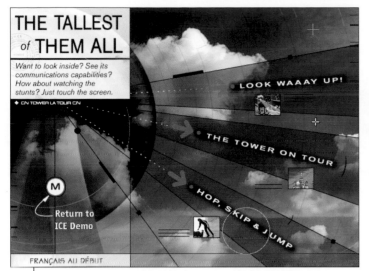

Because the CN Tower is located in Canada, the ICE team had to design the kiosks to accommodate both English- and French-speaking visitors (right and below). A link located at the bottom of each screen offers a choice of languages.

The ICE designers wanted the kiosk experience to be short and engaging—both to avoid tiring the viewer and to limit waiting time for other visitors. To speed the viewer's experience they included only small blocks of text, quick video segments, and a limited number of tabbed "Did You Know?" pullouts.

The kiosk enclosures were designed to allow multiple users and a number of television screens were installed above the actual navigation screens for others to view what was happening on the touch screens.

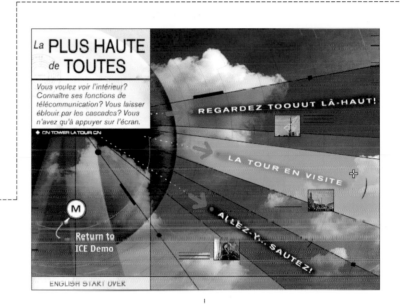

Project:	CN Tower Kiosks
Client:	CN Tower
Design Firm:	ICE Inc.
Design:	Kathy McKechnie
Art Direction:	Pete O'Neil
Programming:	Steve Wicks
Illustration:	Derek Prentice
Authoring Program:	Macromedia Director
Platform Specs:	IBM 300MHz Pentium MMX, Touch Screen Displays, External Speakers, External Video Displays

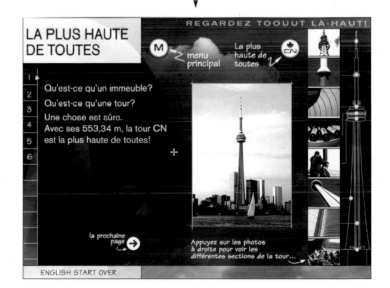

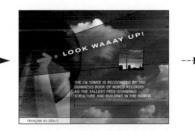

PROMOTION

Royal Caribbean Online is an Internet kiosk produced by John Brady Design Consultants and is available to passengers on Royal Caribbean International cruise ships. The kiosk is an internet terminal that offers users acess to the Web, email via America Online, online postcards, and business applications such as Microsoft Word and Excel.

To maintain consistency with the branding of Royal Caribbean, the designers used a bright and colorful palette of orange, blue, and green—and featured the Royal Caribbean logo—on nearly every page. The navigation for browsing the various sections of the kiosk is simple and clean, with all of the main text links located at the top and a sidebar navigation featuring onboard advertising—for the onboard casino, photography studio, and spa—located at the right of the screen. An interesting element designed into the kiosk is the imbedding of the internet browser into a frame within the kiosk. This allows the cruise line to keep sidebar advertisements and other links visible at all times, rather than have a browser window open and cover the interface. It also helps to keep the kiosk's touchscreen interface from becoming cluttered with too many windows, which could confuse some novice computer users.

Two important items that are incorporated into the kiosk are the choice of either English or Spanish navigation, and a credit card slider built into the terminal for users to pay for using various elements of the kiosk, such as sending postcards, or printing from the applications.

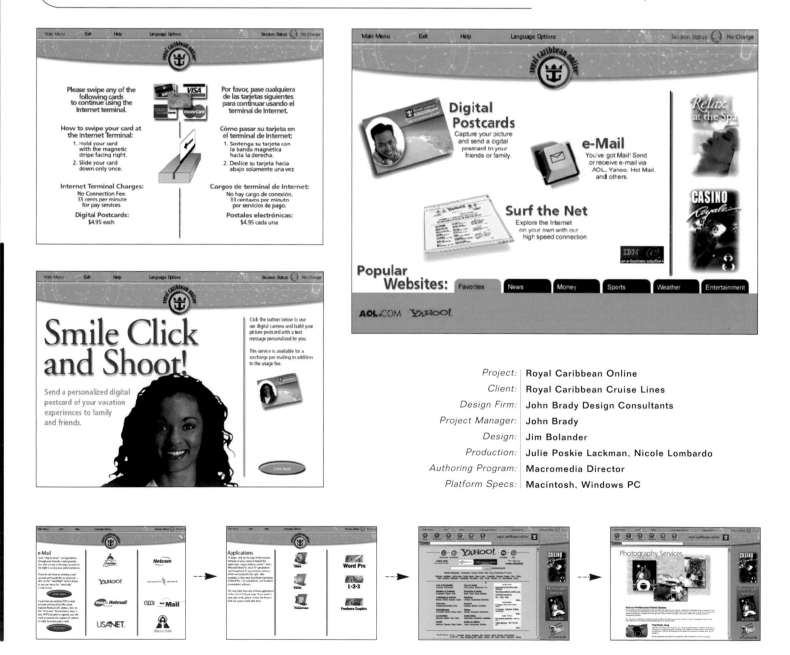

Project:	Royal Caribbean Online
Client:	Royal Caribbean Cruise Lines
Design Firm:	John Brady Design Consultants
Project Manager:	John Brady
Design:	Jim Bolander
Production:	Julie Poskie Lackman, Nicole Lombardo
Authoring Program:	Macromedia Director
Platform Specs:	Macintosh, Windows PC

iN YOUR FACE TOO!

More of the Best Interactive Interface Designs

1K Studios
2811 Cahuenga Blvd. West
Hollywood, CA 90068 USA
(323) 845-0040
Email: info@one-k.com
www.one-k.com

415 Productions
2507 Bryant Street
San Francisco, CA 94110 USA
(415) 642-4200
Email: liisa@415.com / info@415.com
www.415.com

52mm
12 John Street #10
New York City, NY 10038 USA
(212) 766-8035
Email: info@52mm.com
www.52mm.com

AIX Media
8455 Beverly Blvd. #717
West Hollywood, CA 90048 USA
(323) 655-8893
Email: fitz@aixmediagroup.com
www.aixmediagroup.com

Akimbo Design
406 Chestnut Street
San Francisco, CA 94133 USA
(415) 677-9250
Email: ben@akimbodesign.com
www.akimbodesign.com

Alexander and Tom Inc.
3201 Elliott Street
Balto, MD 21224 USA
(410) 327-7400
Email: info@alextom.com
www.alextom.com

Alison Zawacki
P.O. Box 278631
Sacramento, CA 95827-8631 USA
(916) 981-9367
Email: artist@alisonz.com
www.alisonz.com

Angry Monkey
351 9th Street, Suite 202
San Francisco, CA 94114 USA
Email: narcher@angrymonkey.com
www.angrymonkey.com

Art Center College of Design
1700 Lida Street
Pasadena, CA 91103 USA
(626) 396-2352
Email: pr@artcenter.edu
www.artcenter.edu

Arun Kundnani
2-6 Leeke Street
London, WCIX 9H5
United Kingdom
(44) 207-833-2010
Email: Info@homebeats.co.uk
www.homebeats.co.uk

Black Bean Studios, Inc.
103 Broad Street
Boston, MA 02110-3414 USA
(617) 338-5444
Email: alisha@blackbean.com
www.blackbean.com

Brady Interactive
17th Floor, 3 Gateway Center
Pittsburgh, PA 15222 USA
(412) 288-9300
Email: shamburger@bradyinteractive.com
www.bradyinteractive.com

Canned Interactive
6444 Santa Monica Blvd.
Los Angeles, CA 90038 USA
(323) 957-4275
Email: sandy@cannery.com
www.cannery.com

CBO Interactive (Cimarron/Bacon & O'Brien)
812 N. Highland Avenue
Hollywood, CA 90038 USA
(323) 468-9580
Email: mitchellr@cbomedia.com
www.cbomedia.com

Click Active Media
2701 Ocean Park Blvd. #205
Santa Monica, CA 90405 USA
(310) 581-4000 ext.112
Email: cheryl@clickmedia.com
www.clickmedia.com

C02 Media
241 E. 4th Street, Suite 206
Frederick, MD 21701 USA
(301) 682-6515
Email: max@co2media.com
www.c02media.com

Creative Direction Studios
130 N. Butte Street
Willows, CA 95988 USA
(530) 934-8827
Email: cmd@studiocd.com
www.studiocd.com

Domain Design
Jacob Van Lennepkade 233 II
The Netherlands
(00) 3120-6184169
Email: webmaster@netgate.co.uk
www.domain-design.net

Doors 5 Live Team
NW. ujdsvoorburgwal 130 F
Amsterdam, NH 1012SH
The Netherlands
(31) 020-4200743
Email: d5live@dds.nl
live.doorsofperception.com

Ego Communications
27, Rue Cambertin
Cantley, Quebec J8V-2V8
Canada
(819) 827-8238
Email: egocom@egocom.com
www.egocom.com

Enlighten
219 S. Main Street
Ann Arbor, MI 48104 USA
(734) 668-6678
Email: steveg@enlighten.com
www.enlighten.com

E.ON Interactive
412 Cedar Street
Santa Cruz, CA 95060 USA
(831) 420-2660
Email: adam@eoninteractive.com
www.eoninteractive.com

Epic Software Group Inc.
5 Grogans Park Drive, Suite 111
The Woodlands, TX 77380 USA
(218) 363-3742
Email: epic@flex.net
www.epicsoftware.com

Epoxy
506 McGill, 5-Montreal,
Quebec H2Y 2H6
Canada
(514) 866-6900
Email: dfortin@epoxy.ca
www.epoxy.ca

Final
3 Sugarhill Court
St. Louis, MO 63021 USA
(314) 227-0197
Email: staff@final.nu
www.final.nu

François Chalet
Shoeneggstrasse 5
Zurich 8004
Switzerland
(41) 79 634 82 55
(41) 1 291 24 22
Email: chalet@datacomm.ch
www.francoischalet.ch

Frontera Design
336 Broadway #27
Chico, CA 95928 USA
(530) 342-9953
Email: patrick@fronteradesign.com
www.fronteradesign.com

GmunkStudio
1613 Chester Avenue
Arcata, CA 95521 USA
(707) 825-0959
Email: bradley@gmunk.com
www.gmunk.com

Goblin Design
Am Trenschelbuck 7
79853 Lenzkirch, Germany
(49) (0) 7653 962498
Email: info@goblin design.com
www.goblindesign.com

Hollis Design
344 7th Avenue
San Diego, CA 92101 USA
(619) 234-2061
Email: sparky@hollisdesign.com
www.hollisdesign.com

Horizons Companies
1800 West 5th Avenue
Columbus, OH 43212 USA
(614) 481-7200
Email: niebisch@hvf.com
www.horizonsmedia.com

Ice – Integrated Communications & Entertainment
489 Queen Street East,
Toronto, ONT Canada M5A1V1
(416) 868-0423
Email: Info@iceinc.com
www.iceinc.com

I-D Media AG
Dewanger Str. 22
Essingen – Forst State
Baden-Württemberg 73457
Germany
(49) 73 65 96 05 0
Email: I-dmedia@I-dmeida.com
www.i-dmedia.com

In Your Face Design
3091 Chico Avenue
Chico, CA 95928 USA
(530) 894-FACE
Email: iyf@inyourface.com
www.inyourface.com

Juxt Interactive
2201 Mattin Street, Suite 203b
Irvine, CA 92612 USA
(949) 752-5898
Email: toddhead@juxtinteractive.com
www.juxtinteractive.com

Ketch22 Design
1459 Hayes Street
San Francisco, CA 94117 USA
(415) 928-5504
Email: scott@ketch22.com
www.ketch22.com

Lightspeed Interactive Inc.
1235 Pear Avenue, Suite 103
Mountain View, CA 94043 USA
(650) 965-1222
Email: info@lightspeed-interactive.com
www.lightspeed-interactive.com

Luminant Worldwide Corporation
1950 Stemmons Fwy., Suite 3027
Dallas, TX 75207 USA
(214) 800-4266
Email: webmaster@luminant.com
www.luminant.com

Madison Design and Advertising, Inc.
27 Washington Street
Medford, MA 02155 USA
(781) 395-6805
Email: design@madisonadvertising.com
www.madisonadvertising.com

Mark Allen Design
2209 Ocean Avenue
Venice, CA 90291 USA
(310) 396-6471
Email: mallendesign@earthlink.net
www.markallendesign.com

Melia Design Group
905 Bernina Avenue
Atlanta, GA 30307 USA
(404) 659-5584
Email: mike@melia.com
www.melia.com

Natalie Tzobanakis
27 Romillas Street
Nea Erythrea
Athens GR14671 Greece
(301) 6212 251
Email: geonat@iname.com
www.nautilos.com/nataliet

Nofrontiere
Zinckgasse 20-22
Vienna, Austria A1150
Austria
(43) 1/985 57 50
Email: ask@nofrontiere.com
www.nofrontiere.com

Opera Multimedia
Mariano Perrusquia 102 PH,
Colonial San Angel
76030 Santiago de Quéretaro, MX
Mexico
(524) 215-6485
Email: jmier@opera.com.mx
www.opera.com.mx

Pantapoiein – Multimedia
Edif. Ninho de Empresas Gab.37
Estrada da Penha
Faro, Algarve 8000
Portugal
(089) 863397 / 880594
Email: pantap@mail.telepac.pt
www.pantapoiein.com

Rare Medium Inc.
164 Townsend Street, #4
San Francisco, CA 94107 USA
(415) 957-1975
Email: tim@circumstance.com
www.raremedium.com
www.circumstance.com

Second Story Interactive Design
239 NW 13th Avenue #214
Portland, OR 97209 USA
(503) 827-7155
Email: info@secondstory.com
www.secondstory.com

Spidereye Studios
2 Rouse Street
Port Melbourne, Victoria 3207
Australia
(03) 9646 7766
Email: johnr@spidereye.com.au
www.nineinch.com

STAT Media Limited
7077 E. Shorecrest Drive
Anaheim Hills, CA 92807
USA
(714) 280-0038
Email: gbirch@statmedia.com
www.statmedia.com

Subnet
Suite 223 Lomeshaye Business Village
Nelson, Lancashire BB9 7DR
United Kingdom
(44) 1282 616000
Email: bren@subnet.co.uk
www.subnet.co.uk

Temporary Items
539 Venice Way
Venice, CA 90291
USA

Timea Bradley
Flat 103, 2A Riverbank St
Pollokshaws, Glasgow
Great Britain
(44) 141-636-8543
Email: tbradley@ukonline.co.uk

Wanganui Polytechnic, Dept. Computer Graphic Design
Private Bag 3020
Wanganui,
New Zealand
(6) 348-0909
Email: infoline@whanganui.ac.nz
www.wanganui.ac.nz

A

ACCESS TIME: Amount of time it takes a CD-ROM drive (or other type of device) to locate and retrieve information.

B

BANDWIDTH: Data transmission capacity, in bits, of a computer or cable system; the amount of information that can flow through a given point at any given time.

BANNER: A graphic image that announces the name or identity of a site (and often is spread across the width of the Web page) or is an advertising image.

BAUD RATE: Speed of a modem in bits per second.

BROWSER: A program that allows users to access information on the World Wide Web.

BYTE: A single unit of data (such as a letter or color), composed of 8 bits.

C

CACHE: A small, fast area of memory where parts of the information in main, slower memory or disk can be copied. Information more likely to be read or changed is placed in the cache, where it can be accessed more quickly.

CD-ROM: (Compact Disc-Read Only Memory) An optical data storage medium that contains digital information and is read by a laser. "Read Only" refers to the fact that the disc cannot be re-recorded, hence the term.

CGI: (Common Gateway Interface) Enables a Website visitor to convey data to the host computer, either in forms, where the text is transferred, or as web maps, where mouse click coordinates are transferred.

CMYK: Cyan, magenta, yellow, black (kohl in German), the basic colors used in four-color printing.

COLOR DEPTH: The amount of dataused to specify a color on an RGB color screen. Color depth can be 24-bit (millions of colors), 16-bit (thousands of colors), 8-bit (256 colors), or 1-bit (black and white). The lower the number the smaller the file size of the image and the more limited the color range.

COMPRESSION: Manipulating digital data to remove unnecessary or redundant information in order to store more data with less memory.

D

DPI: Dots-per-inch, referring to the number of halftone dots per inch or the number of exposing or analyzing elements being used. 72-dpi is the resolution of computer display monitors.

DIGITIZE: Convert information into digital form.

E

E-ZINE: A small self-published magazine distributed electronically through the internet or on floppy disk.

F

FPS: Frames per second.

FRAMES: The use of multiple, independently controllable sections on a Web page.

G

GIF: (Graphics Interchange Format) A file format for images developed by CompuServe. A universal format, it is readable by both Macintosh and PC machines.

GIF89A ANIMATION: GIF format that offers the ability to create an animated image that can be played after transmitting to a viewer.

H

HOME PAGE: The Web document displayed when viewers first access a site.

HOTSPOTS: Areas onscreen that trigger an action when clicked upon or rolled over; usually these areas are not obvious to the user.

HTML: (HyperText Markup Language) The coding language used to make hypertext documents for use on the WWW.

HYPERLINK: Clickable or otherwise active text or objects that transport the user to another screen or Web page with related information.

HYPERTEXT: A method of displaying written information that allows a user to jump from topic to topic in a number of linear ways and thus easily follow or create cross-references between Web pages.

I

IMAGE MAP: A graphic image defined so that users can click on different areas of an image and link to different destinations.

INTERACTIVE: Refers to a system over which users have some control, which responds and changes in accordance with the user's actions.

INTERFACE: Connection between two things so they can work together; methods by which a user interacts with a computer

INTERNET: A global computer network linked by telecommunications protocols. Originally a government network, it now comprises millions of commercial and private users.

INTERNET SERVICE PROVIDER (ISP): Enables users to access the internet via local dial-up numbers.

INTRANET: A local computer network for private corporate communications.

J

JAVA: Java is a programming language expressly designed for use in the distributed environment of the Internet.

JAVASCRIPT: JavaScript is an interpreted programming or scripting language from Netscape.

JPEG: (Joint Photographic Expert Group) An image compression scheme that reduces the size of image files with slightly reduced image quality.

K

KILOBYTE: As a measure of computer processor or hard disk storage, a kilobyte is approximately a thousand bytes.

L

LINEAR: Refers to a story, song, or film that moves straight through from beginning to end.

M

MEGABYTE (MB): Approximately 1 million bytes.

MODEM: (modulator-demodulator) A device that allows computers to communicate to each other across telephone lines.

MORPHING: The smooth transformation of one image into another through the use of sophisticated programs.

MPEG: (Moving Pictures Expert Group) A video file compression standard for both PC and Macintosh formats.

MULTIMEDIA: The fusion of audio, video, graphics, and text in an interactive system.

N

NON-LINEAR: Refers to stories, songs. or films, the sections of which can be viewed or heard in varying order, or which can have various endings depending on what has preceded.

O

ONLINE SERVICE PROVIDER: An OSP is a company that provides access to the Internet through its own special user interface and propietary services.

P

PALETTE DETERIORATION: Refers to the degradation of colors in the system color palette when graphics are over optimized for Web implementation.

PALETTE FLASHING: When color pixels do not align correctly, such as in a GIF89a animation.

PLUG-INS: Plug-in applications are programs that can easily be installed and used as part of Web browsers.

R

REPURPOSE: To adapt content from one medium for use in another, i.e., revising printed material into a CD-ROM.

RESOLUTION: Measurement of image sharpness and clarity on a monitor.

RGB: (Red, Green, Blue) A type of display format used with computers. All colors displayed on a computer monitor are made up of red, green, and blue pixels.

ROLLOVER: The act of rolling the cursor over a given element on the screen, resulting in another element being displayed or a new action beginning.

S

SEARCH ENGINE: A software program that allows a user to search databases by entering in keywords.

SHOCKWAVE: The Macromedia add-on that allows users to create compressed Web animations from Director files.

SITE: A WWW location consisting of interlinked pages devoted to a specific topic.

SPLASH PAGE: An opening page used to present general information for the viewer, such as plug-ins or browser requirements.

STREAMING AUDIO: Sound that is played as it loads into the browser.

STREAMING VIDEO: Video that plays as it loads into a browser window.

T

T1 AND T3: High-speed digital channels often used to connect Internet Service Providers. A T1 runs at 1.544 megabits per second, A T3 line runs at 44.736 megabits per second.

THROUGHPUT: The rate of data transmission at a given point, related to bandwidth.

TRANSFER RATE: The rate at which a CD-ROM drive can transfer information.

TRANSPARENT GIF: A GIF image with a color that has been made to disappear into or blend into the background of a Web page.

U

URL: (Universal Resource Locator) Standard method of identifying users or machines on the Internet. May be either alphanumeric or numeric.

V

VIDEO CONFERENCING: Using online video to connect with one or more people for communicating over long distances.

VIRTUAL REALITY: A simulation of the real world or an imaginary alternative presented on the computer.

VRML: (Virtual Reality Markup Language) The coding language used to create simulated 3D environments online.

W

WWW: (World Wide Web) graphical Internet interface capable of supporting graphics within text, sound, animation and movies, as well as hypertext linking from site to site.

Check out these Website URLs for additional Web terminology:

http://whatis.com/

http://iasw.com/glossary.html

DESIGN RESOURCE
http://www.lynda.com
Resource for Web design tips and techniques by leading Web book author Lynda Weinman.

DESIGN RESOURCE
http://www.spctrum.com/cedge/resource.htm
Cutting-edge resources for Web designers.

DESIGN RESOURCE
http://www.photodisc.com
More than 32,000 royalty-free stock photos available from PhotoDisc. The site also features an easy-to-use search engine.

DESIGN SCHOOLS/US
http://www.arts.ufl.edu/graphic_design/designschools.html
Schools in the United States with graphic design programs.

DESIGN SCHOOLS/WORLD
http://www.arts.ufl.edu/graphic_design/worldschools.html
Schools from around the world with graphic design programs.

DOWNLOAD/ANIMATED GIFS
http://www.animagifs.com
Animated GIF89a graphics available for use on non-commercial Websites.

DOWNLOAD/BACKGROUND GIFS
http://eric.tcs.tulane.edu/images/backgrounds/index3.html
Excellent site containing hundreds of GIFS to use as Website backgrounds.

DOWNLOAD/DESIGN TOOLS
http://ccn.cs.dal.ca/~aa731/feathergif.html
Downloadable Macintosh Photoshop plug-in filter to create GIF images with blurry, transparent edges.

DOWNLOAD/DESIGN TOOLS
http://www.cooltool.com/maxanimation.html
Cool tools for creating Web pages and graphics.

DOWNLOAD/DESIGN TOOLS
http://www.aris.com/boxtop/plugpage
Download PhotoGIF 2.0, a Photoshop plug in for optimizing GIFs.

DOWNLOAD/DESIGN TOOLS
http://www.mindworkshop.com/alchemy/gifcon.html
Downloadable Windows tools for creating GIFs or animated GIFs.

DOWNLOAD/DESIGN TOOLS
http://www.mit.edu:8001/tweb/map.html
Online graphic tool to make transparent GIFs.

DOWNLOAD/DESIGN TOOLS
http://www.ohiocars.com/urlcheck/resources.html
Web design tools and HTML editors, as well as links to other design resources.

DOWNLOAD/GIF ALPHABETS
http://www.dineros.se
Swedish font foundry featuring many unique GIF alphabets.

DOWNLOAD/JAVA SCRIPT
http://www.essex1.com/people/timothy/js-index.htm
Archive of java script examples.

DOWNLOAD/PLUG-INS
http://browserwatch.iworld.com/plug-in.html
One-stop shop for all the plug-ins on the net for Macintosh, UNIX, or Windows platforms.

DOWNLOAD/PLUG-INS
http://home.netscape.com/comprod/products/navigator/version_2.0/plugins
Netscape site for plug-ins.

DOWNLOAD/SHAREWARE
http://www.shareware.com
Large site featuring Mac or PC shareware and freeware.

DOWNLOAD/SOUNDS & MUSIC
http://www.geek girl.com/audioclips.html
Downloadable sounds, music, and voices.

EUROPE WEB DIRECTORY
http://www.yweb.com
European Web listings directory.

HTML WRITERS GUILD
http://www.hwg.org/
Organization for HTML programmers and designers.

LINKS/ICONS, BUTTONS, ETC.
http://eglobe.com/~melissa/links.html
Links to sites with good downloadable icons, buttons, and textures.

WEBTV
http://www.webtv.net/html/home.about.html
Information about WebTV, a service that provides access to the Web through television.

DVD DESIGNERS/DEVELOPERS
AIX Media Group
http://www.aixmediagroup.com/new/hires.html

BD Fox Interactive
http://www.bdfox.com

Cinram International Inc
http://www.cinram.com/index3.html

Crush Digital Video_DVD Studio_1.888.CRUSHDV
http://www.crushdv.com/pages/home/hom_fr.html

DVD : Magazines
http://www.dvdmags.com/

DVD Awards
http://www.dvdawards.com/first/main.html

DVD Video Group
http://www.dvdvideogroup.com/

Highway One DVD & Multimedia Developers
http://www.highway1media.com/

ENHANCED CD LINKS
Ardent Records
http://www.ardentrecords.com/

AIX Entertainment Inc.
http://www.itrax.com/AixEntertainment.html

CDEXTRA sony design
http://www.cdextra.com/

Enhanced CD database
http://www.musicfan.com/ecd/

FLASH LINKS
The Flash Guide:
http://www.lunarmedia.com/asmussen/tutorials/index.html

BertoFlash
http://www.bertoflash.nu

Canfield Studios
http://www.canfieldstudios.com/

CNET Flash Help Directory
http://www.help.com/cat/2/657/187/188/hc/index.html

Ens - Tutorials and Demos
http://www.enetserve.com/tutorials/

Flash Central
http://www.flashcentral.com

Flash discussion
http://www.devdesign.com/flash/

Flash FAQ
http://www.flashfaq.net

Flash Kit
http://www.flashkit.com

FlashLite
http://www.flashlite.net

FlashMaster
http://www.flashmaster.nu/

Flash Pad
http://www.flasher.net/flashpad.html

Flashwave
http://www.flashwave.co.uk

FlashZone
http://www.flashzone.com

HelpCentre
http://www.helpcentre.co.uk

Macromania
http://www.users.bigpond.com/xtian/welcomenew.html

Macromedia
http://www.macromedia.com

Moock WebDesign Flash
http://www.moock.org/webdesign/flash/index.html

Quintus Flash Index
http://qfi.ucc.nl/

ShockFusion
http://www.shockfusion.com

T.I.P.'s - Flash
http://www.crazyraven.com/Tutorials/flash.htm

Virtual-FX
http://www.virtual-fx.net

KIOSK DEVELOPER LINKS
Ark Studios
http://www.arkserver.com/

Botticelli Interactive!
http://www.botticelli.com/

Envoy Kiosks
http://www.envoykiosks.com/

Frost & Sullivan Web Site
http://www.frost.com/

HTS Interactive
http://www.htsinteractive.com/projects/default.htm

KIOSKCOM Kiosk Applications
http://www.kioskcom.com/

Kiosks.Org
http://kiosks.org/

Lexitech Kiosk Services
http://www.lexitech.com/

Media Seven Productions
http://www.mediaseven.com/

Morasi Kiosk Design and Fabrication
http://www.morasi.com/

NetShift touchscreen Kiosk software
http://www.netshift.com/

Rocky Mountain Multimedia
http://www.rockmedia.com/

Summit Research Associates: Kiosk
http://www.summit-res.com/

WEB COUNTRY CODES
http://burn.best.com/bob/102195a.html

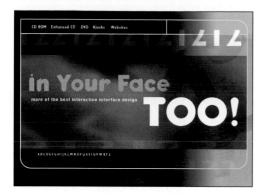

BEFORE OPENING THE *IYFT!* CD-ROM

1. For best performance be sure to turn off virtual memory in your control panel's "memory." When you do this you will need to restart your machine.

2. Set your monitor's color depth to 16-bit (thousands of colors).
IYFT! runs exclusively from the CD-ROM and does not install to your hard drive.

The *IYFT!* CD-ROM features links to each of the Website URLs featured in the *IYFT!* book. For optimal performance when linking to each project's Website we have included a self-contained "*IYFT!* Home Page" that can be accessed by your browser. This page will link you to the project's URLs.

TO PLAY THE *IYFT!* CD-ROM:

Macintosh:
1. Double-click the *IYFT!* icon.

3. The "Help" button will show you how to navigate the interface.

4. For more Web design software links, check out the "Resources" section on page 157 or open the "*IYFT!* Home Page" and check out the "Updated Resources" area on "inyourface.com."

Windows PC:
Choose your CD-ROM drive and open the IYF2_CDROM. Double-click the IYF2.exe file.

ADDITIONAL PROJECT CREDITS

Art Center College of Design

Producer: Sharon Tani
Interface & Package Design: Saeri Cho
Interactive Design: Brad Gerstein
Video Editing and Coordination: Sung Woo Kim
Videography: Gabe Gerber, Vee Vitanza
Poster and Program Design: Merlin Lembong
Website Design & Coding: Albert Tan
Photography: Craig Schriber
Organizing Team: Milka Broukhim, Saeri Cho, Merlin Lembong, Melissa Stone, Albert Tan, Sharon Tani
Faculty Advisors: John Chambers, Andrew Davidson, Peter Lunenfeld, Laura Silva, Petrula Vrontikis

Art Center College of Design: Beyond Glory

Executive Producer: Greg Thomas
Voiceover: Martin Pollack
Music Recording: Daniel Brice, Marc Dabe
Programming: Scott Seward
Video Editing: Brooks Harrington
Gospel Music: First African Methodist Episcopal chruch
Designers: Becky Brown, Michael Delahaut, Joel Hanlin, Debra Hidayat, eena Kim, Rudy Manning, Rion J. Nakaya, Caroline Nyanjui, R. Paul Seymour
Faculty Designers: Andrew Davidson, Allison Goodman, Laura Silva

Second Story Interactive: DreamWorks Records

Creative Director: Brad Johnson
Producer/Designer: Julie Beeler
Designer: Sam Ward
Programmers: Kim Markegard, Ken Mitsumoto
Flash Artists: Andy Slopsema/Construct, Britta Boland, Elizabeth Weinberg, elliot Earls, Future Farmers, Josh Ulm, Speared Peanut, Third Door, Todd Greco, Kelvin Lee
Micro-sites: Speared Peanut, Doug Kosmo, John Croteau, Britta Boland, Alex Pettas, Jennifer Petersen, Helios

DreamWorks

Executive Producer: Adam Somers
Digitarian: Kevin Murray
First Lady: Lisa Macy
Webmaster: Justin Landskron

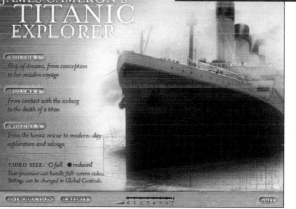

Rare Medium Inc.: James Camerons Titanic Explorer

Creative Directors: Tim Barber, Michele Thomas
Interface Design: Tim Barber, David Bliss, Brian Kralyevich, Brian Kromrey
Writers: Alan K. Lipton, Noel Franus
Programmers: Brian Kromrey, David Bliss, Chi-an Chien, Larry Doyle
Video Directors: Amanda Moore, Michele Thomas
Digital Video Producers: Amanda Moore, Michele Thomas
Graphic Designers: George Rodgers, Joerg Stierle, Fiel Valdez
Photographers: Charlie Arneson, Michael Morgan
Illustrators: George Rodgers, Joerg Stierle, Fiel Valdez
Animators: Brian Kralyevich, Michele Thomas, Don Lynch
Sound Editors: Troy DeRego, Amanda Moore, Sean Rooney
Producers: David wisehart, Tim Barber, David Bliss, Michele Thomas
Titanic Historian: Don Lynch
Titanic Visual Historian: Ken Marschall

http://www.rockpub.com

iYF

http://www.inyourface.com